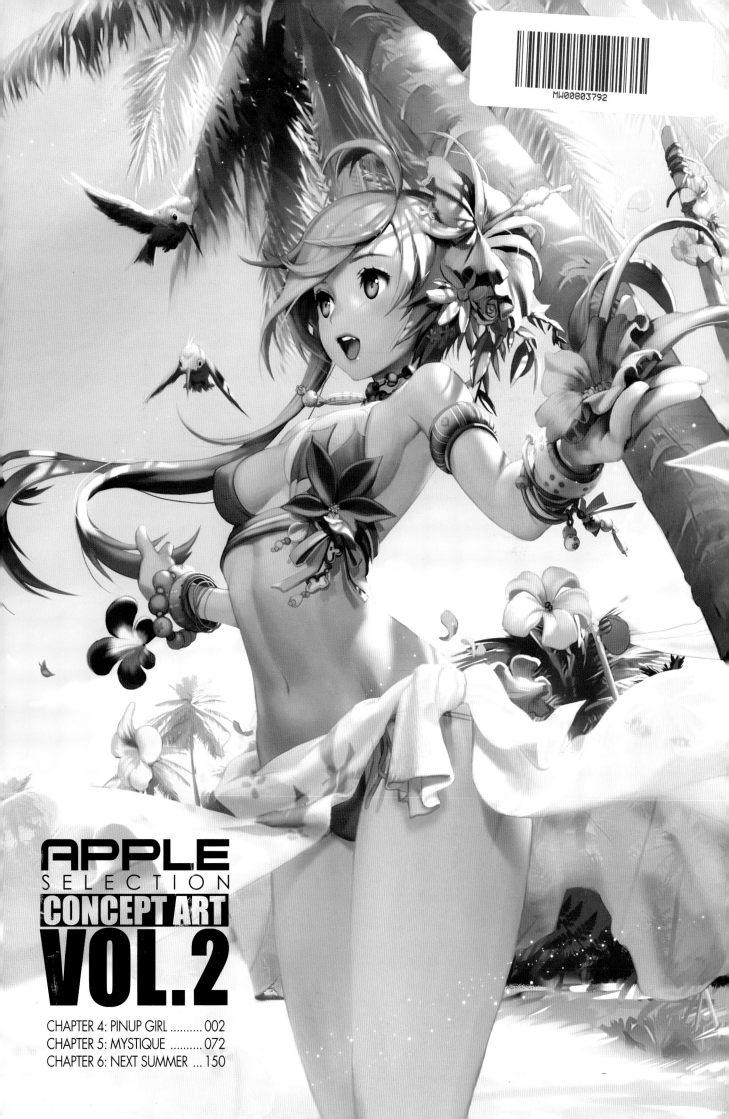

APPLE SELECTION
CONCEPT ART
VOL.2

Artists Profile

Appleselection Concept Art 4th Concept

004-007 스타토/STATO

김석훈/Kim Suk-hoon

008-009 석가/Stoneman

석정현/Seok Jeong-hyeon

010-011 날범/NAL
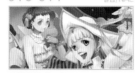
오은주/Oh Eun-ju

012 신미/sunme
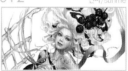
이선미/Lee Sun-mi

013 에일리언/ALIEN

오경석/Oh Kyoung-seok

014 남극빈도/SOUTHPOLEPEN

남극/Nam Geuk

015 정용석/Jung.Yong-seok

정용석/Jung Yong-seok

016-017 겨울님/winterlady

임겨울/Im Kyeo-ul

018-019 얌/YAM

양만식/Yang Man-sik

020 소년/deflads

한지원/Han Ji-won

021 가야/GAYA
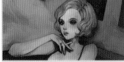
송현정/Song Hyun-jung

022-023 죽다살다/juk da sal da
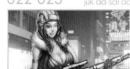
한국동/Han Kuk-dong

024-025 스나퍼/Snifer
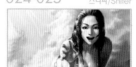
장영욱/Jang Young-uk

026 민트쵸코/Mintchoco
김현아/Kim Hyun-ah

027 올리비아/OLIVIA

임연희/Lim Yun-hee

028-029 자카드/zacade
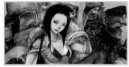
김민호/Kim Min-ho

030 신의 아들/brother of god
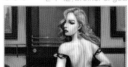
김동우/Kim Dong-woo

031 거친팬족/Panchok
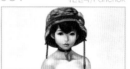
박준석/Park Joon-suk

032-033 아트벨/ArtBell
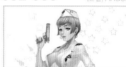
권현종/Kwon Hyun-jong

034-035 맨드릴/MandRi
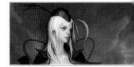
이종철/Lee Jong-chul

036-037 인접/inzup
임인섭/Lim In-sub

038 앙승검/ASK
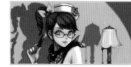
공혜진/Kong Hye-jin

039 엘 사르/El Char
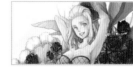
이승희/Lee Seung-hee

040-041 엘리즈/eLiz
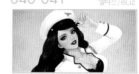
이윤희/Lee Yun-hee

042-043 헬독/helldog
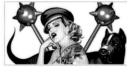
조성우/Cho Sung-woo

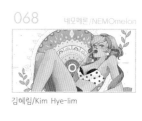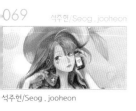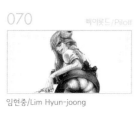

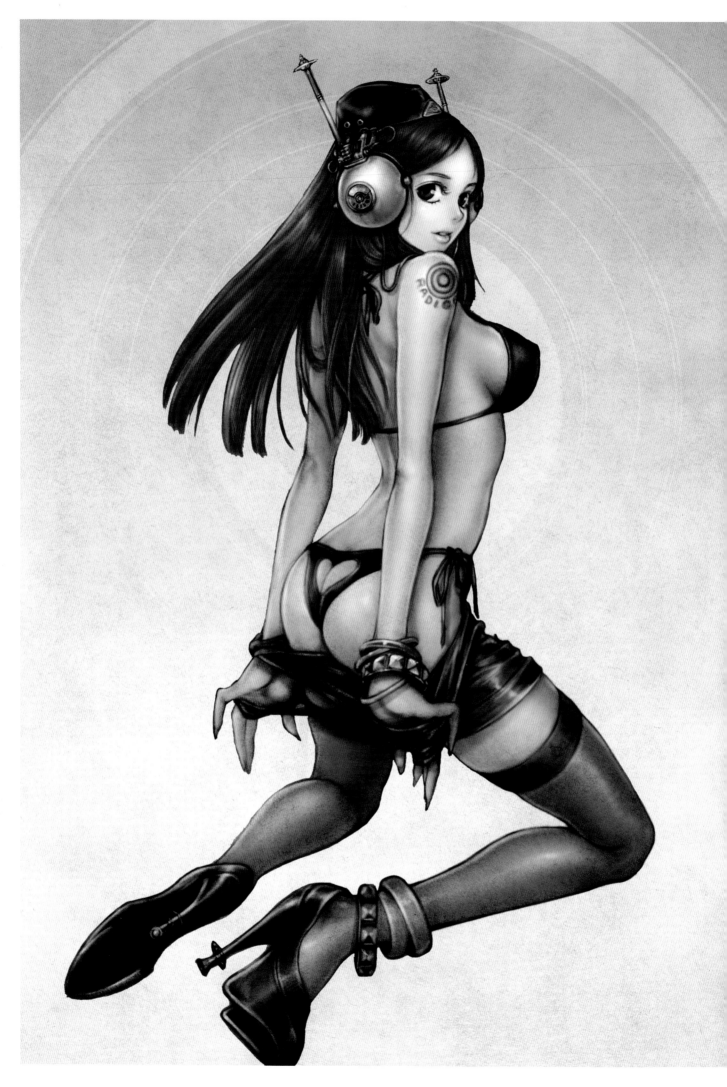

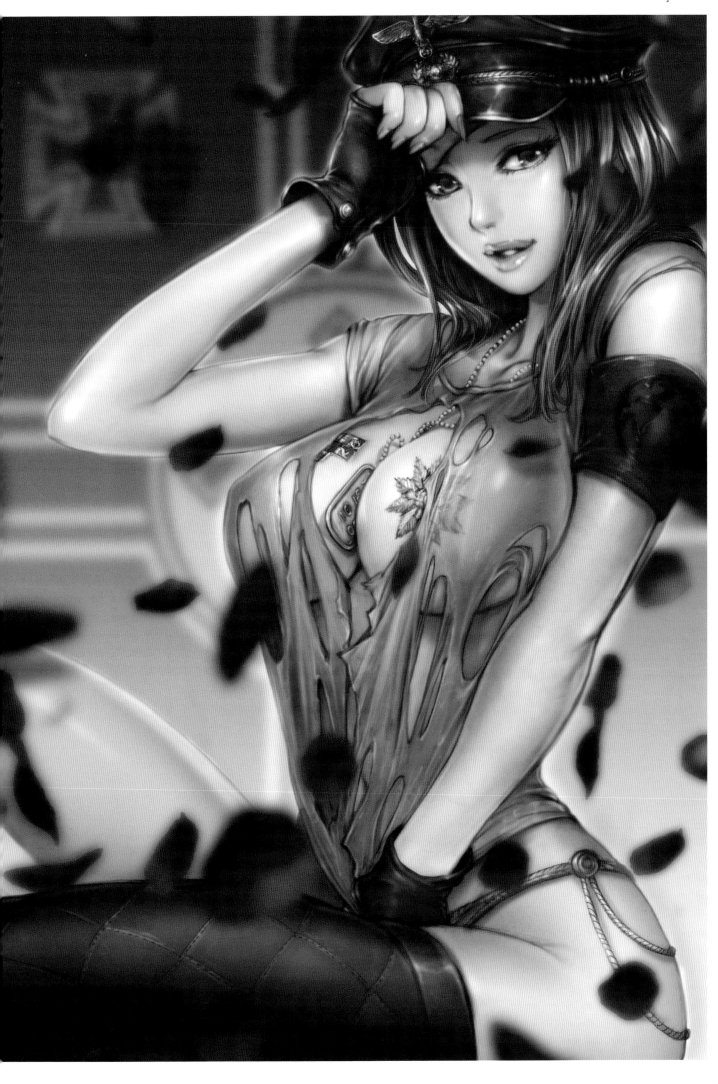

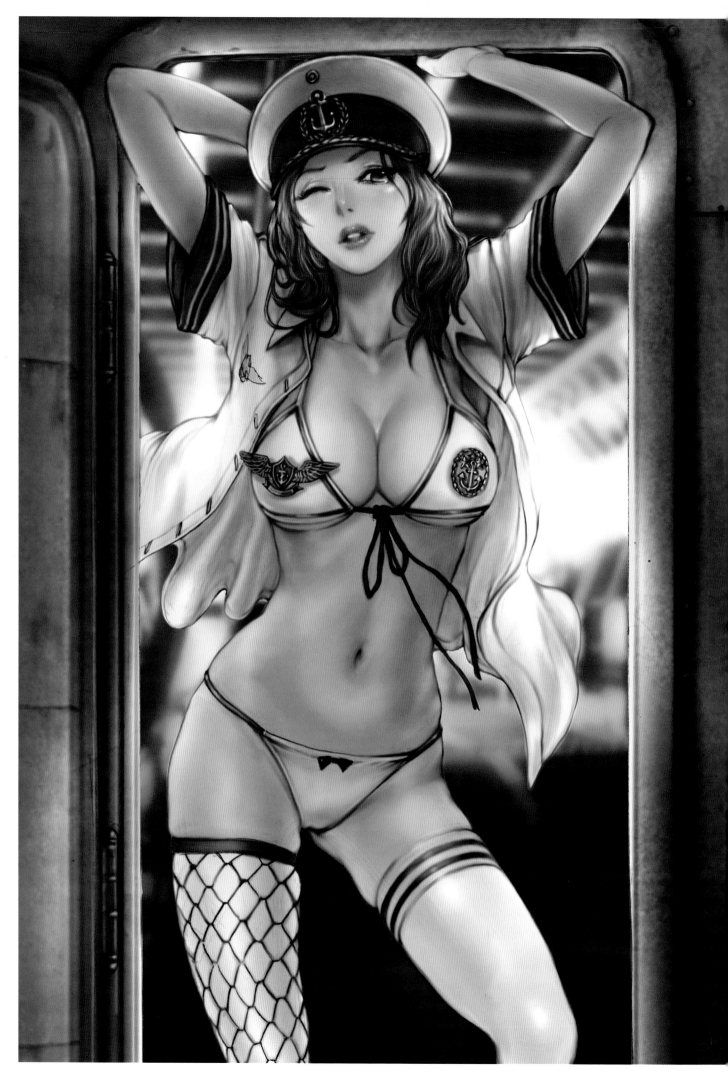

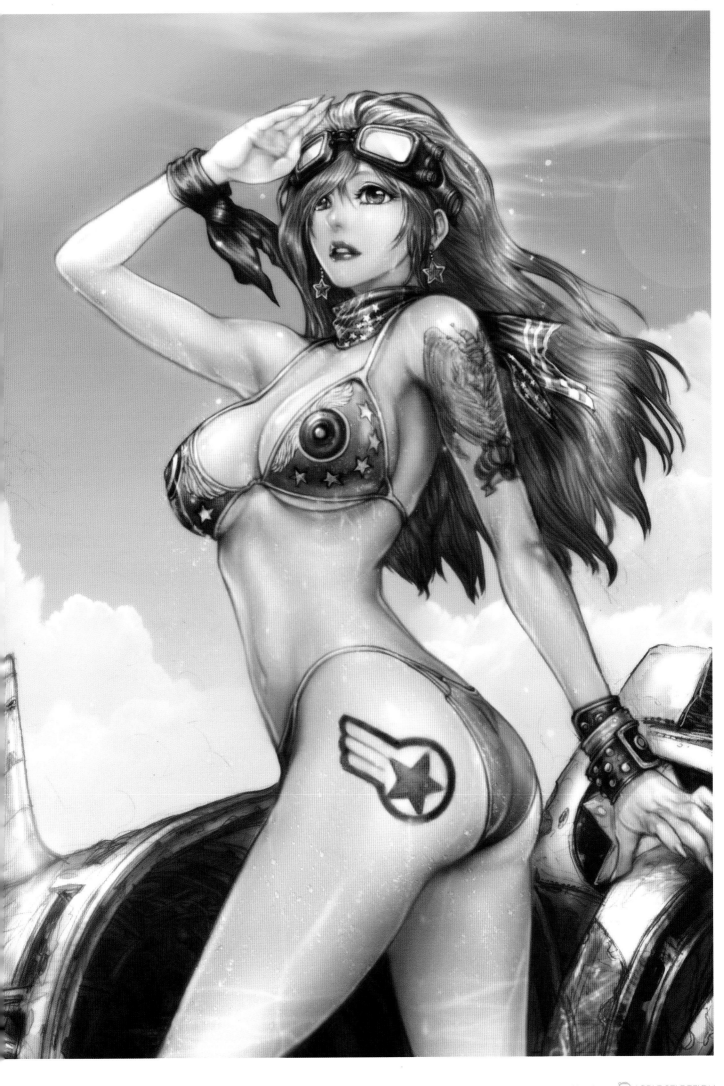

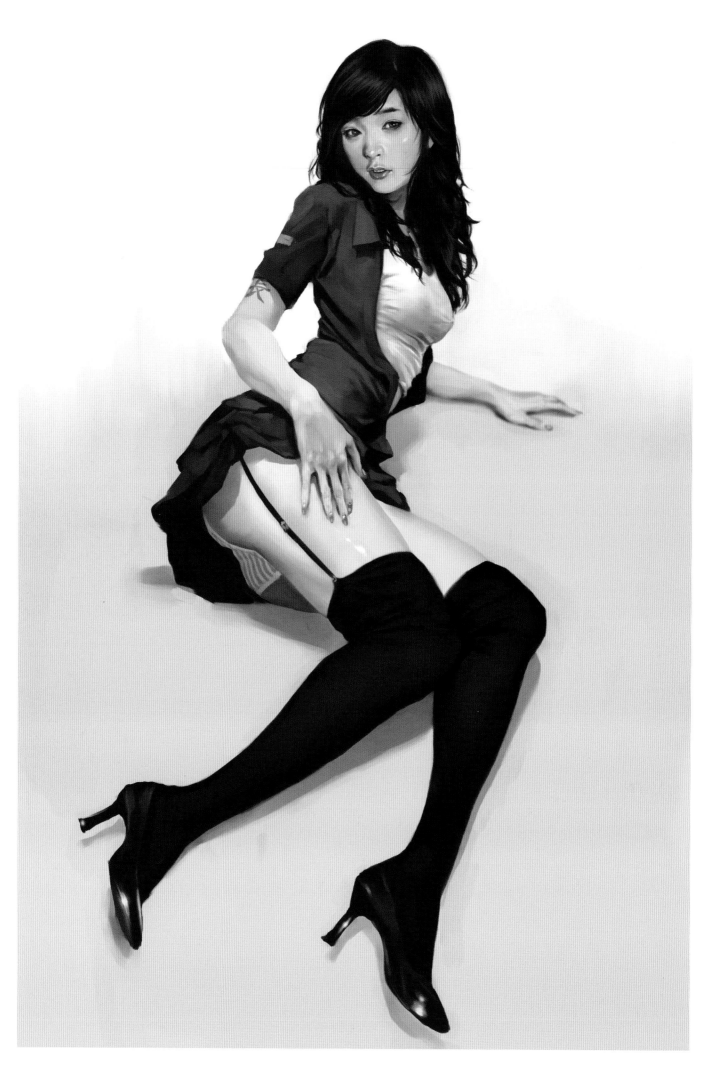

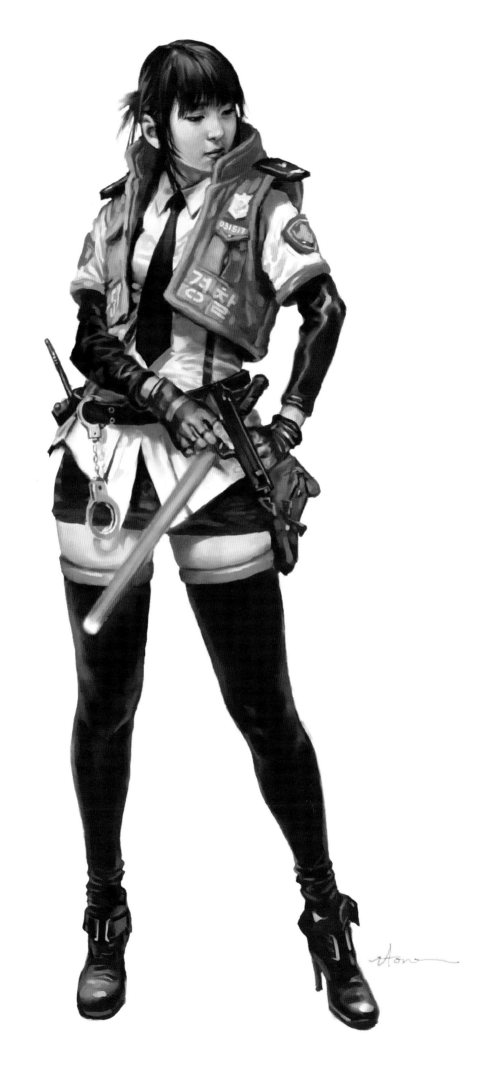

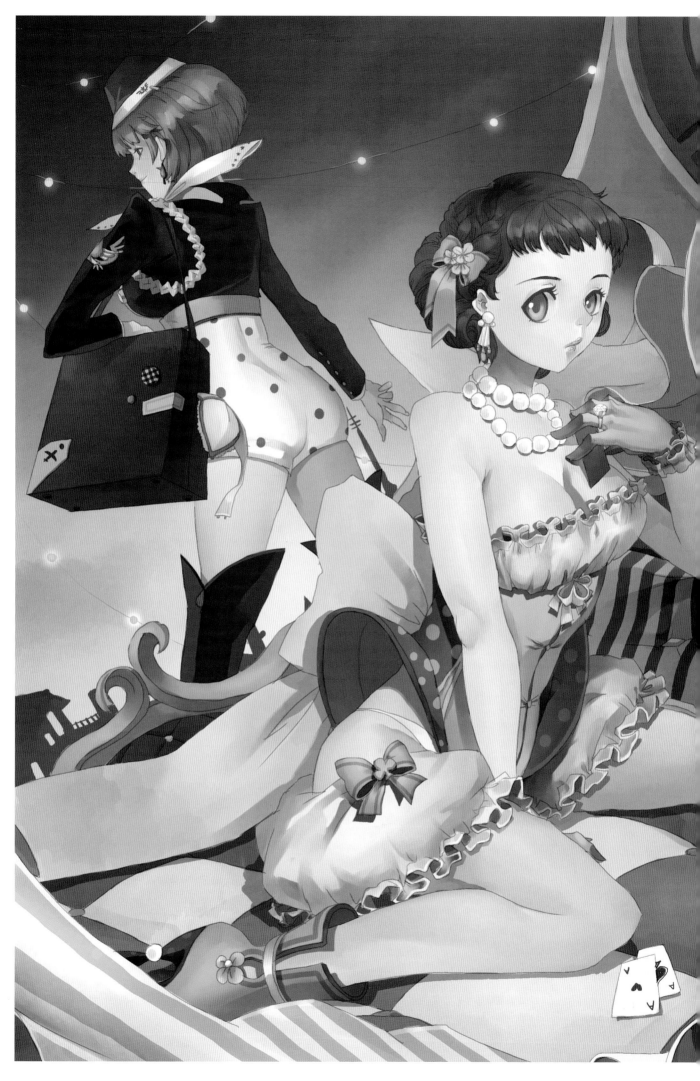

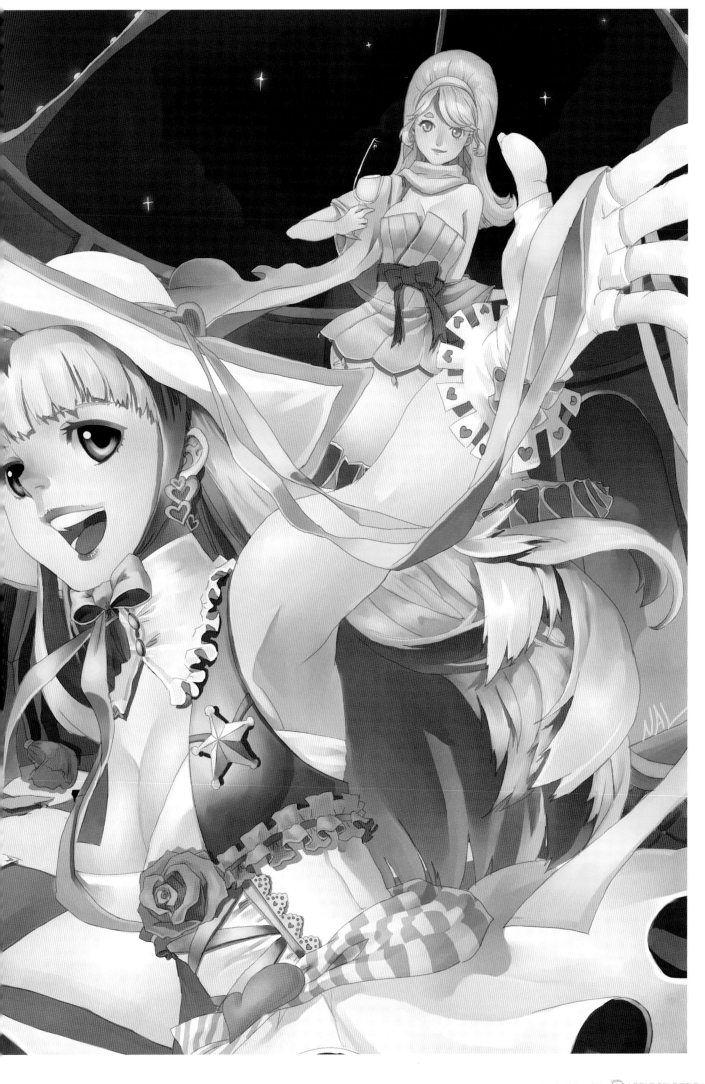

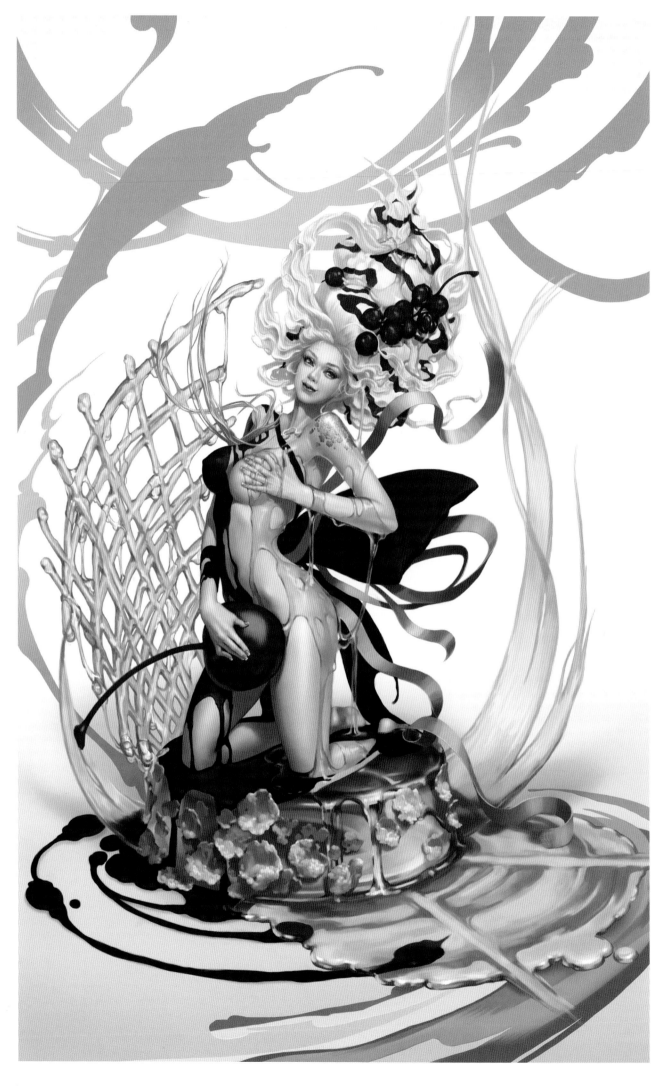

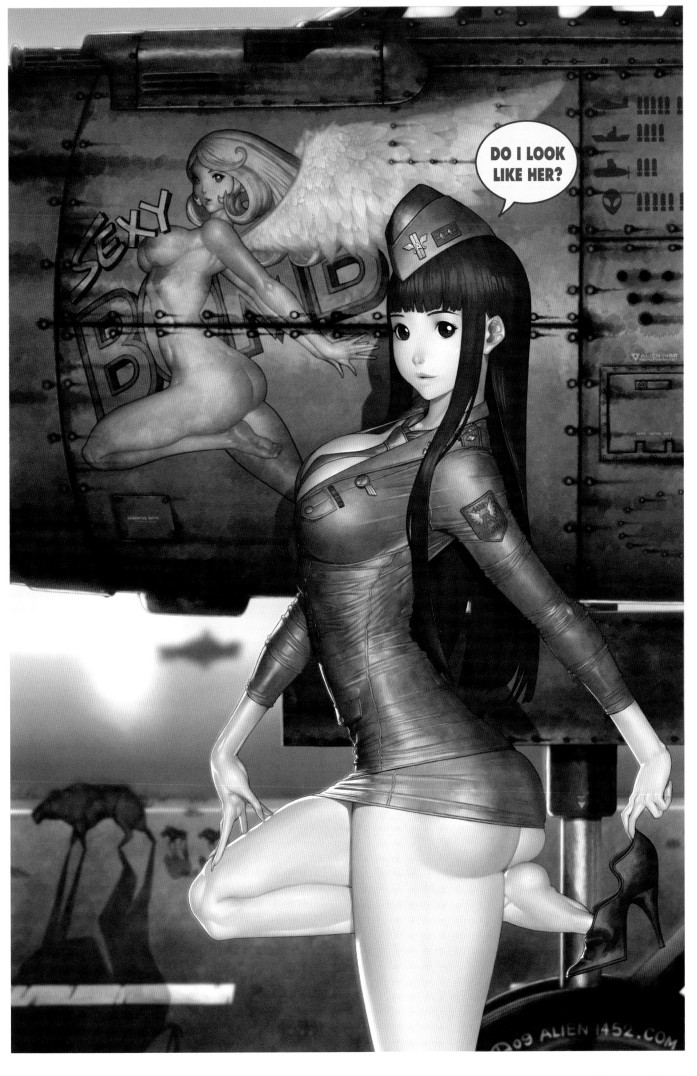

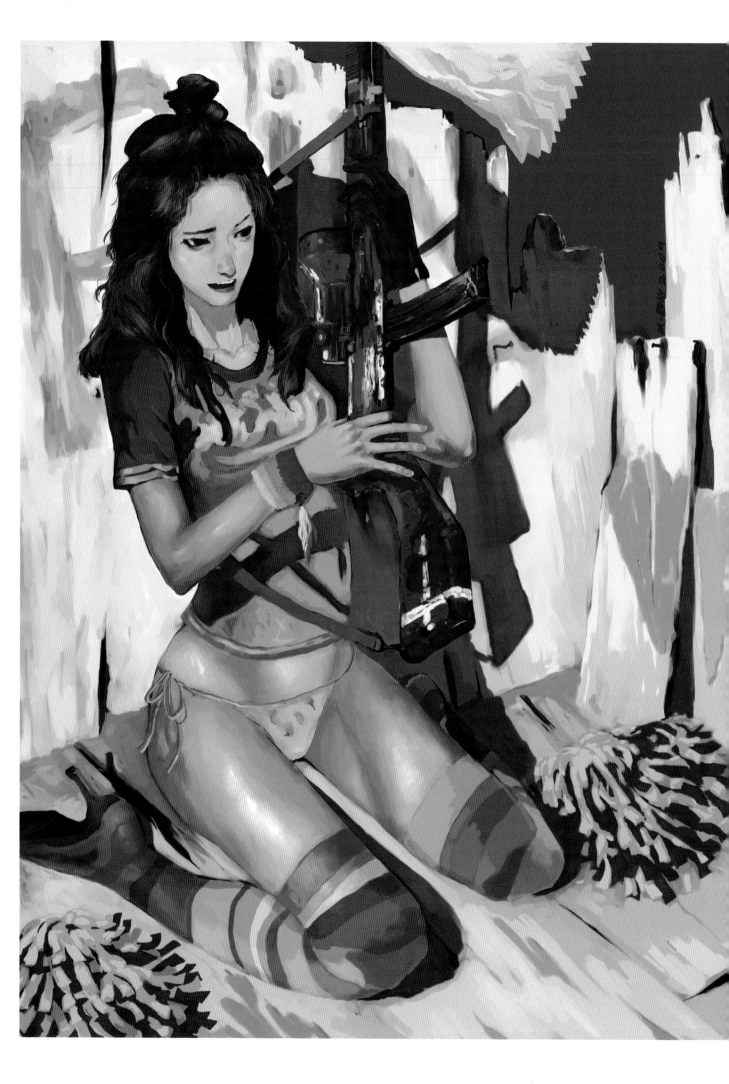

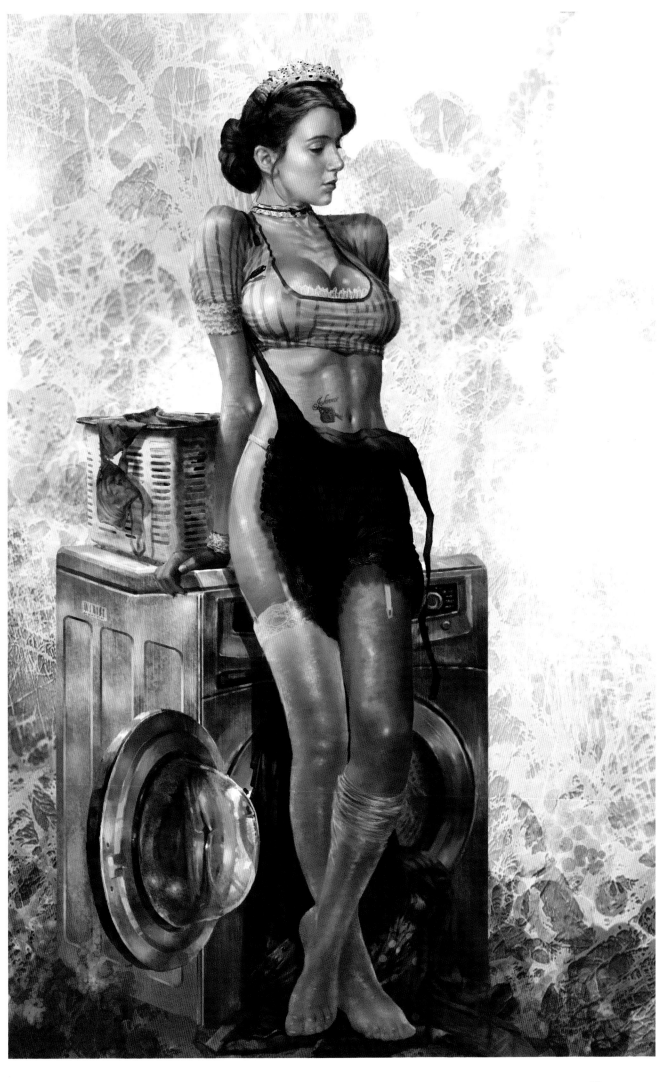

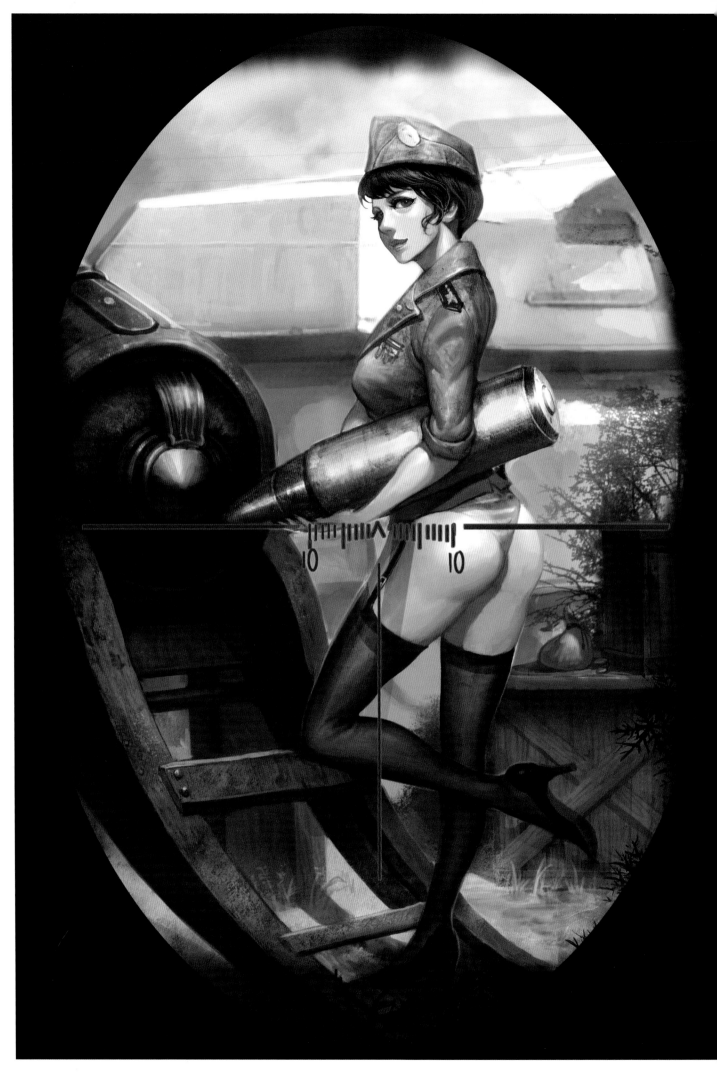

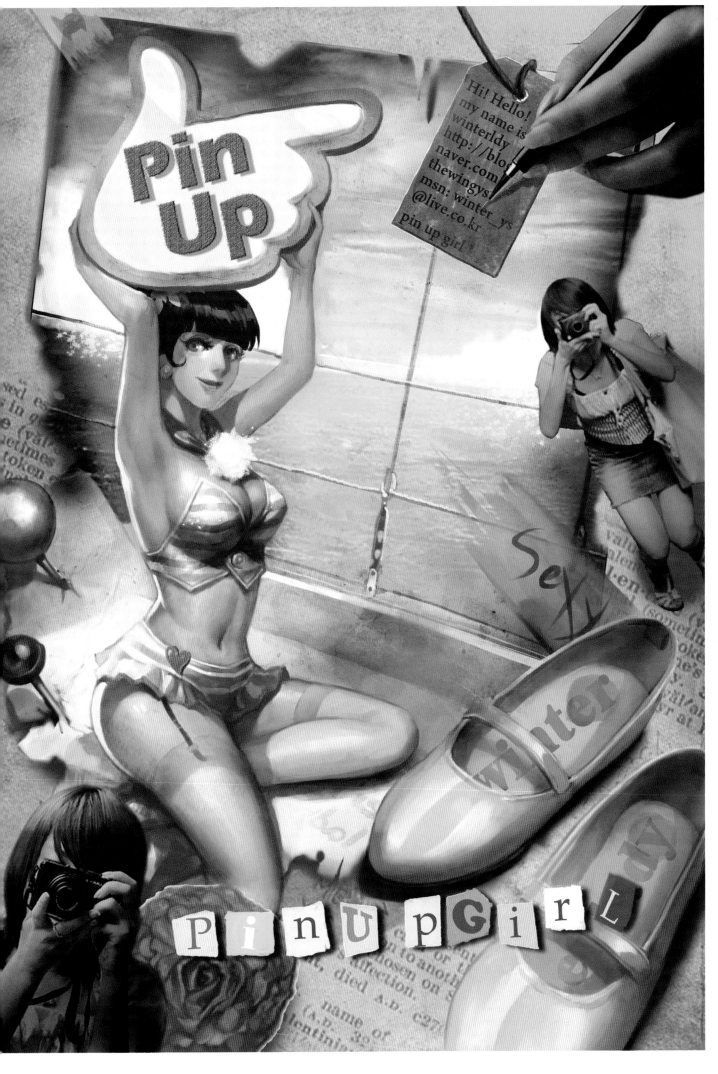

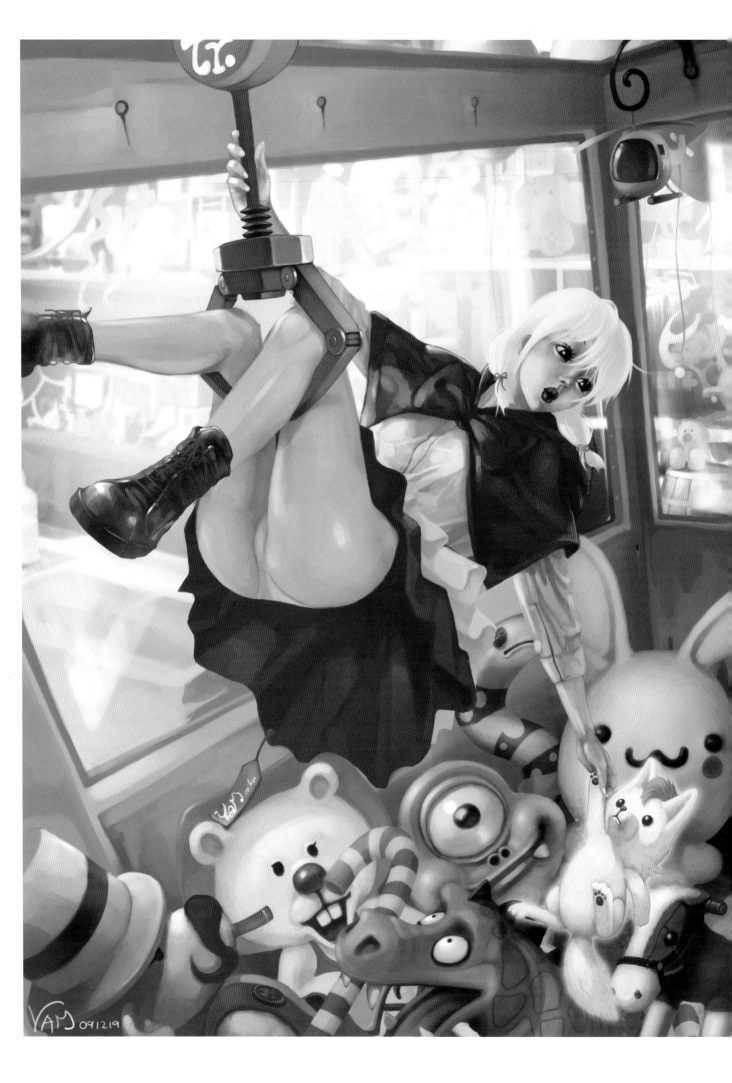

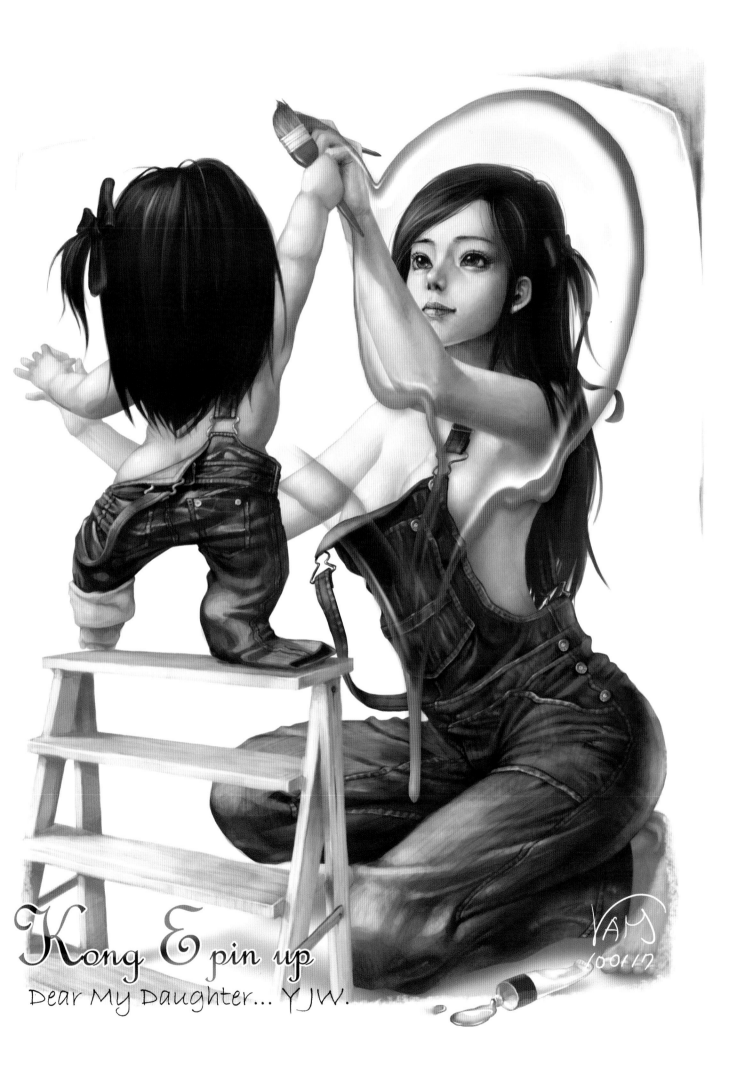

Kong E pin up

Dear My Daughter... YJW.

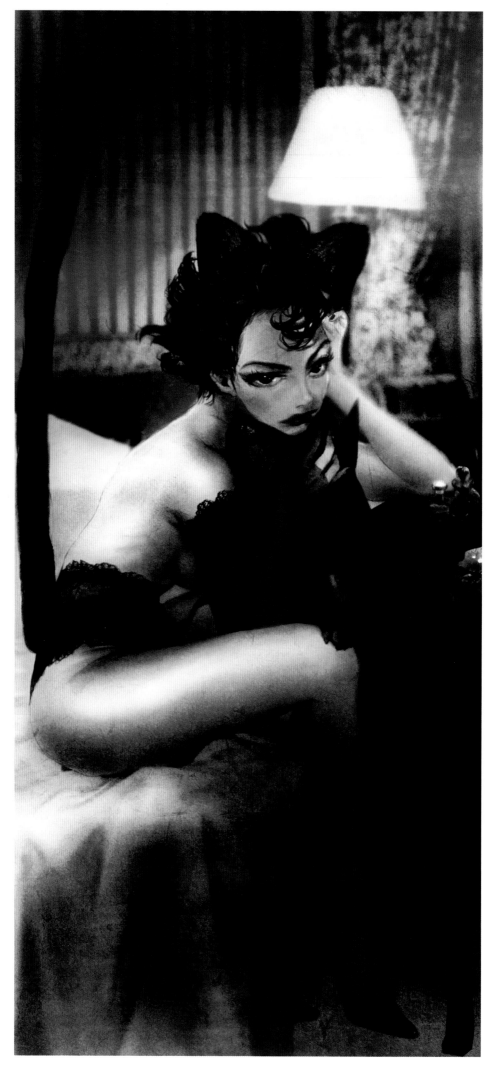

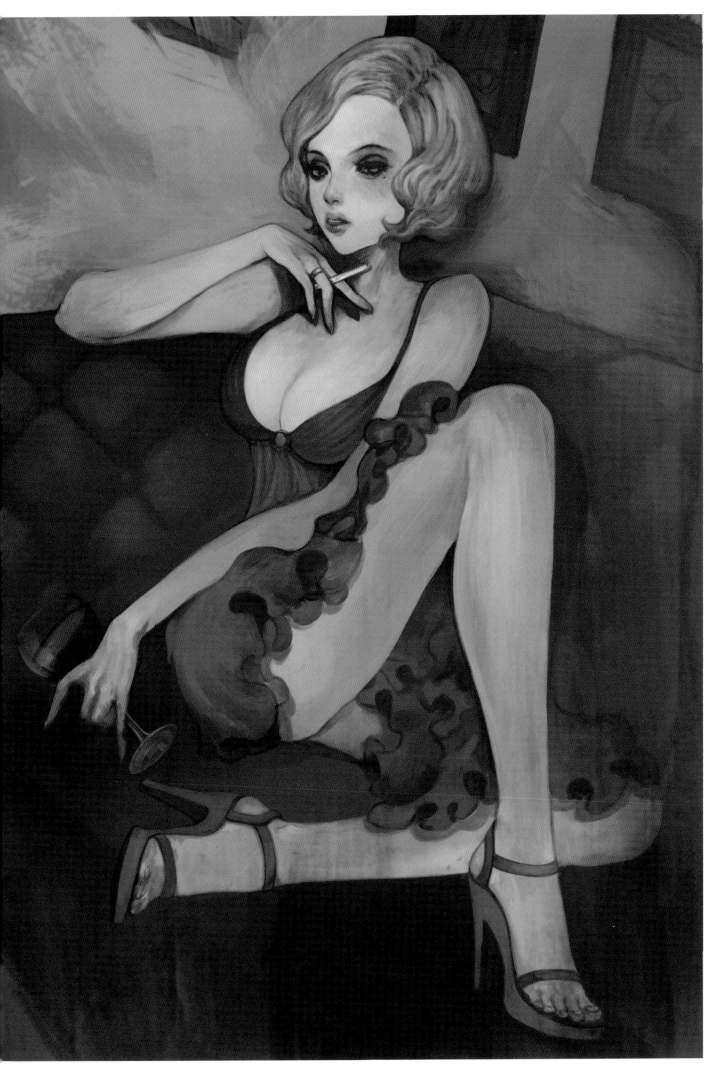

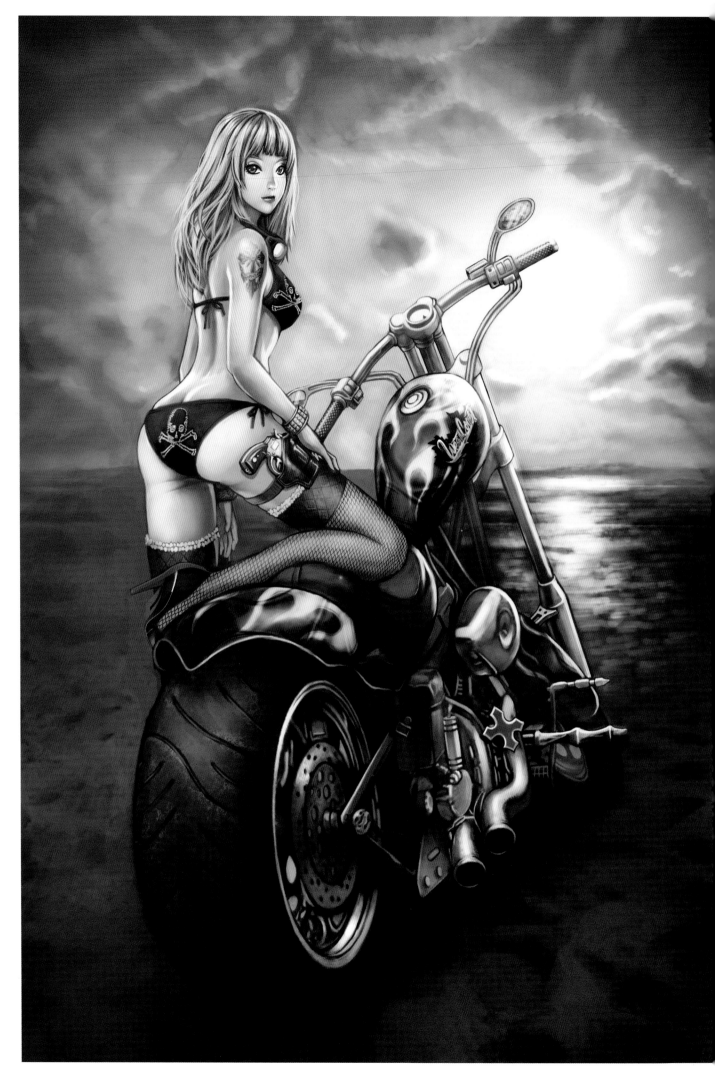

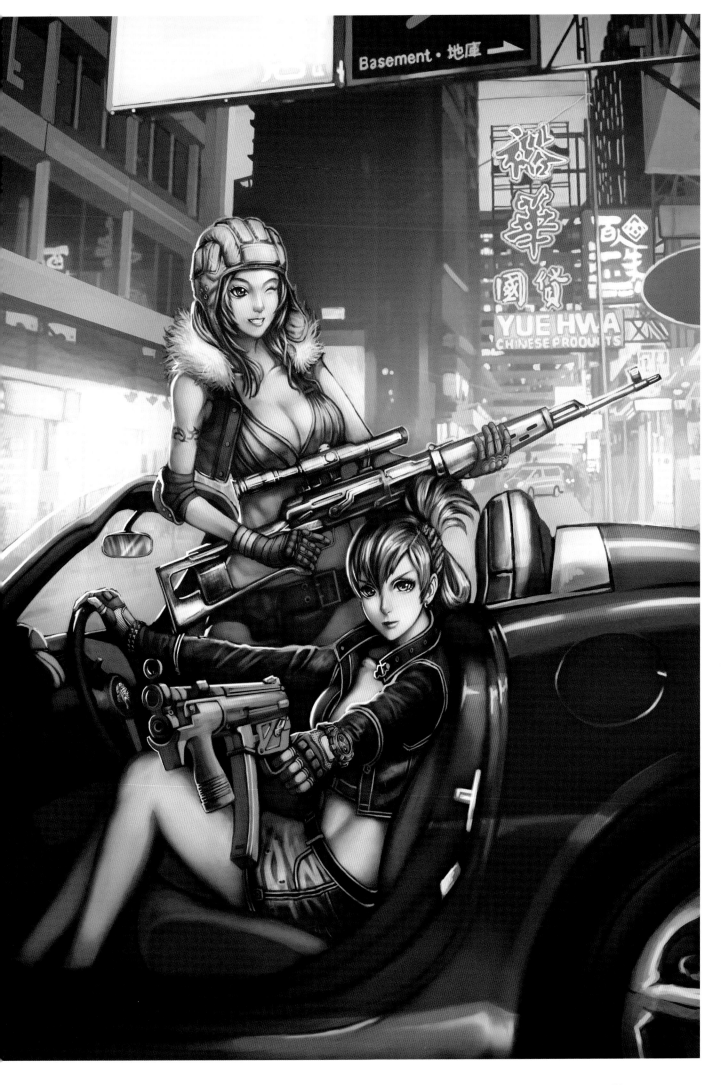

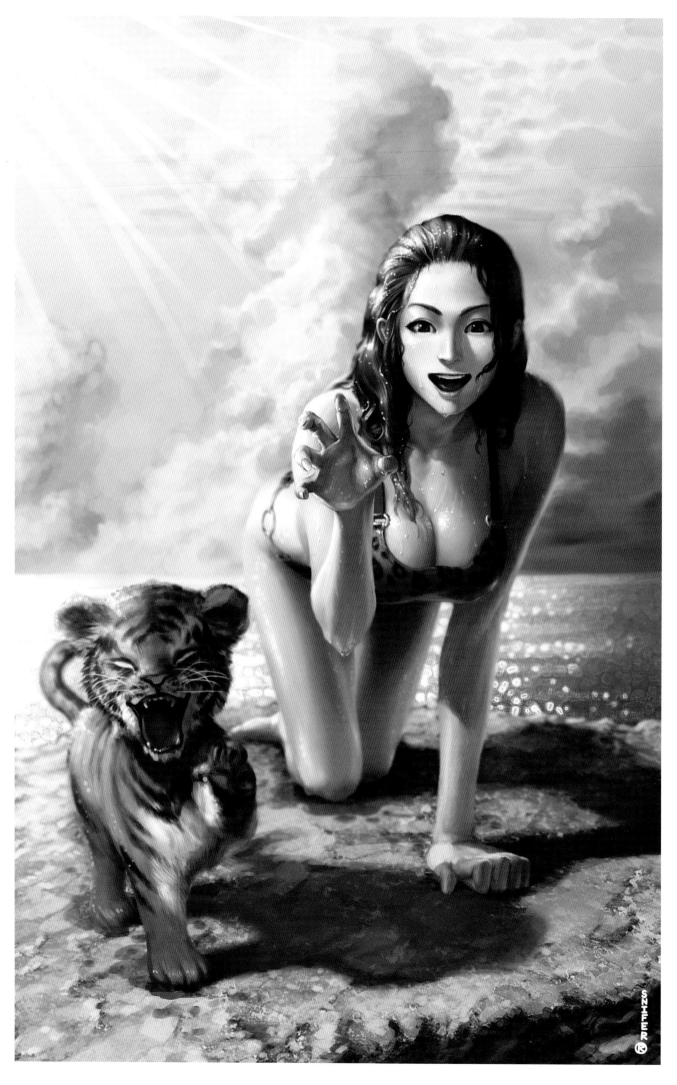

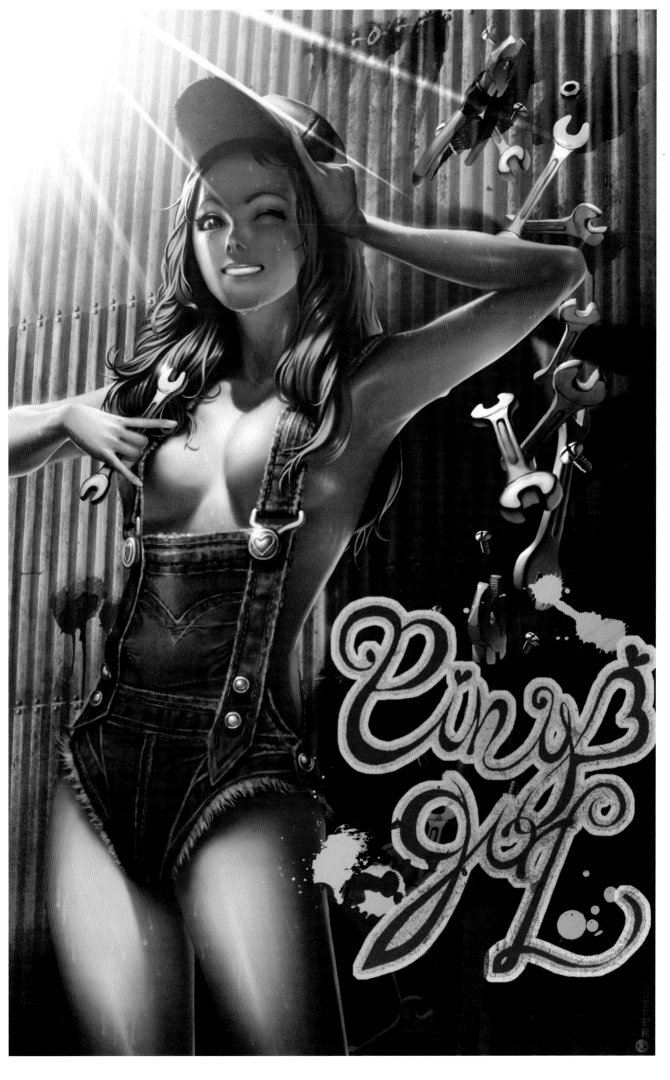

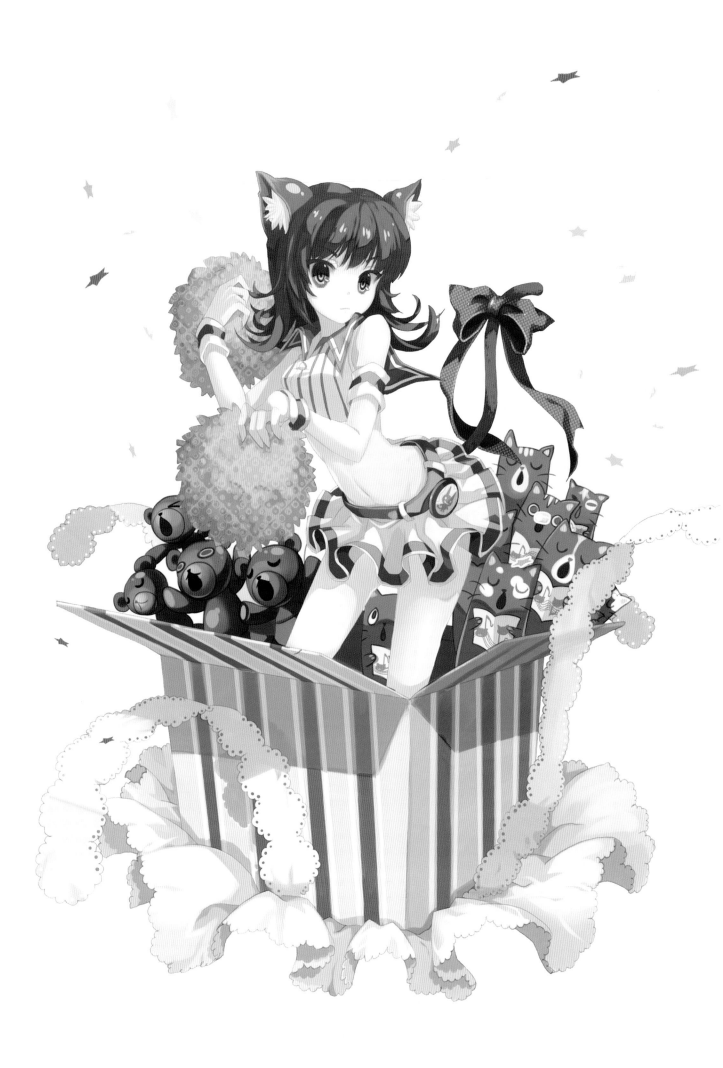

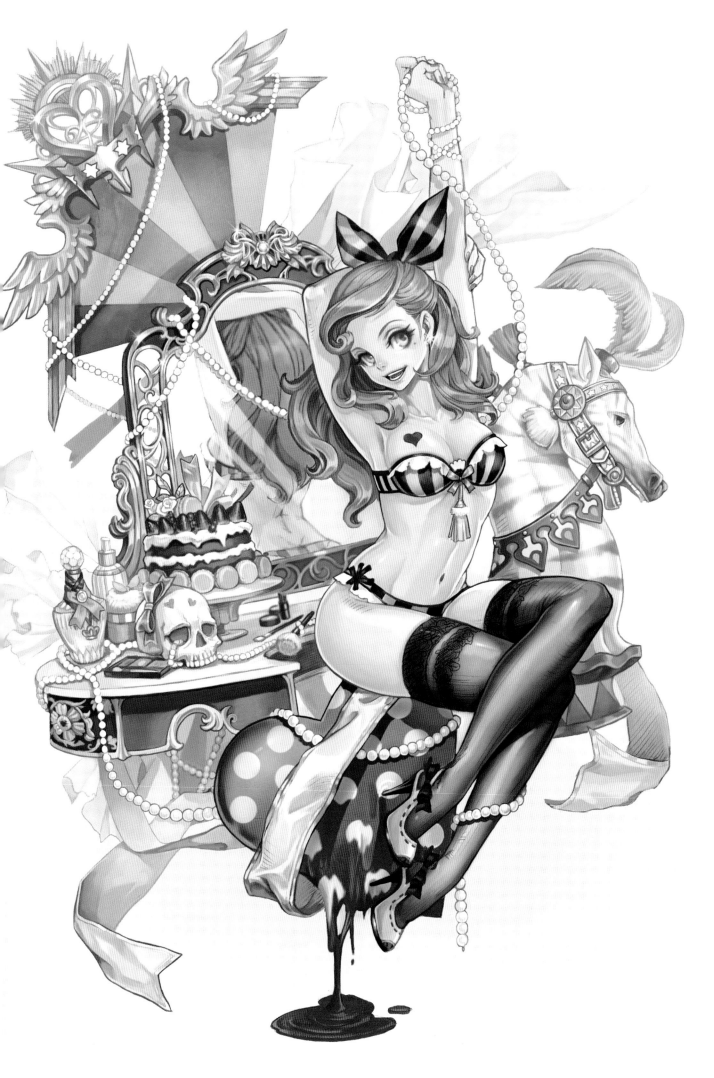

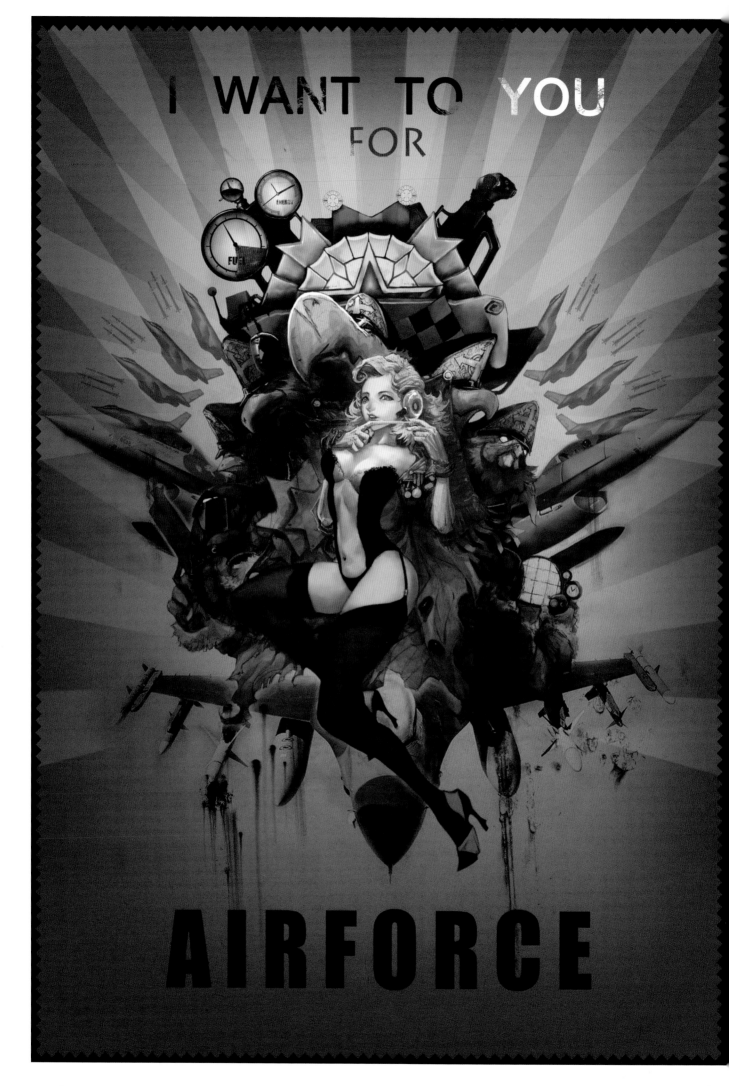

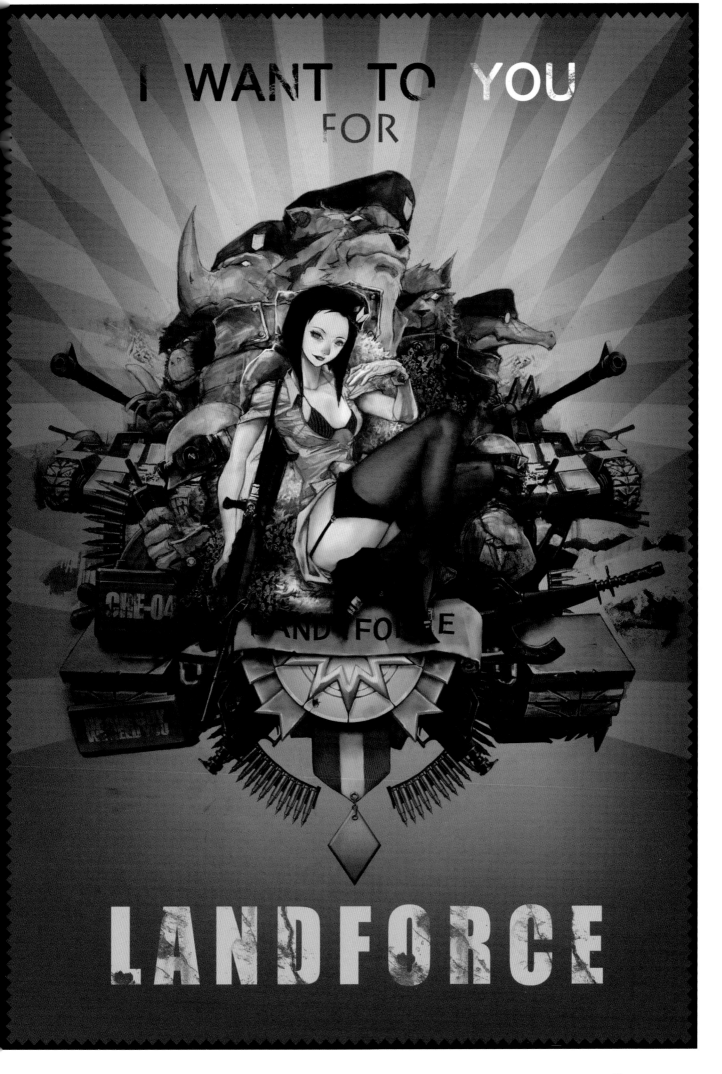

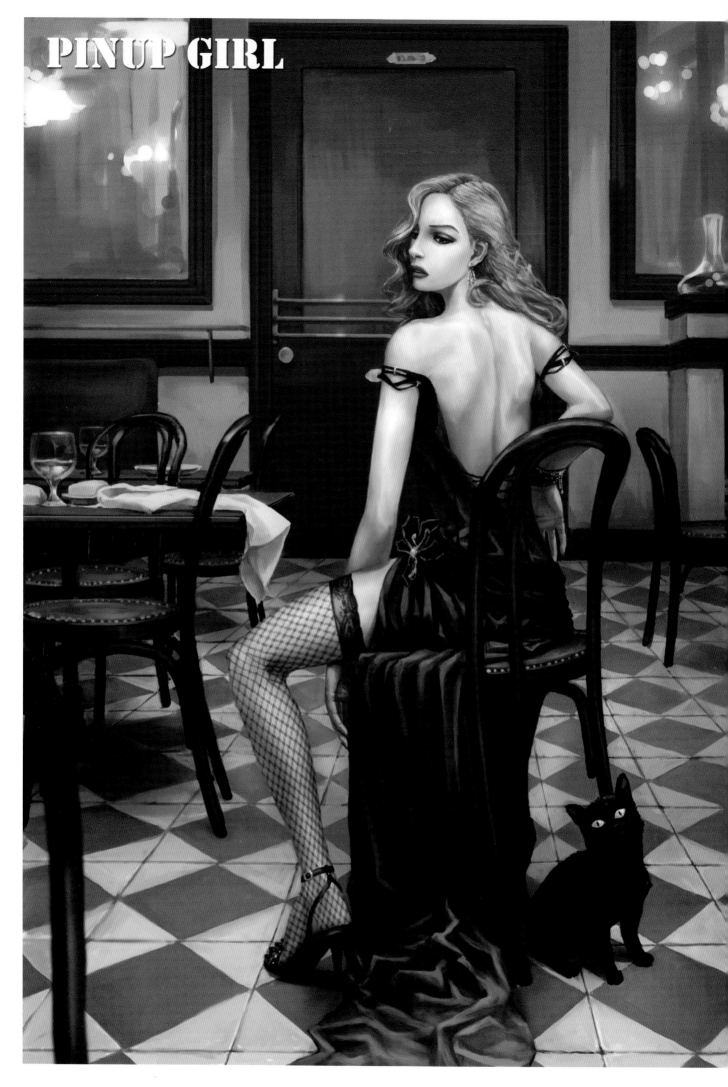

http://PanchokWorkshop.com

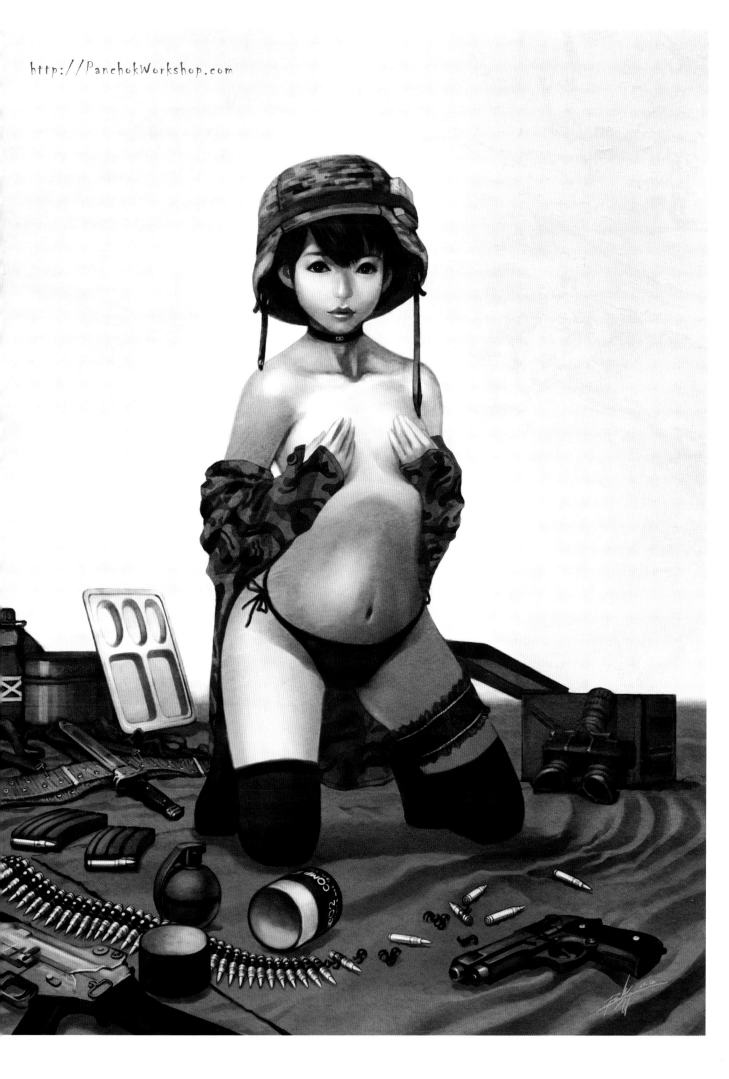

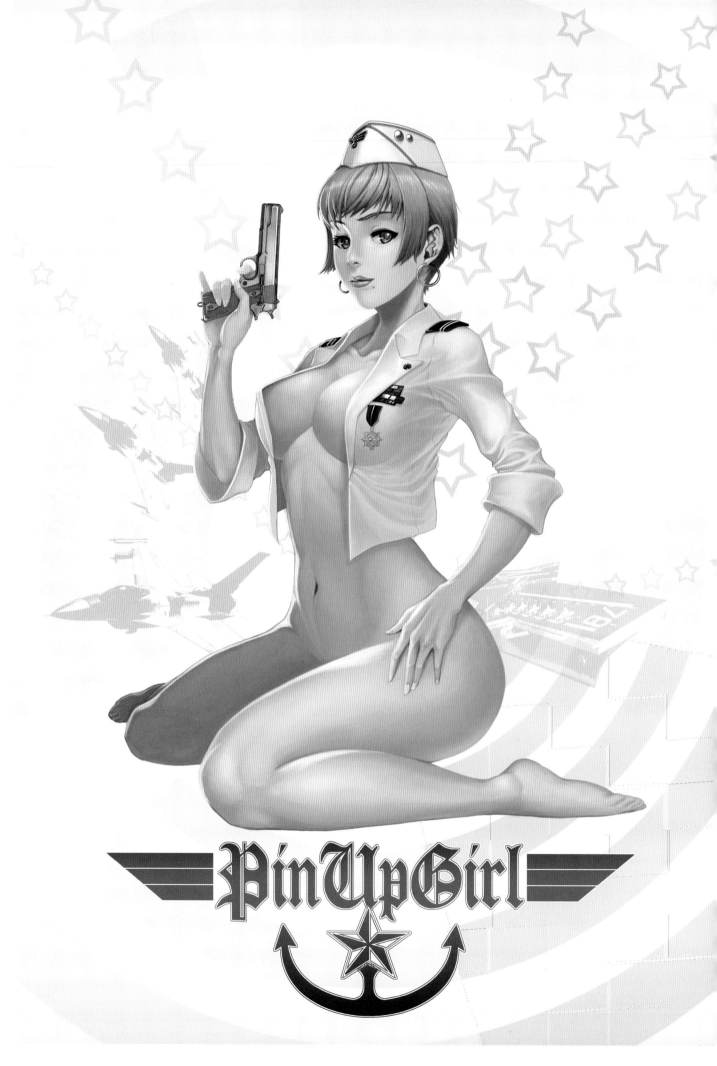

PinUpGirl

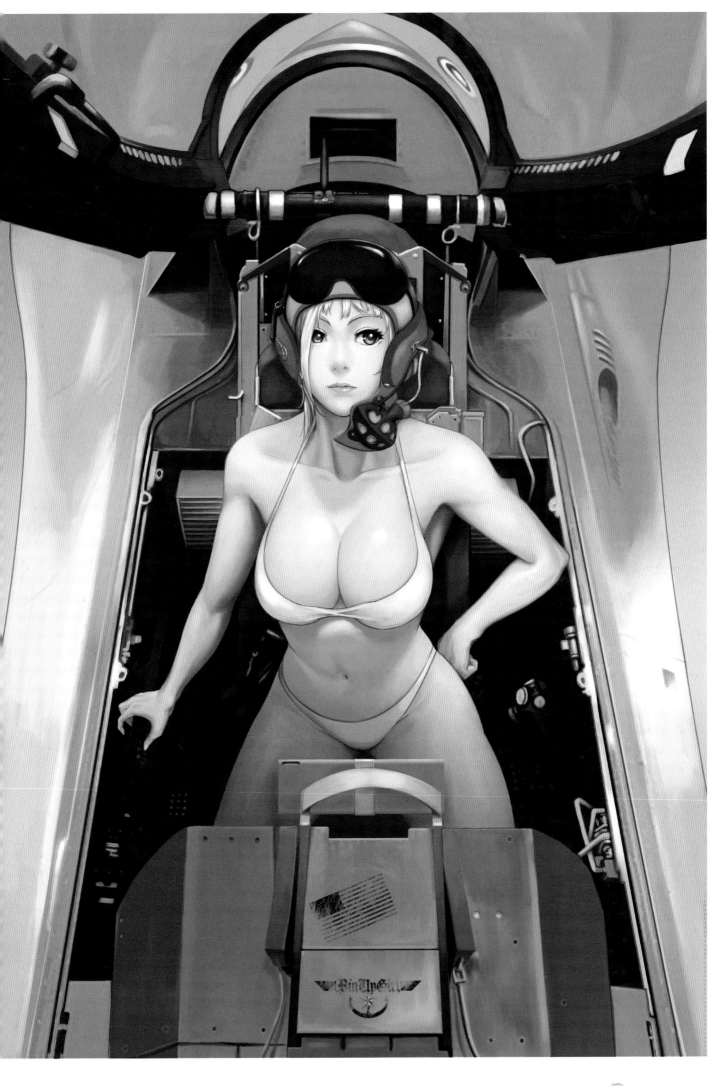

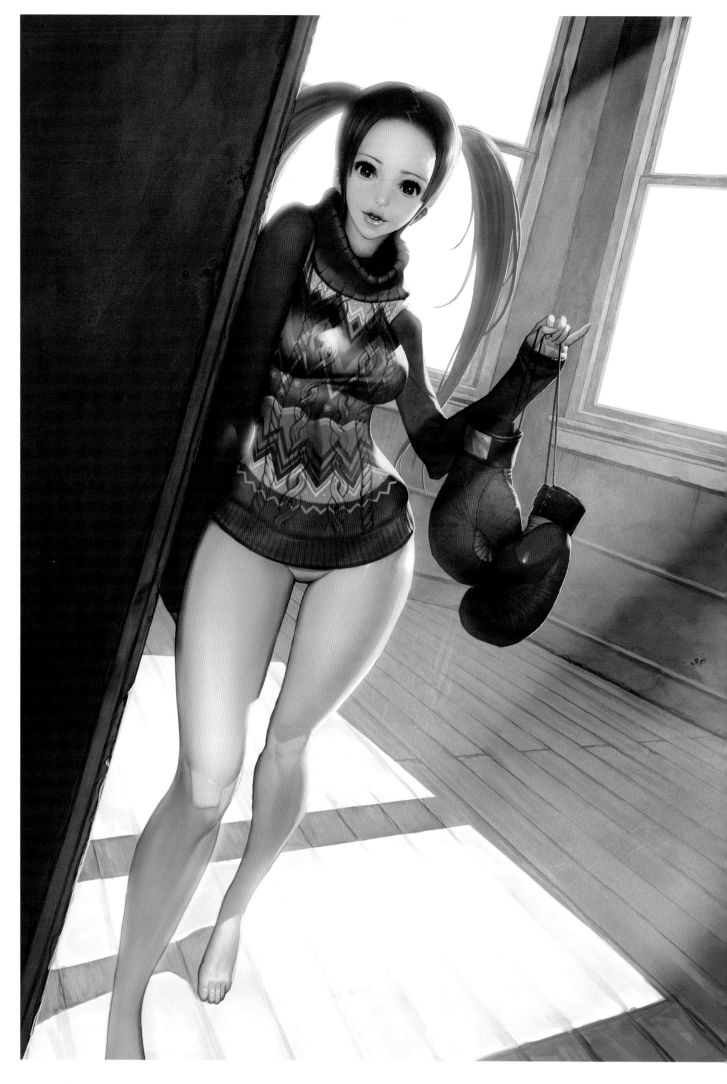

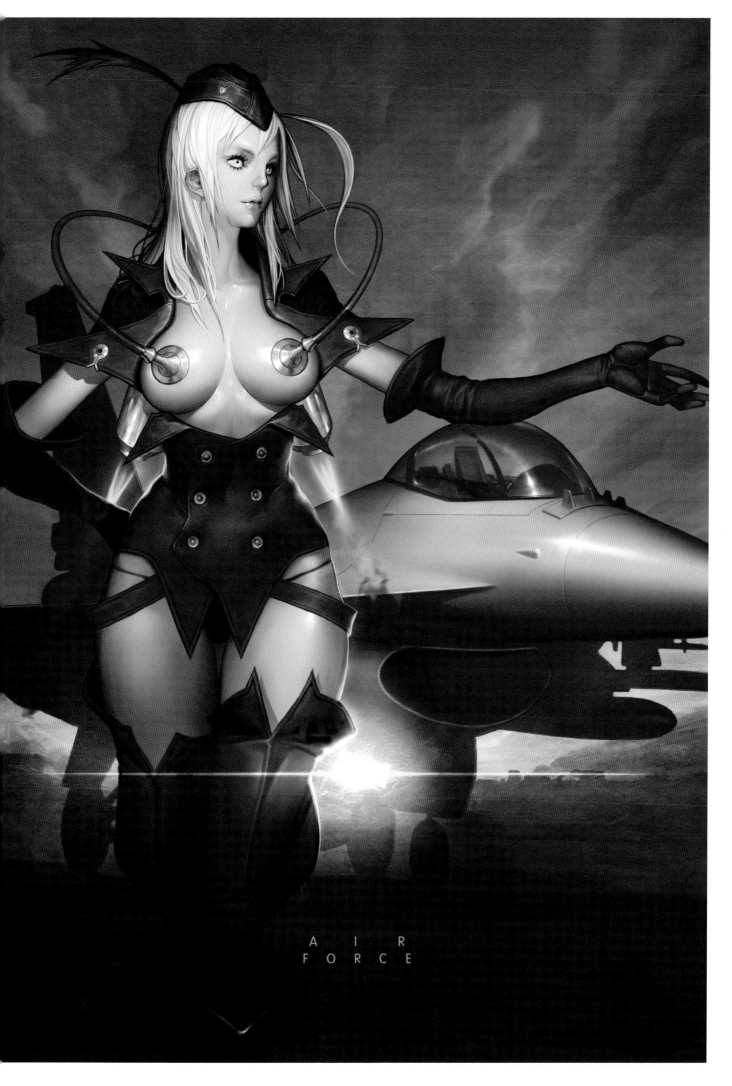

AIR
FORCE

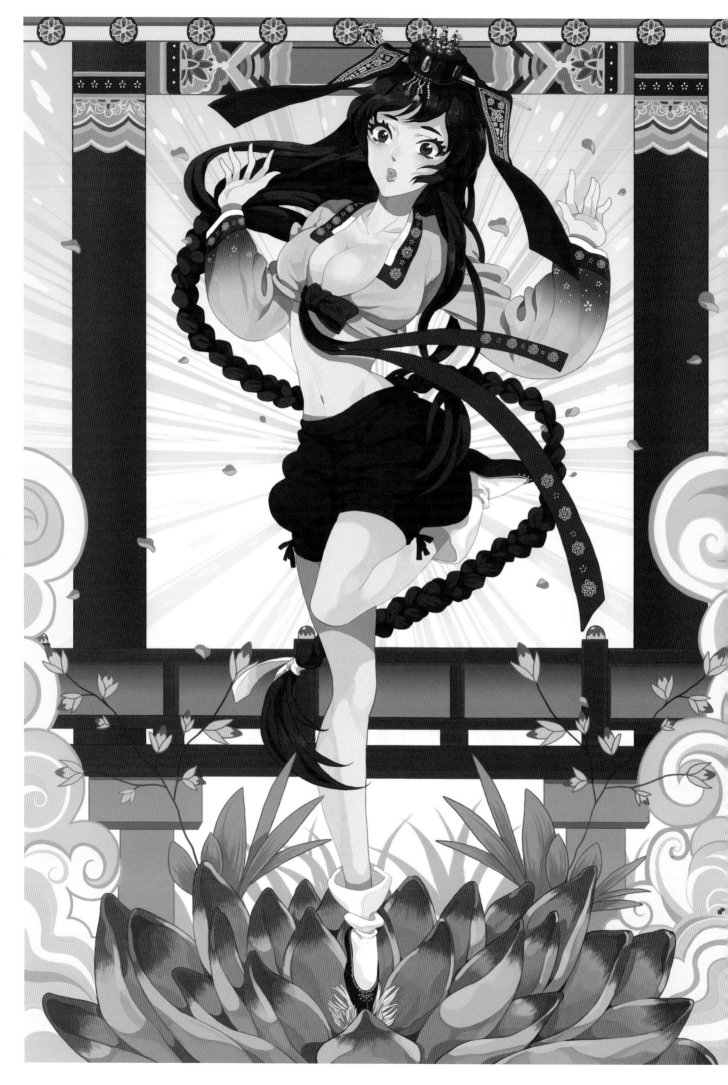

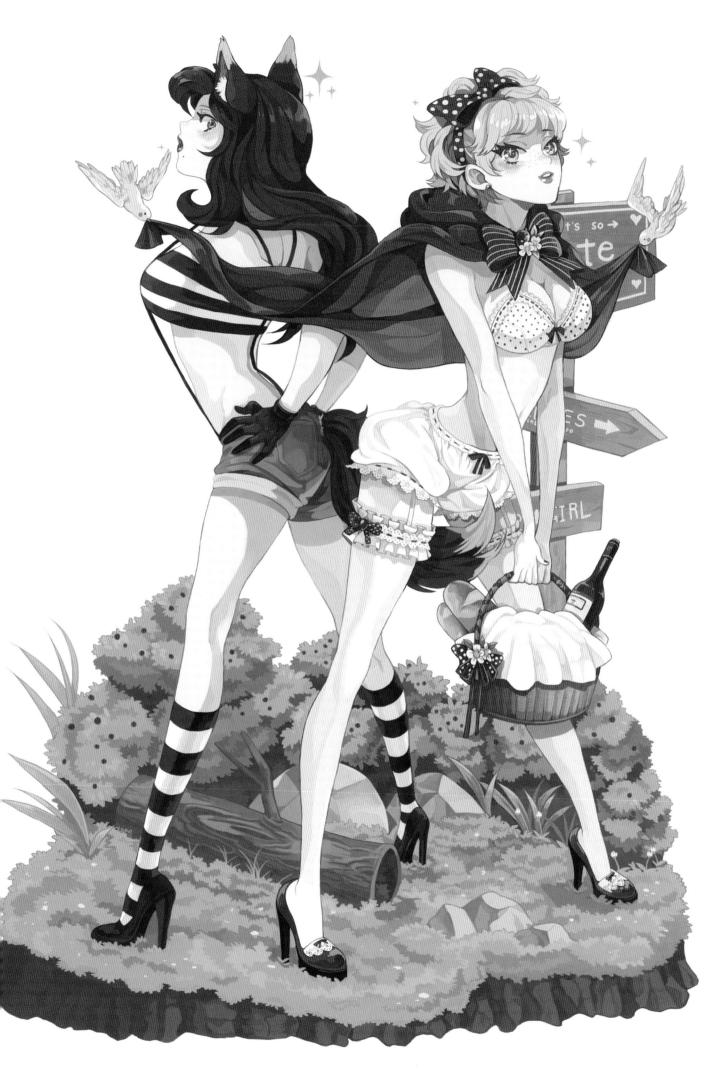

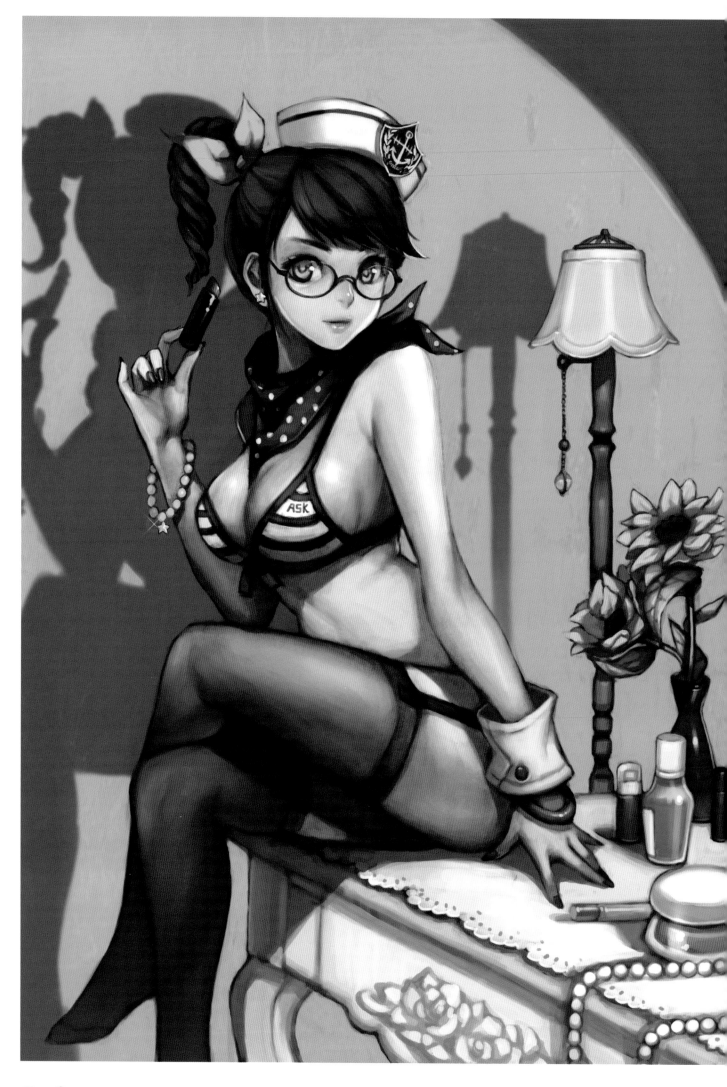

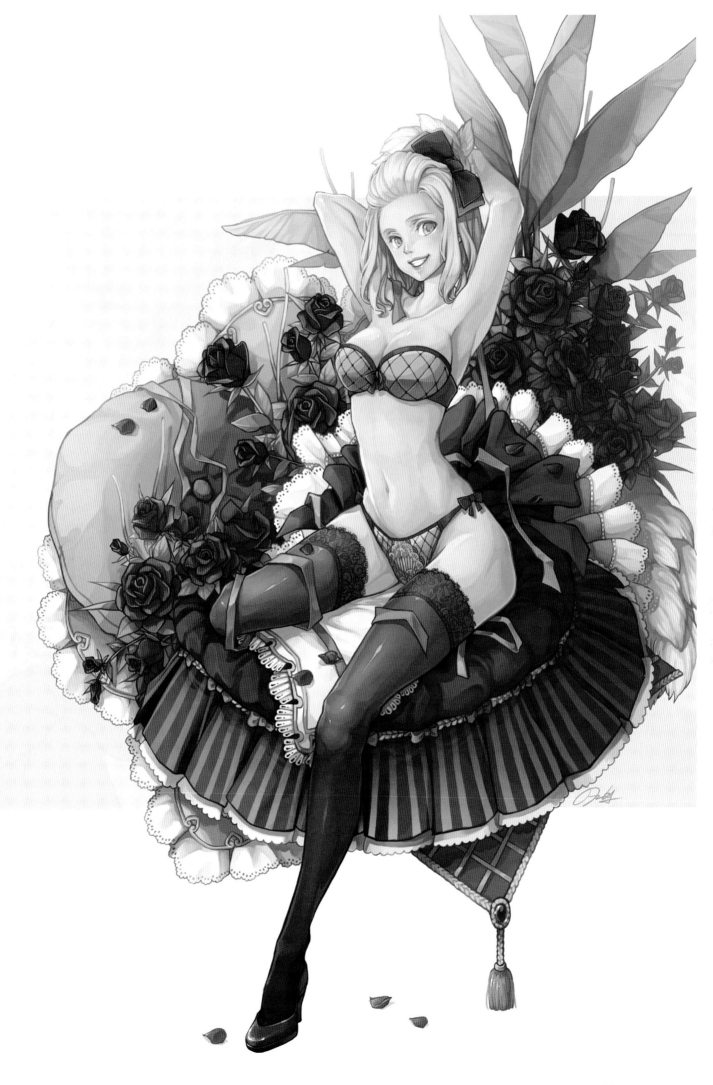

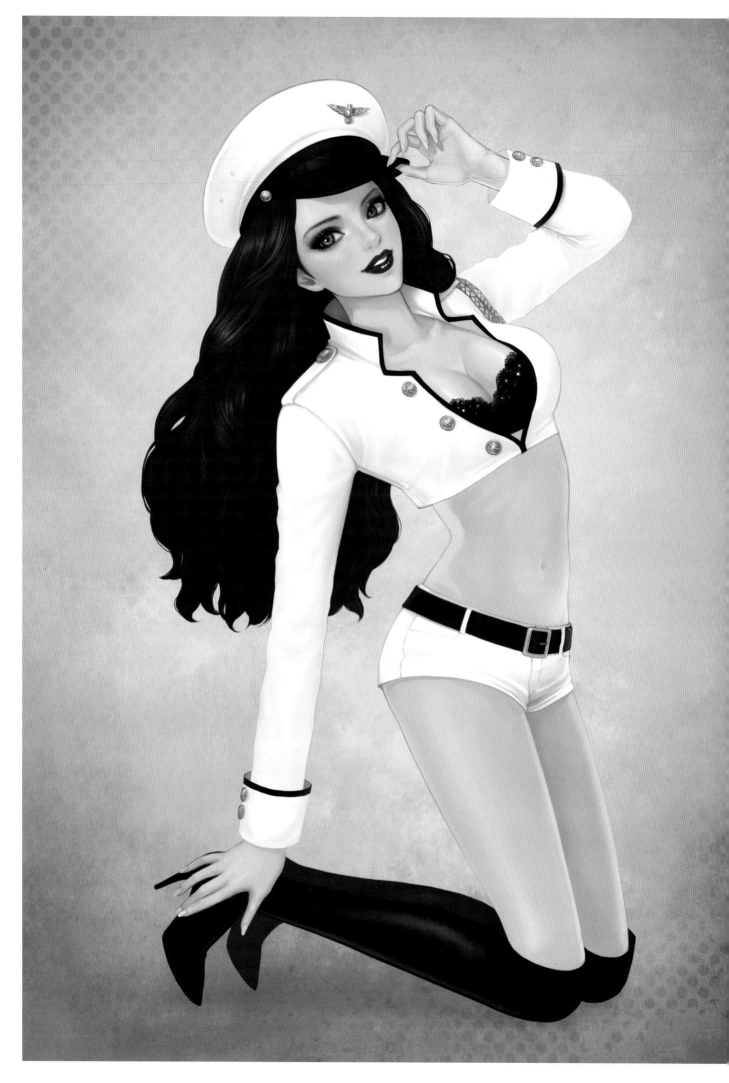

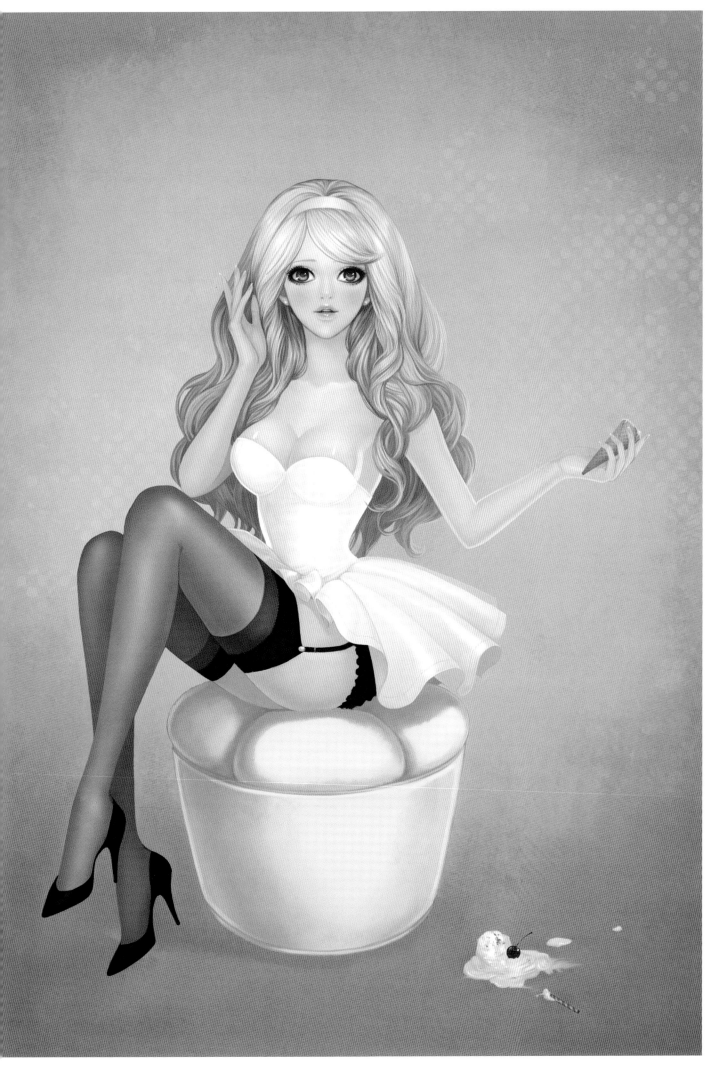

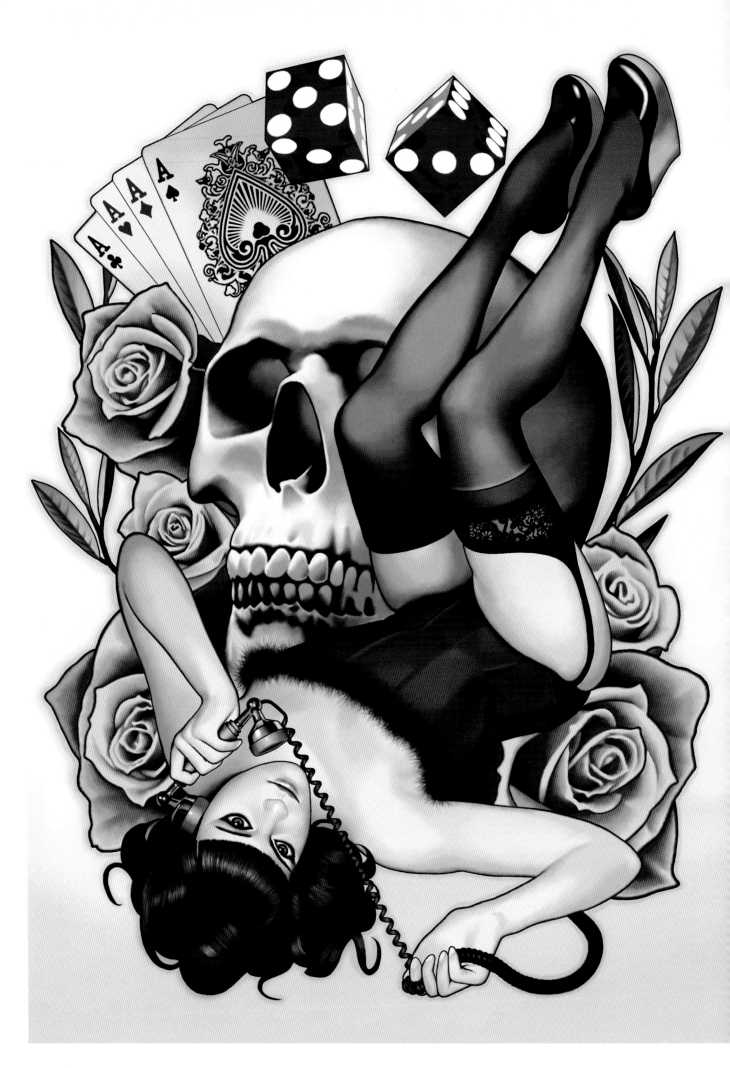

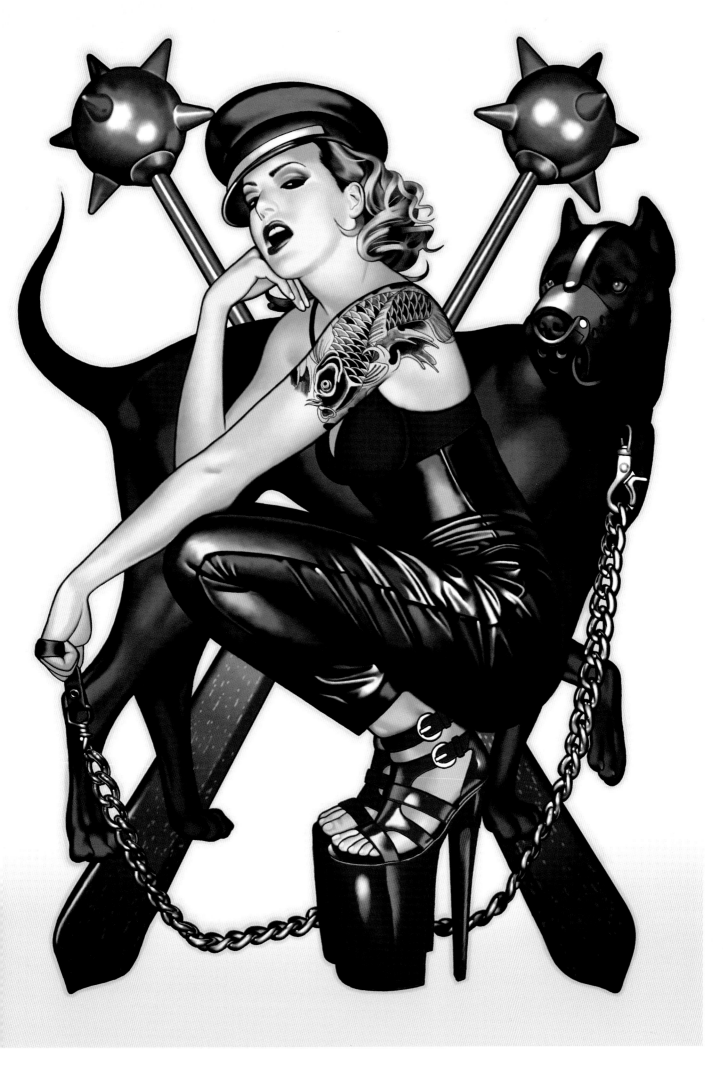

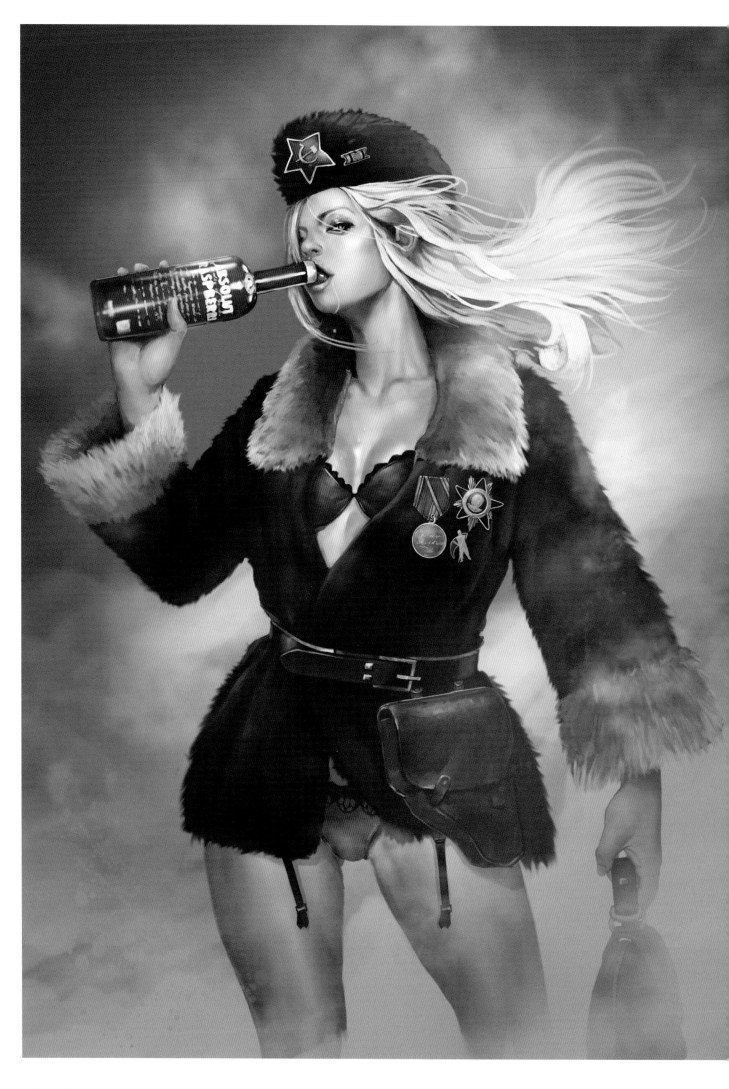

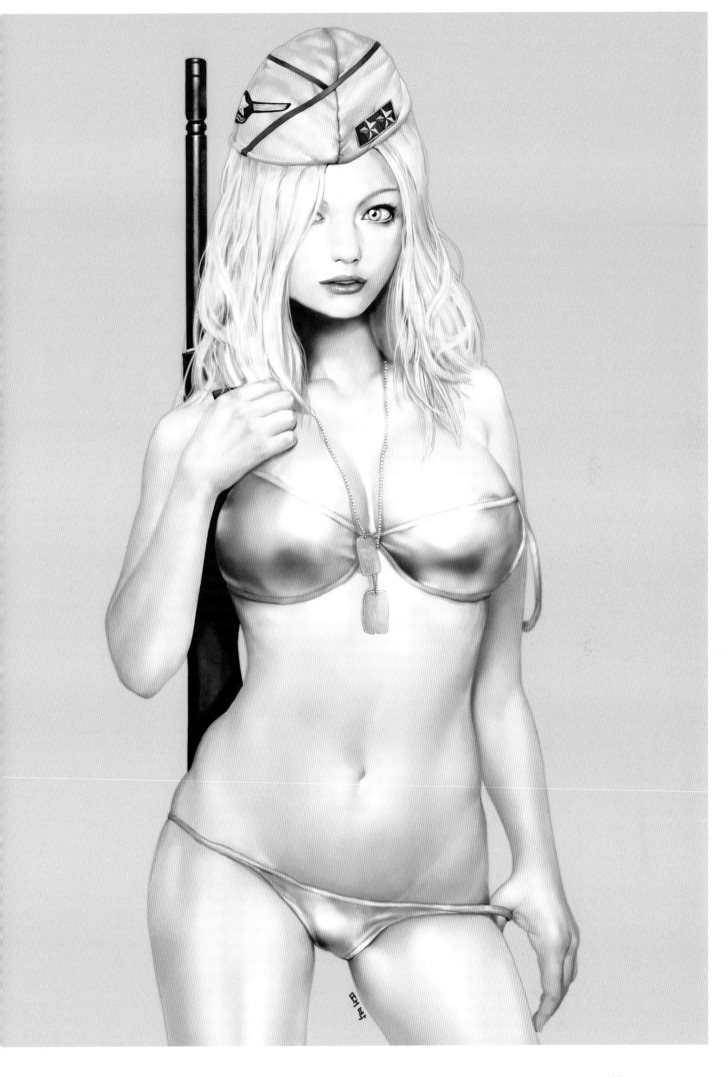

APPLE SELECTION

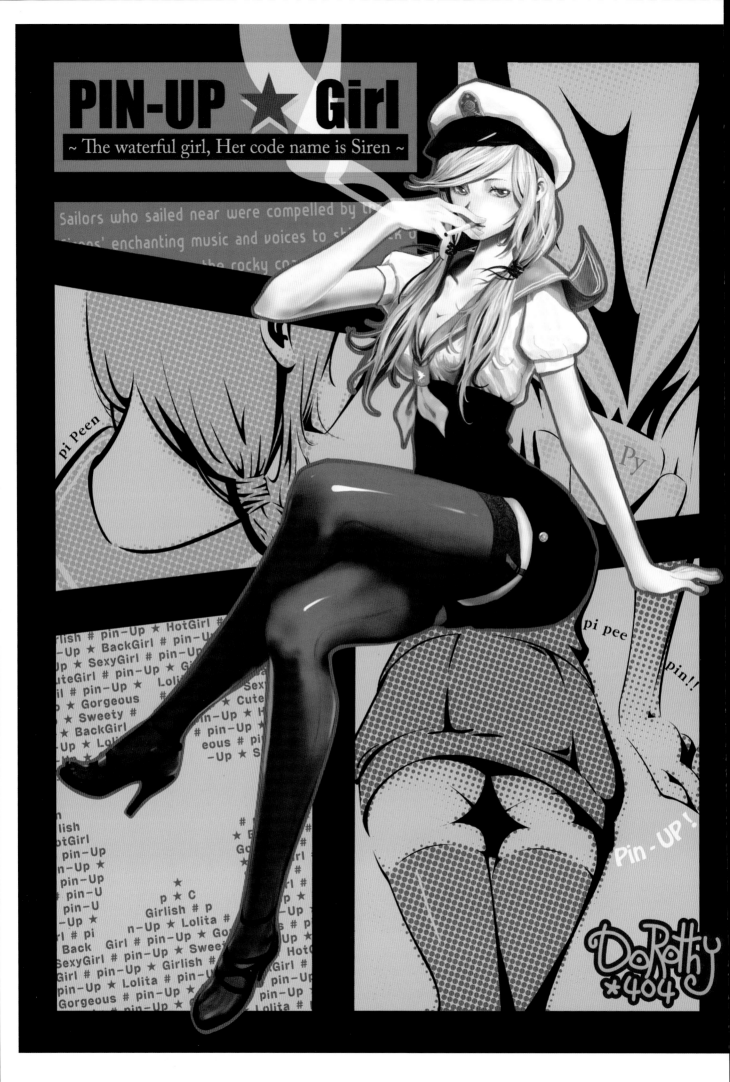

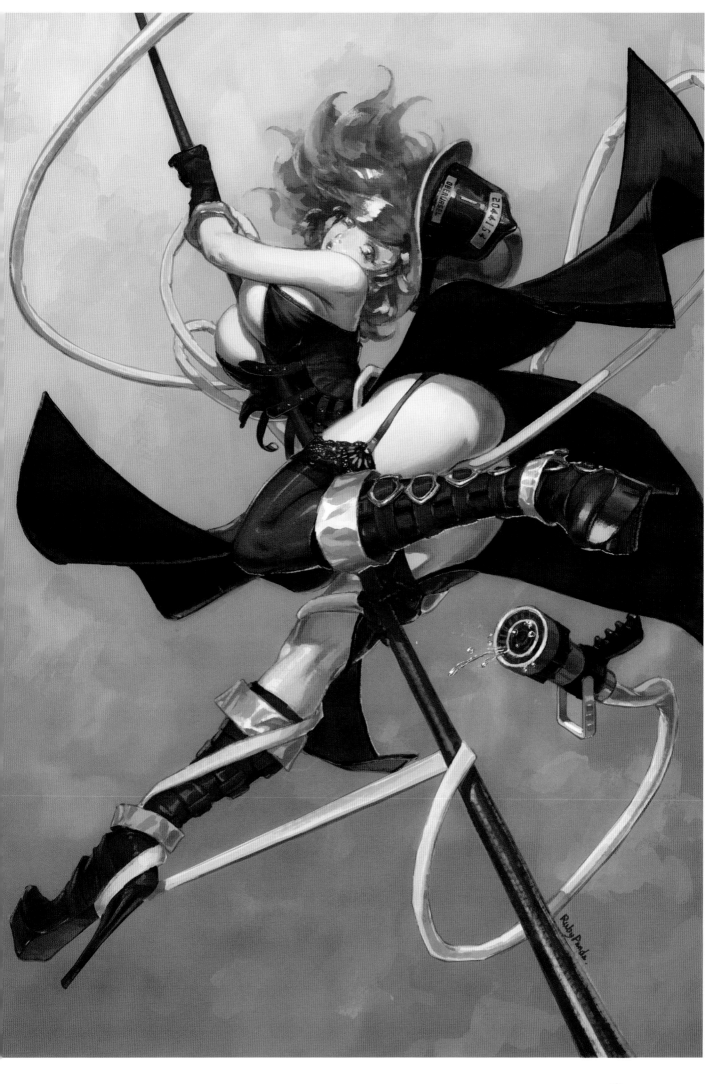

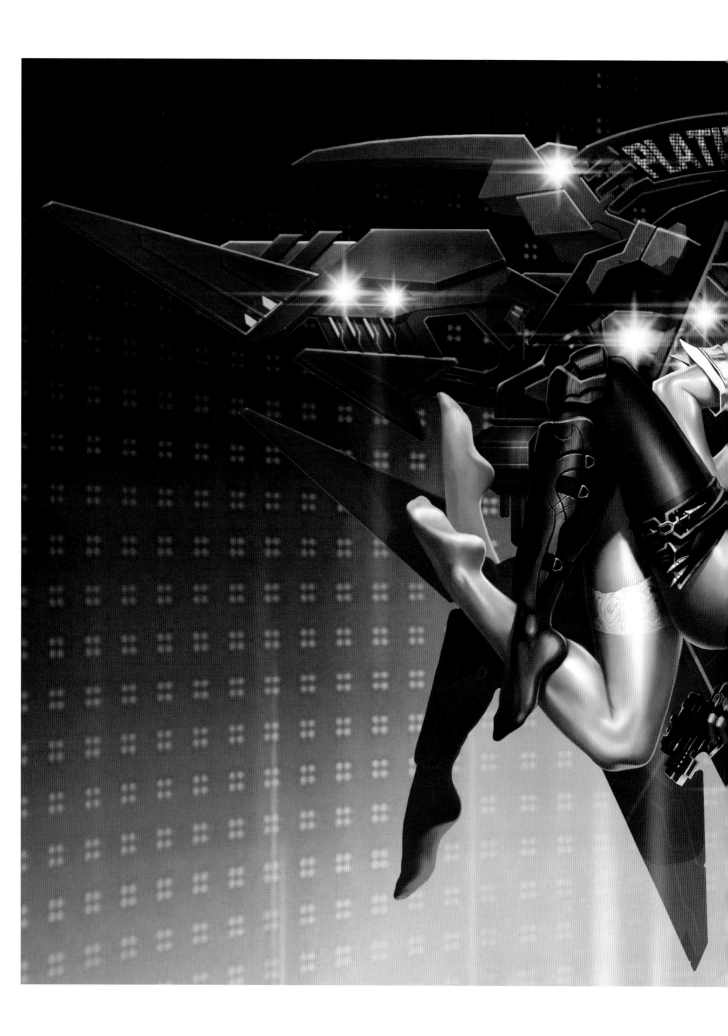

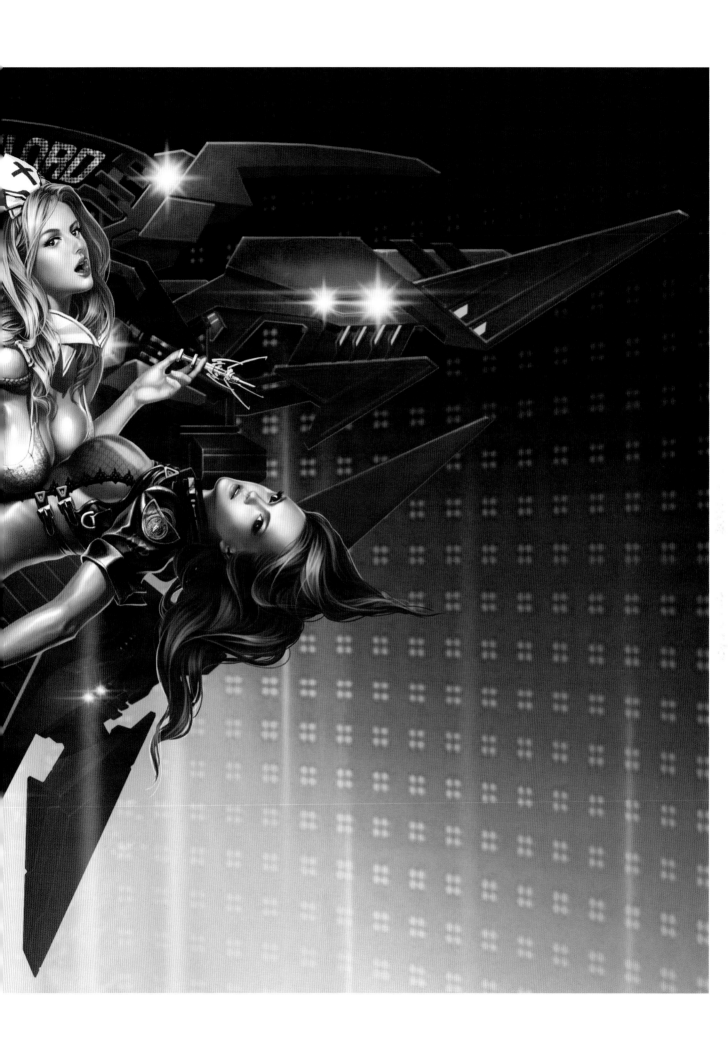

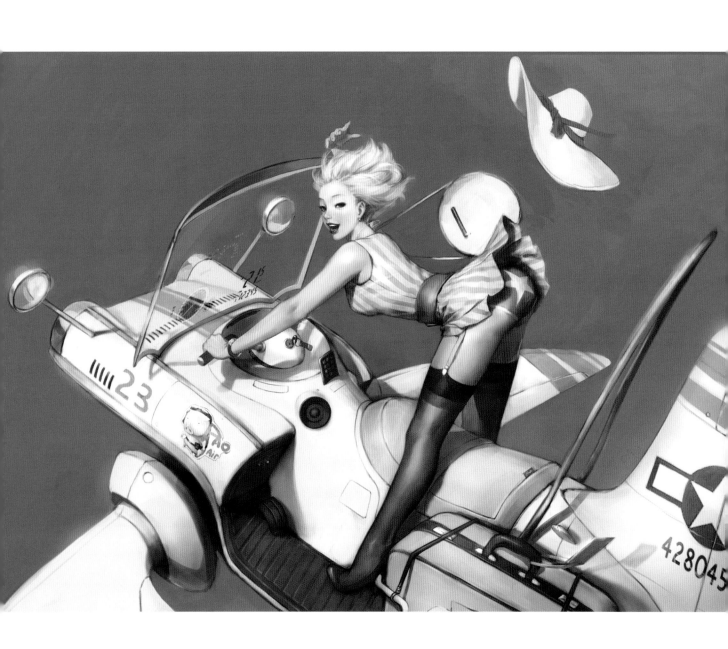

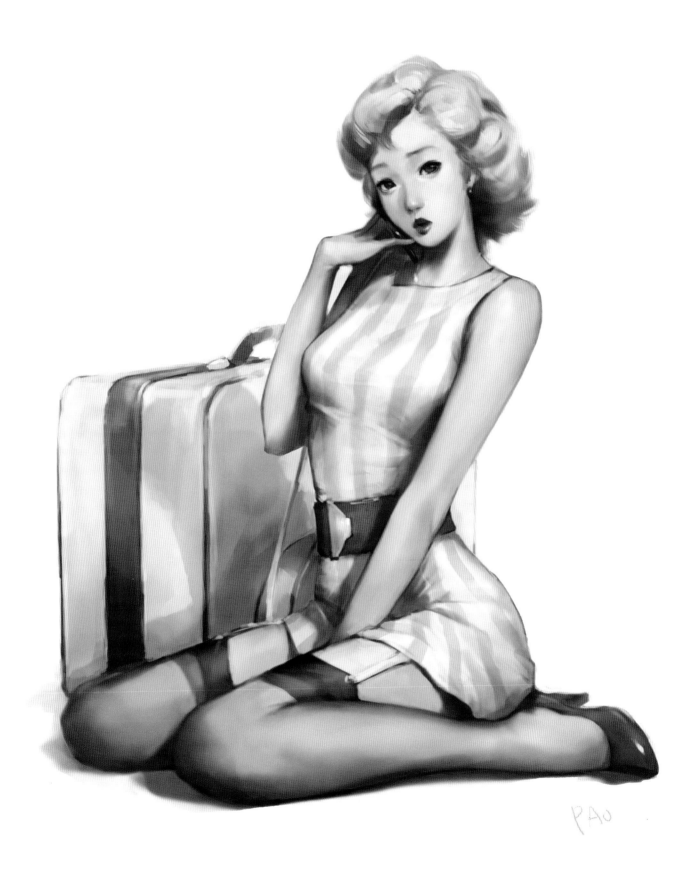

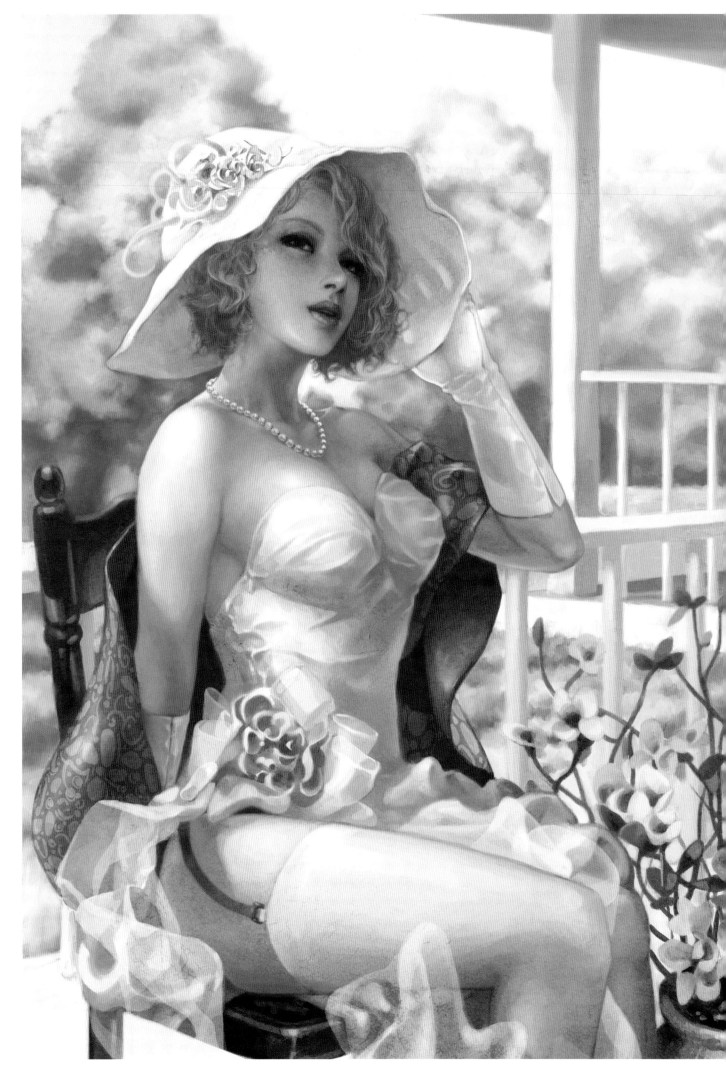

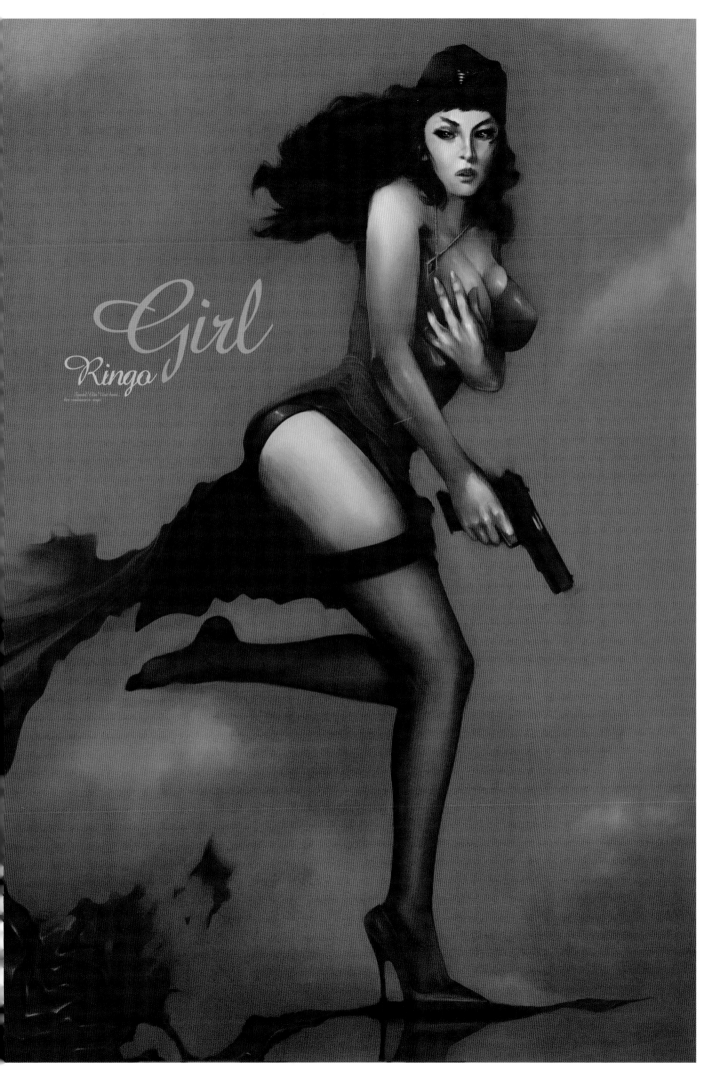

Girl

Ringo

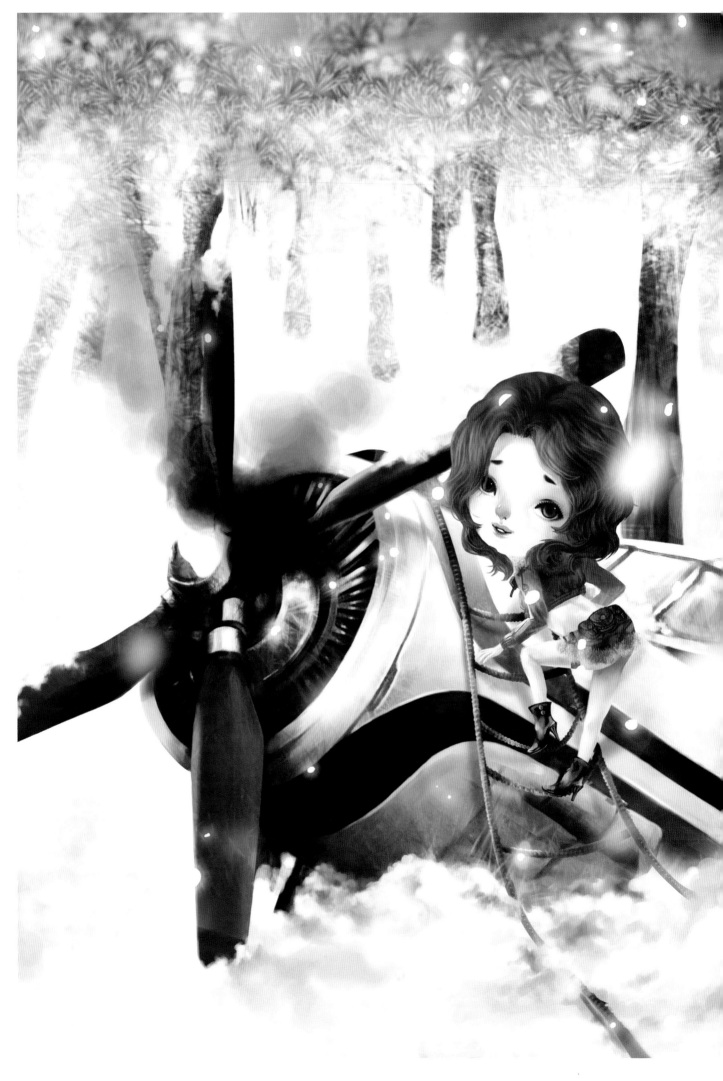

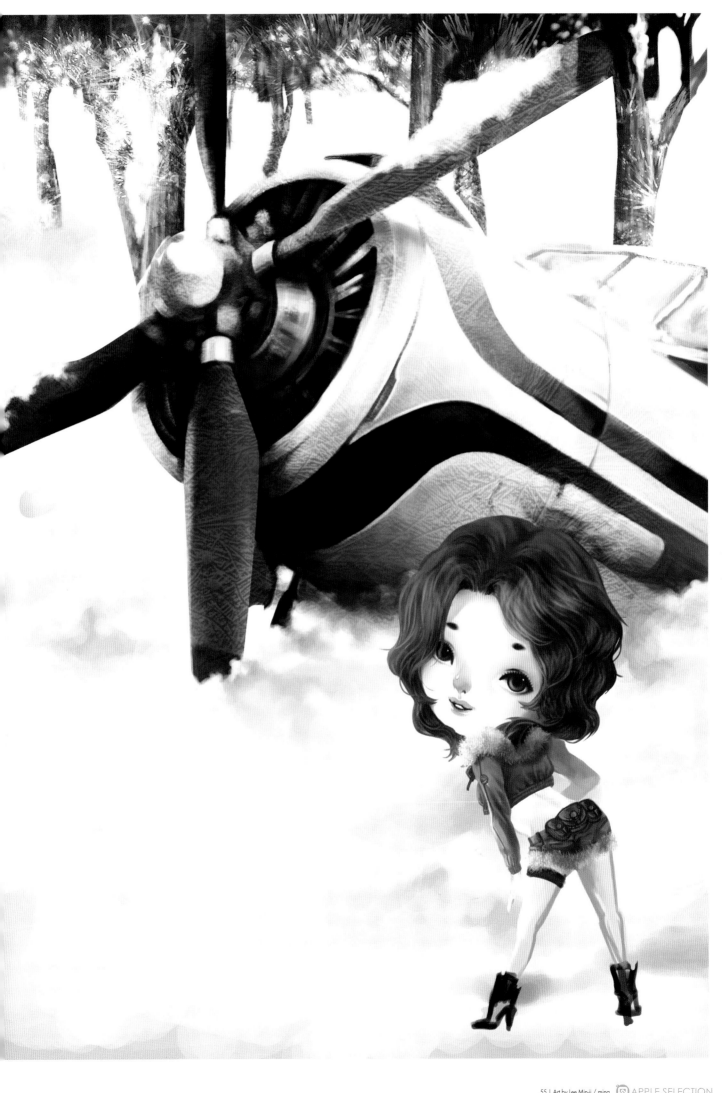

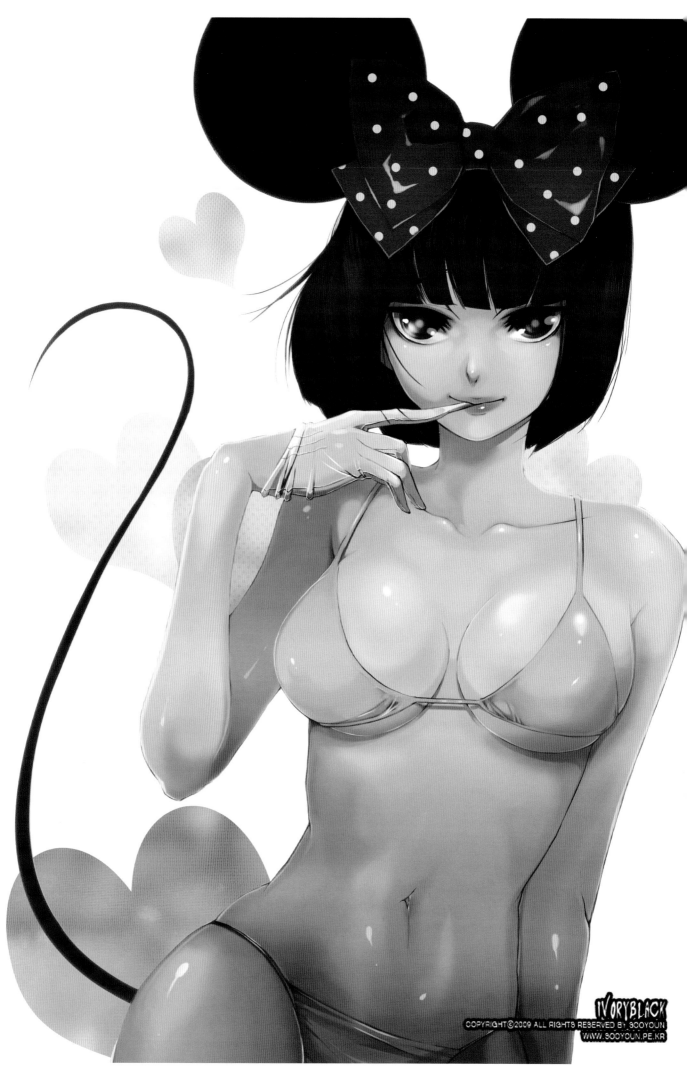

IVORYBLACK
COPYRIGHT©2009 ALL RIGHTS RESERVED BY SOOYOUN
WWW.SOOYOUN.PE.KR

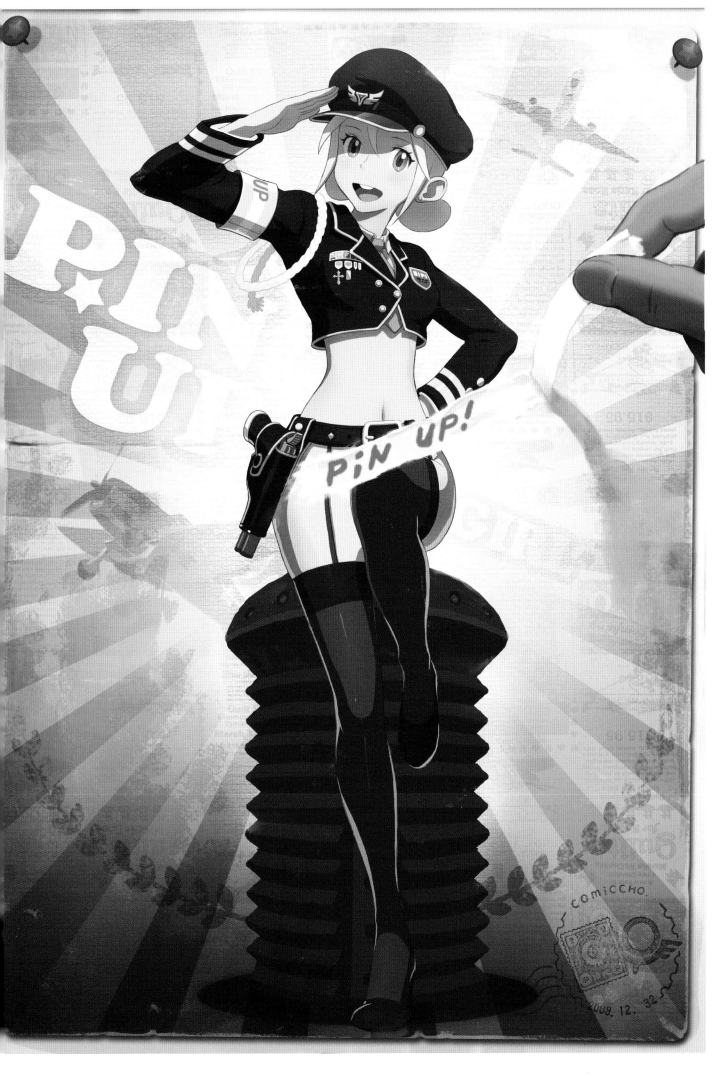

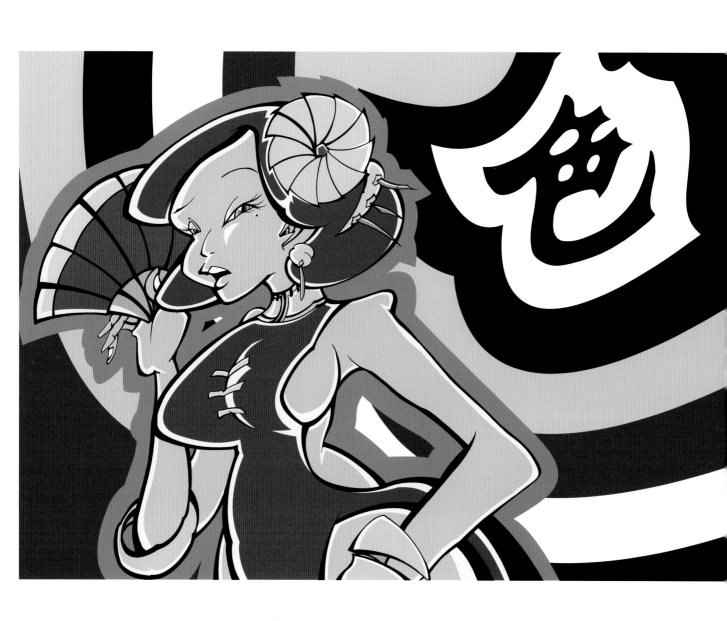

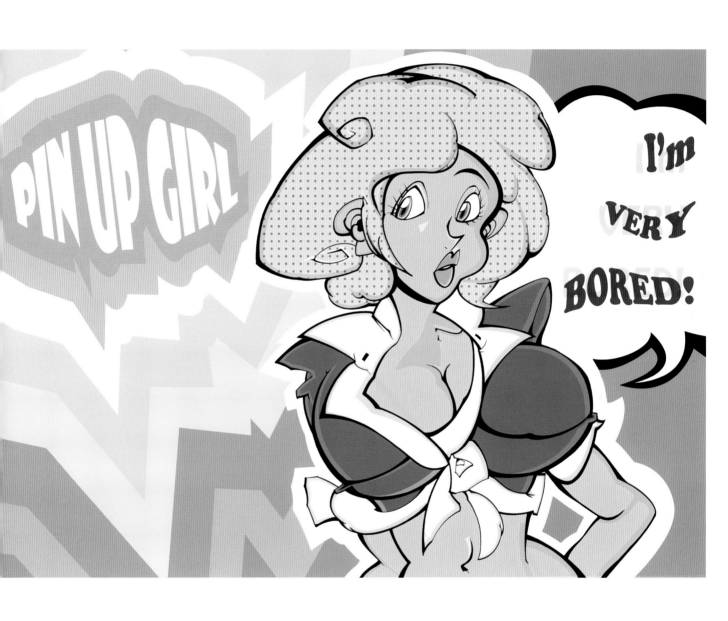

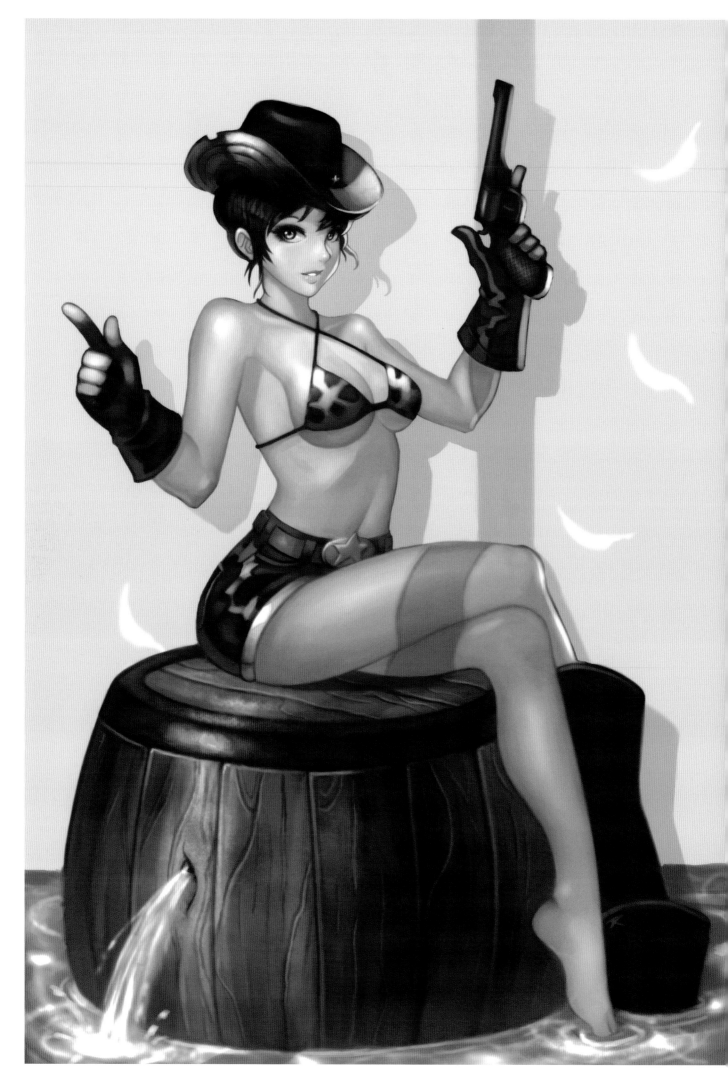

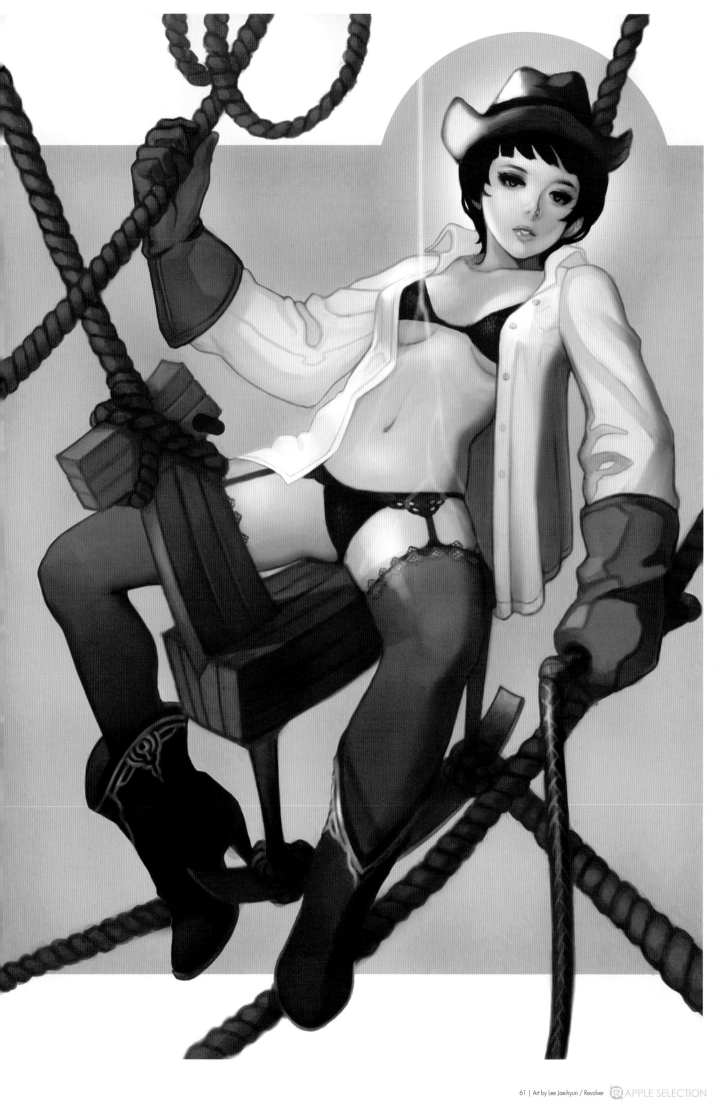

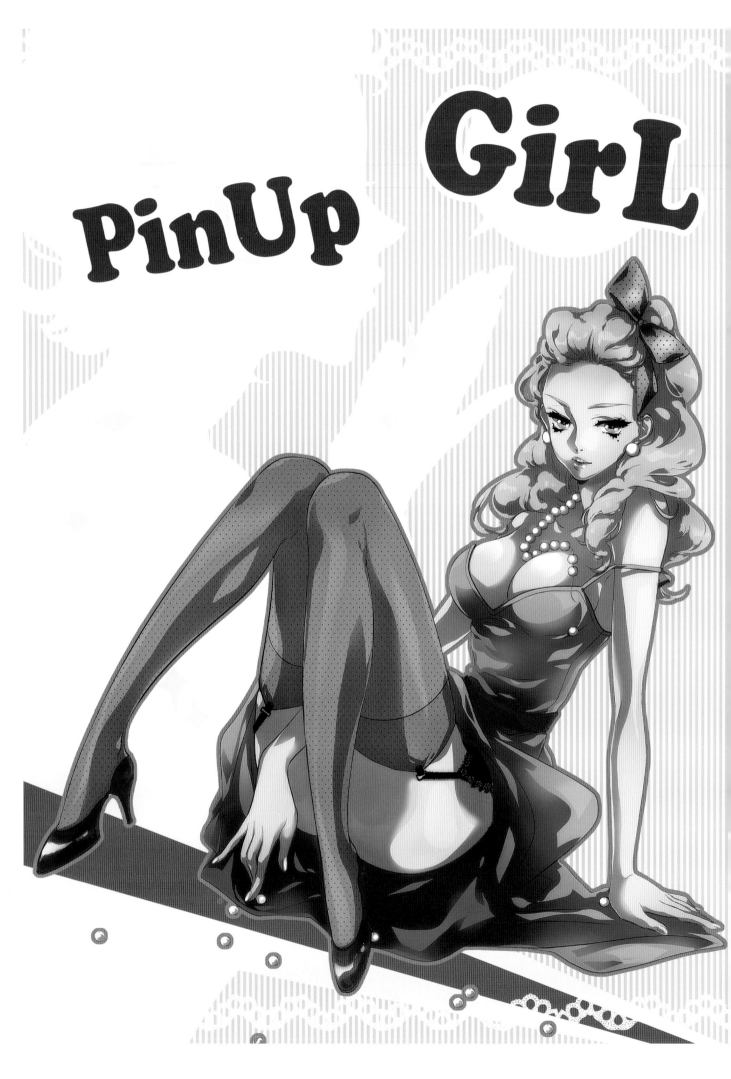

PinUp GirL

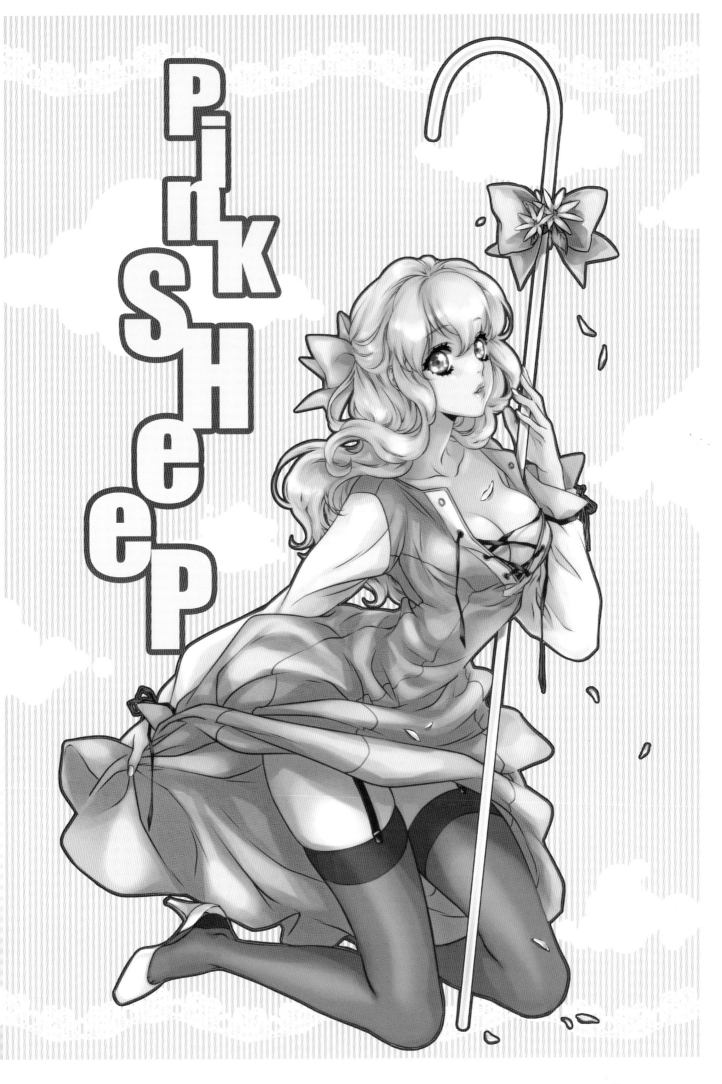

PINK SHEEP

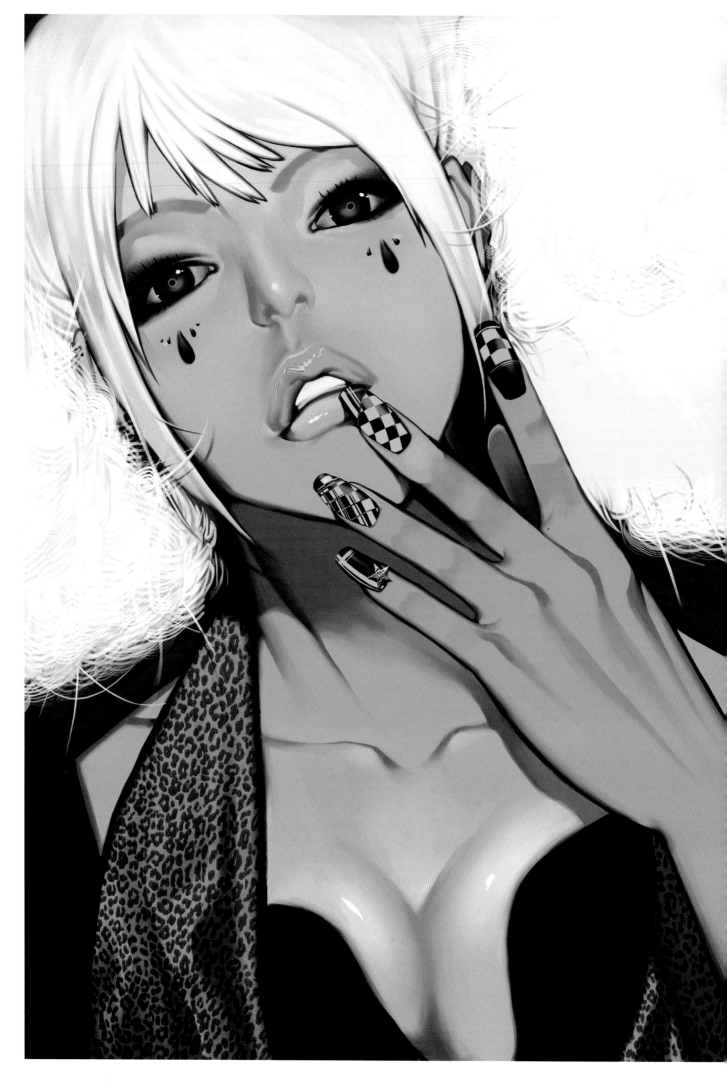

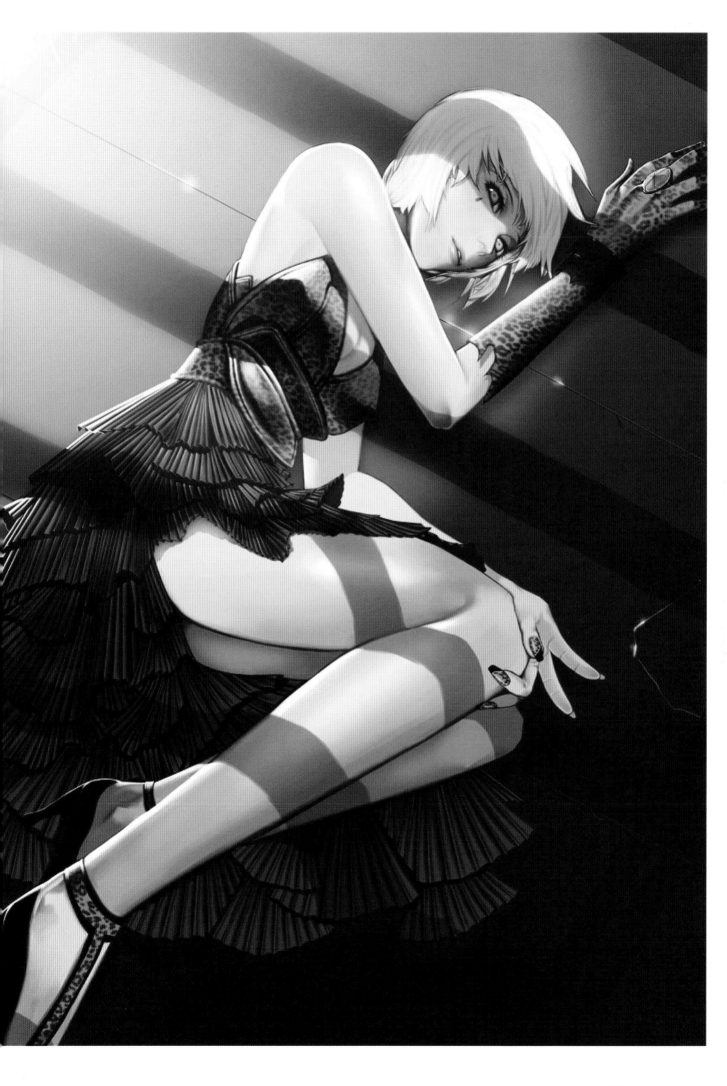

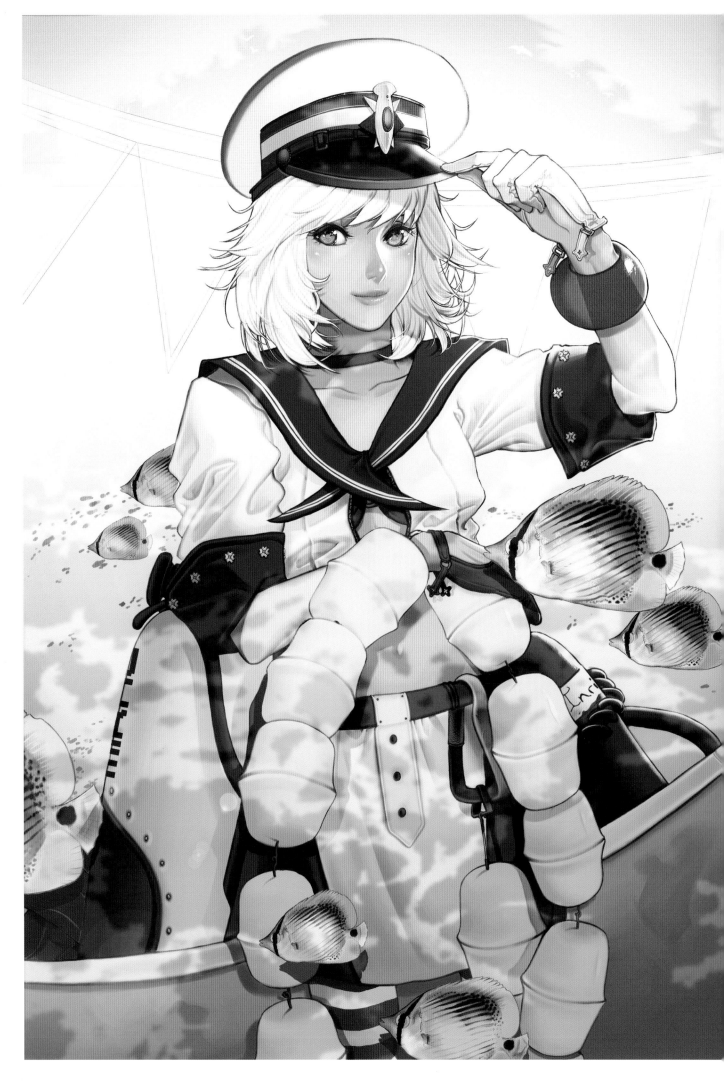

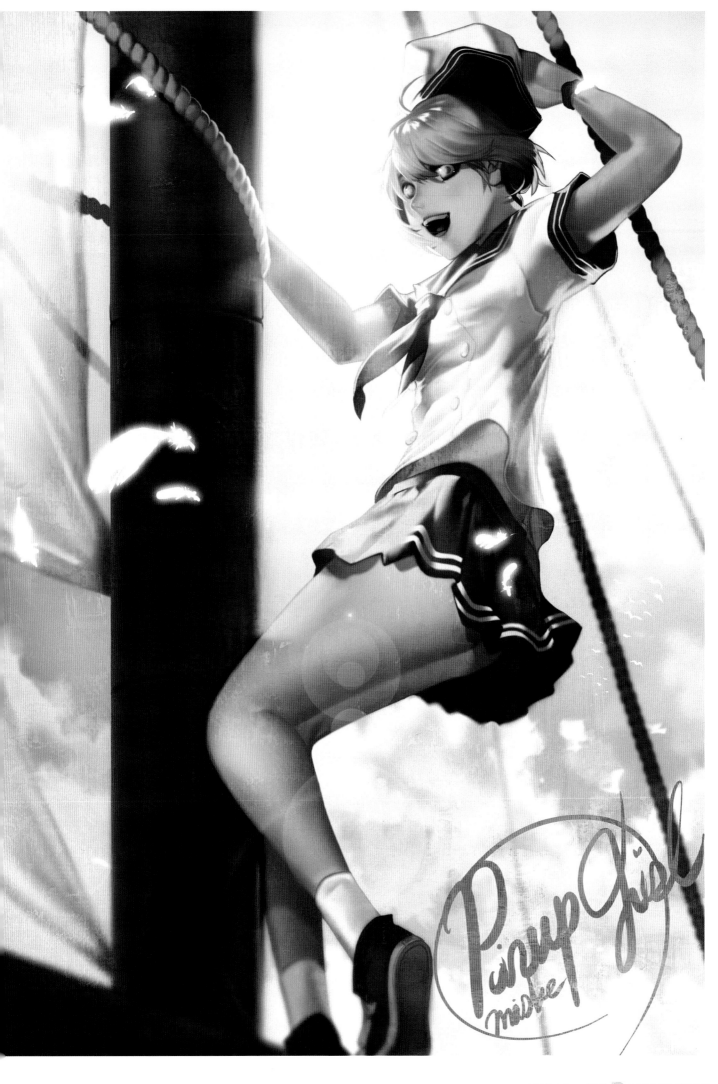

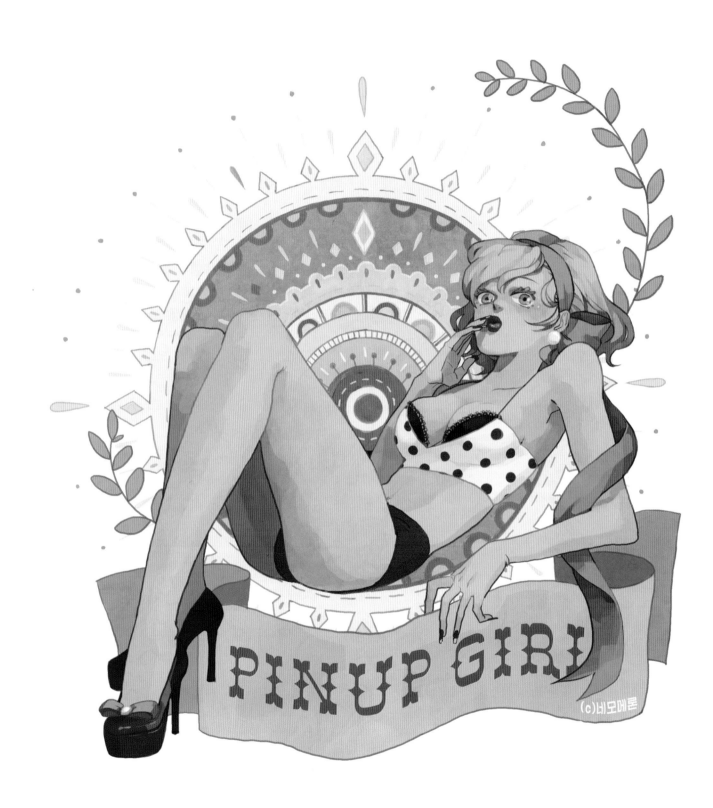

PINUP GIRL

(c)비모메론

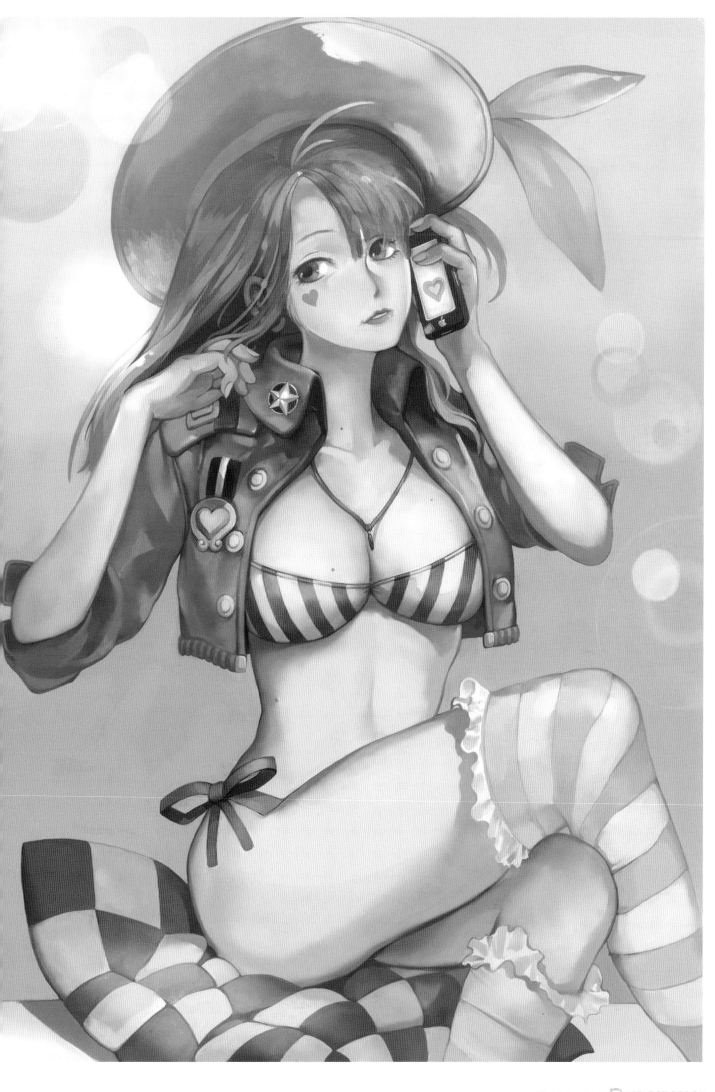

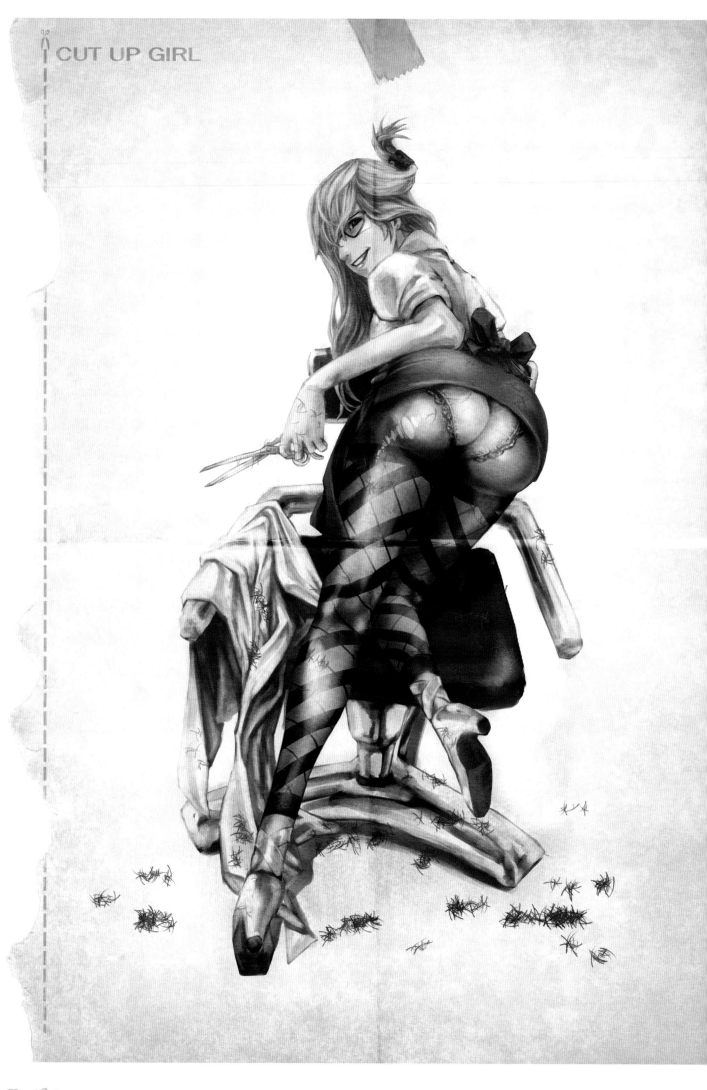

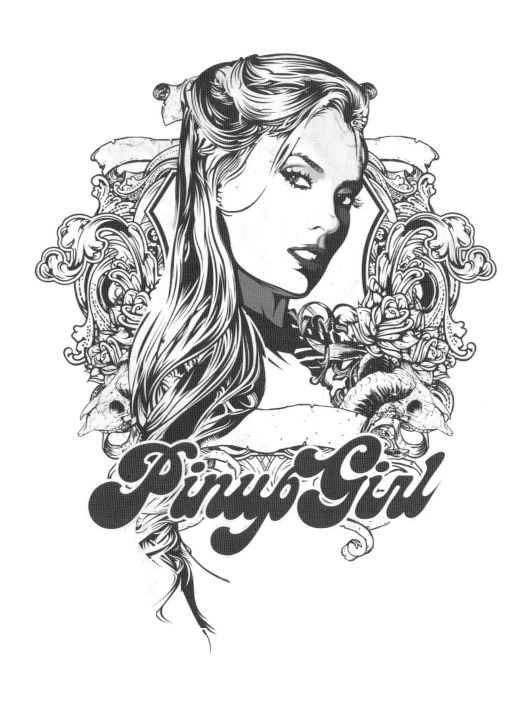

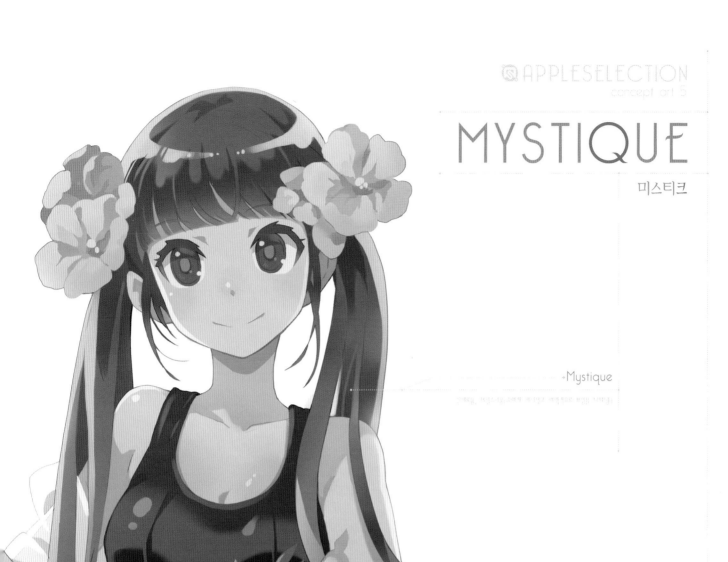

APPLESELECTION
concept art 5

MYSTIQUE

미스티크

Mystique

首尔视觉工作所
www.applecomicshop.com
www.seoulvisualworks.com

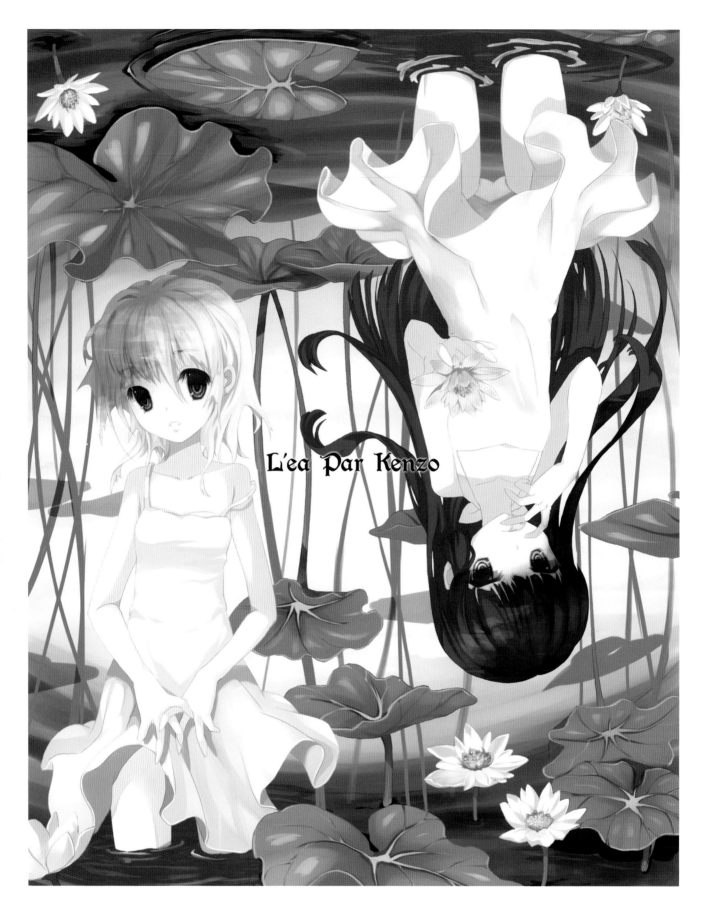

L'ea Par Kenzo

MINTCHOCO

Nickname: Mintchoco
Real Name: Kim Hyun-Ah
Website: http://mintto.web-bi.net
Circle Name: Orange Sorbet

Comment:
I worked as a concept artist at a game company for five years, but now I
am a freelancer (which is another word for "jobless").

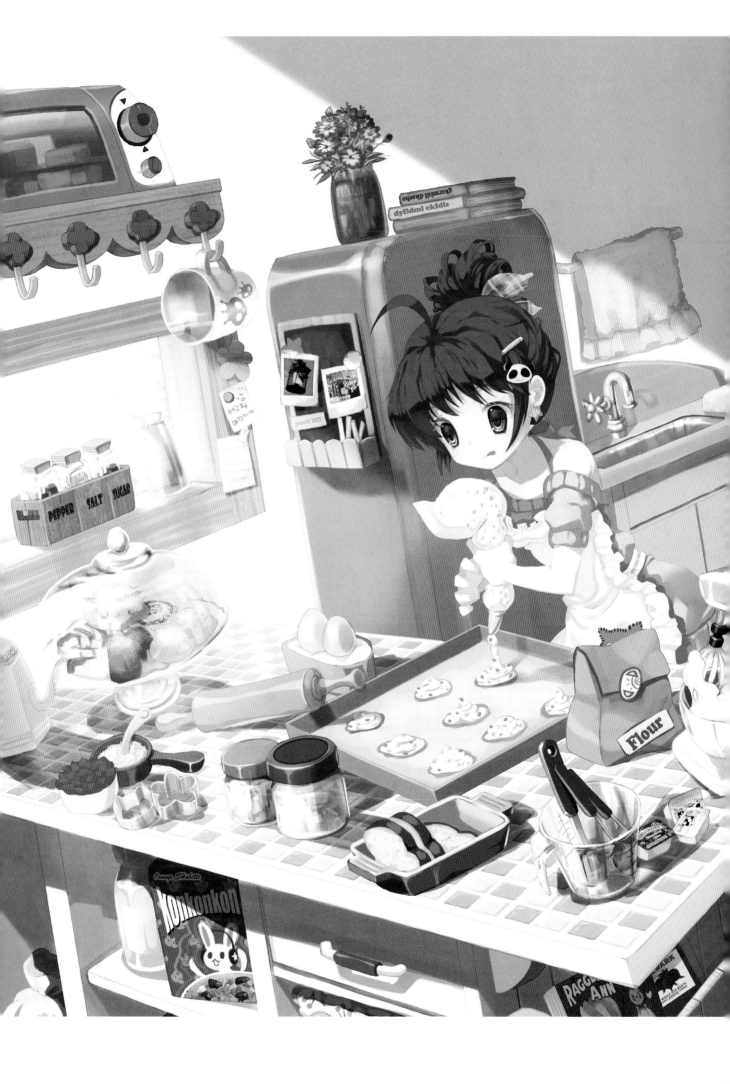

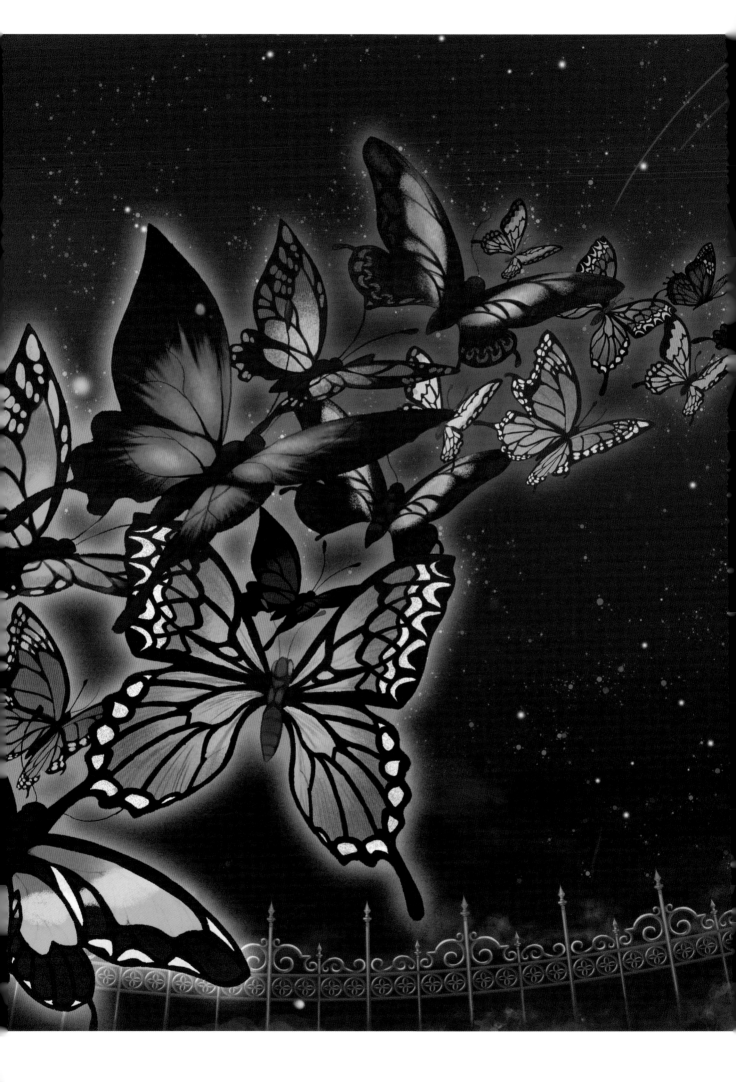

MYSTIQUE

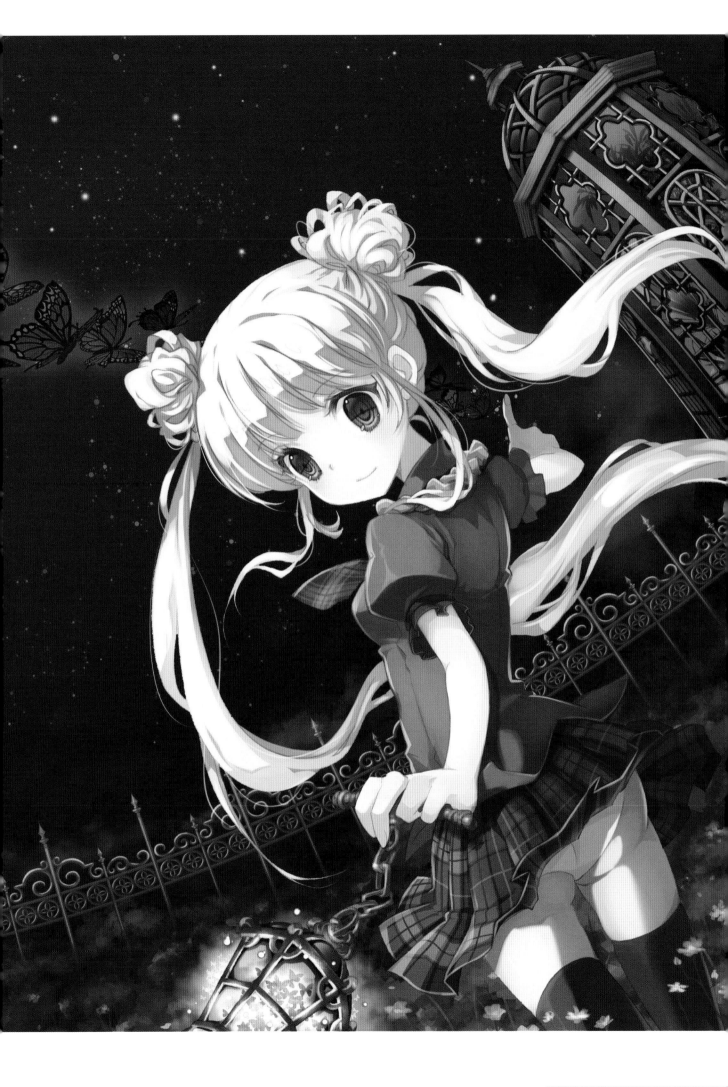

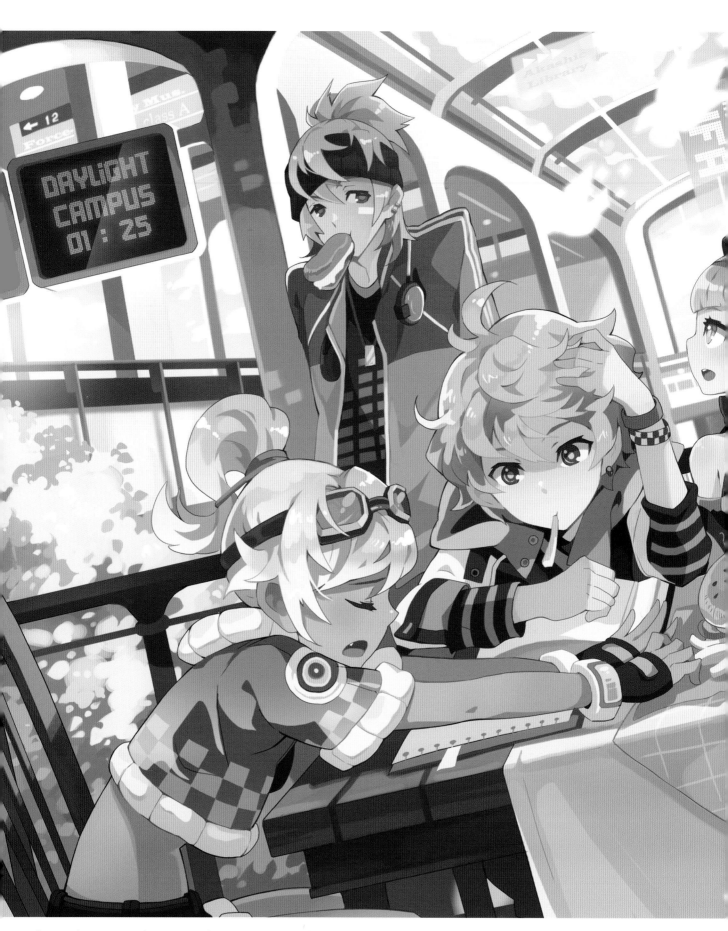

Illustration by Project D' Light (pen name) of "Team Digital Garden" from SanHa Studio of Line Game development Iya Soft. Based on the concepts of school life and the supernatural, and set in a futuristic city, the image depicts an attractive world. All the characters in the image are students of the UFA training school, and each student has a specific superpower that they specialize in. They are known as the most powerful individuals in the city, even though their everyday lives appear to be similar to those of average students…

MYSTIQUE

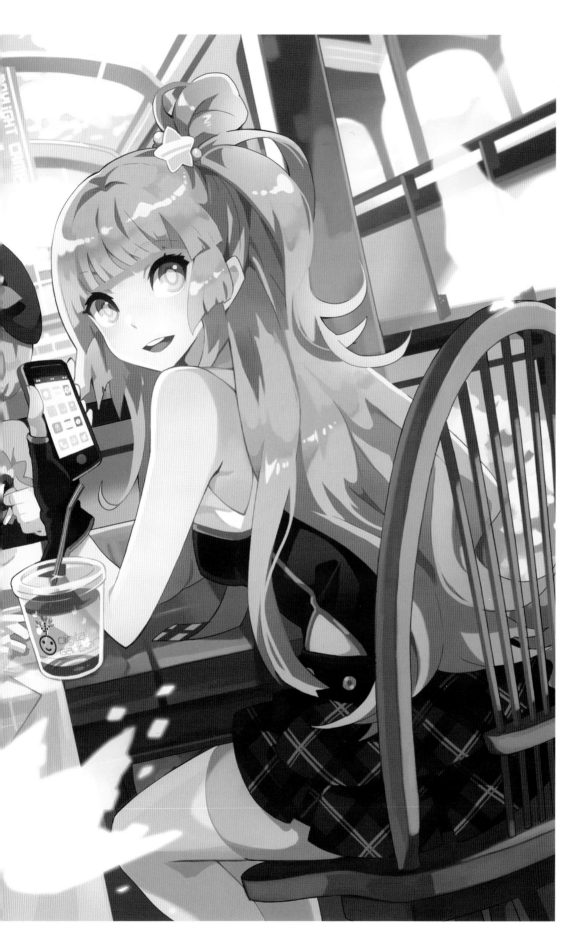

BF

Nickname: BF Beef Friend
Website: http://user.chol.com/~bf17
E-mail: bf8107@gmail.com

Comment:
I am an artist who mainly deals with illustrations and character concepts. My nickname comes from the fact that I like meat (?). Beef is a very delicious friend! +ㅠㅠ+

Main Credits:
Actoz Soft / Latail / background
NEXON / Asgard / character concepts, illustration
SeedNovel / Alchemist Boy illustration
EA Mobile Korea / Chronoswing character illustration
Seoul Visual Works / Apple Vol.1, Apple X
月肆 / Quarterly Publication S Volume 28 pinup illustration
BNN / 100 Masters of Bishojo Painting
KENAZ/COO Plus 01. Colorful Pentavision, DJ Max series
BGA Illustration - Miles, in My Heart, Melody, SweetDream
EYA SOFT / Project D'Light / character concepts, illustration

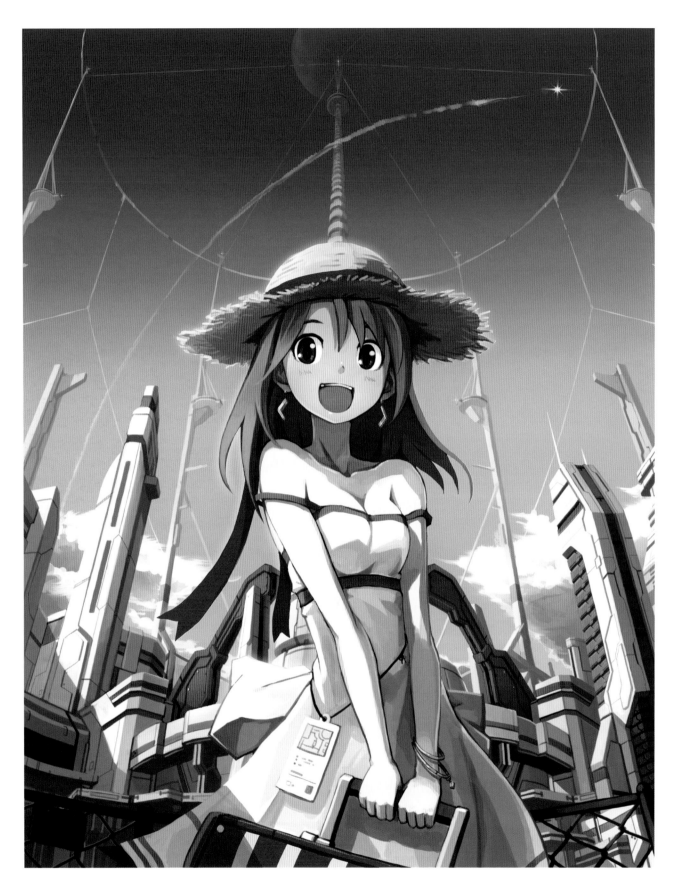

BAILKNIGHT

Nickname: Bailknight
Real Name: Kwon Dae-Hwan
Website: http://bailknight.nazzang.net
Website: bailknight@hotmail.com
Experience: Game company illustrator

Comment:
I am a busy office worker, just barely getting by.

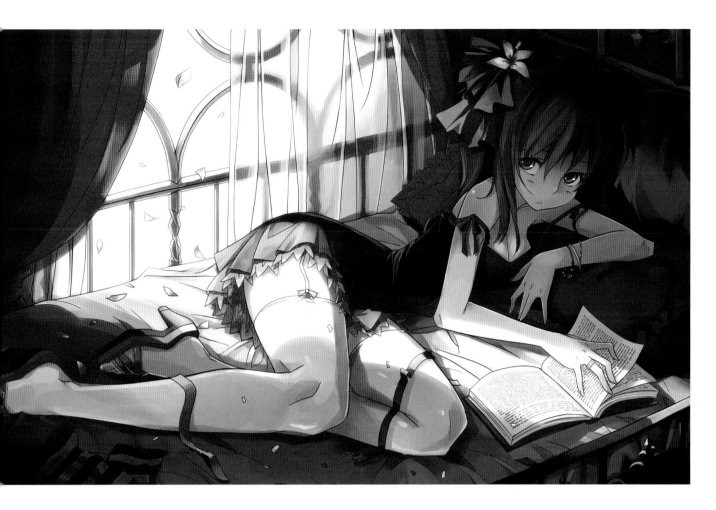

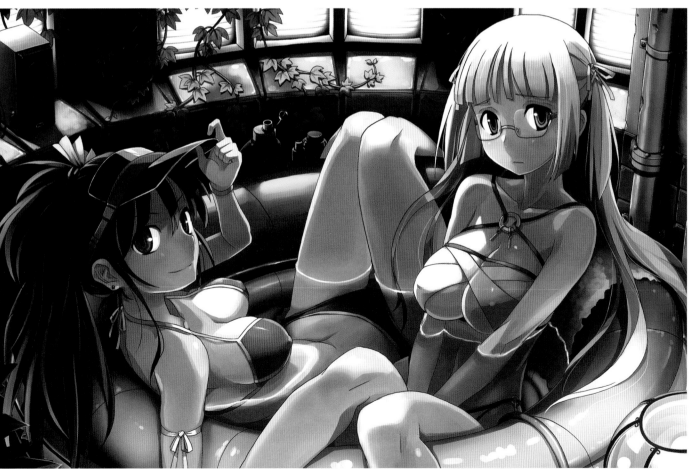

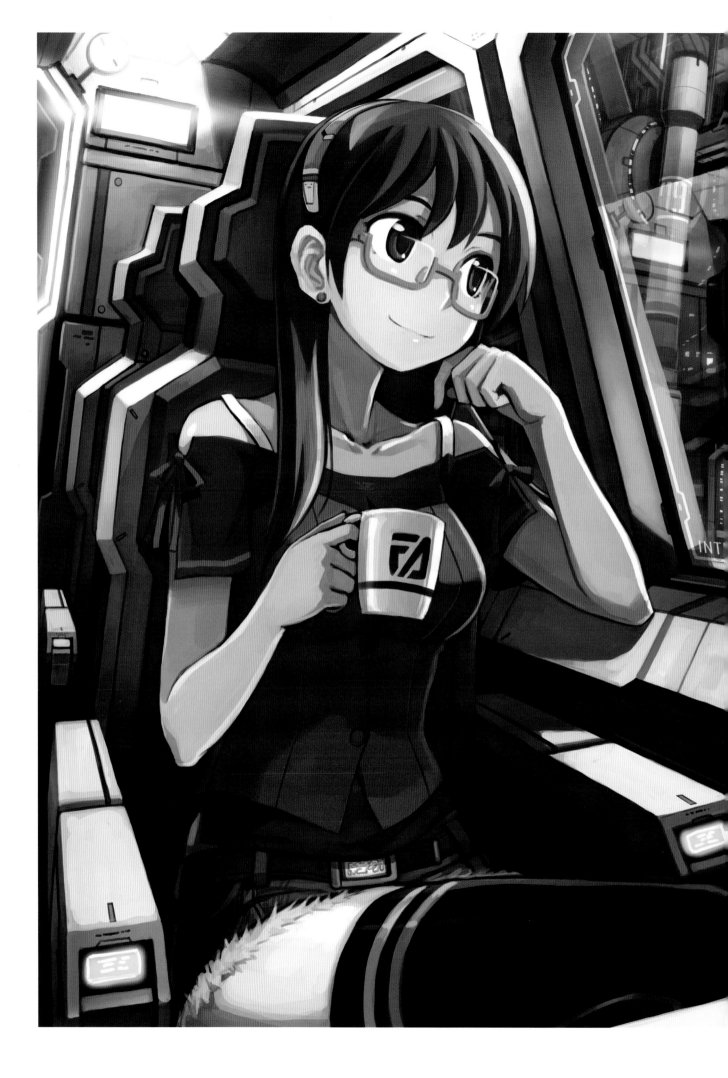

MYSTIQUE

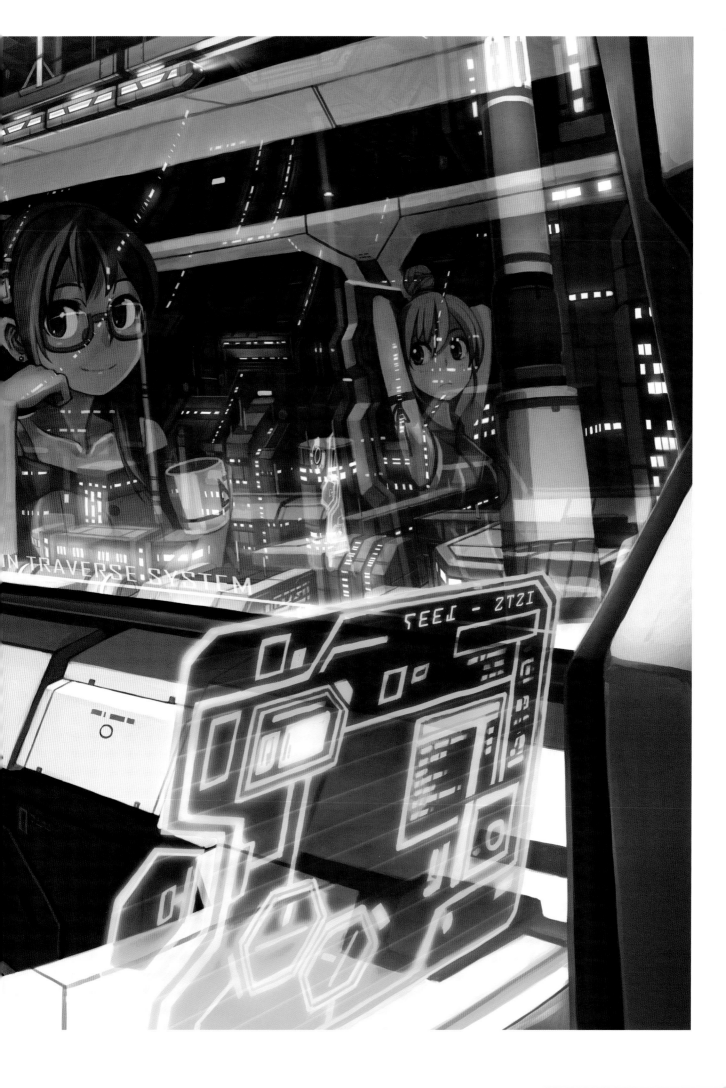

N TRAVERSE SYSTEM

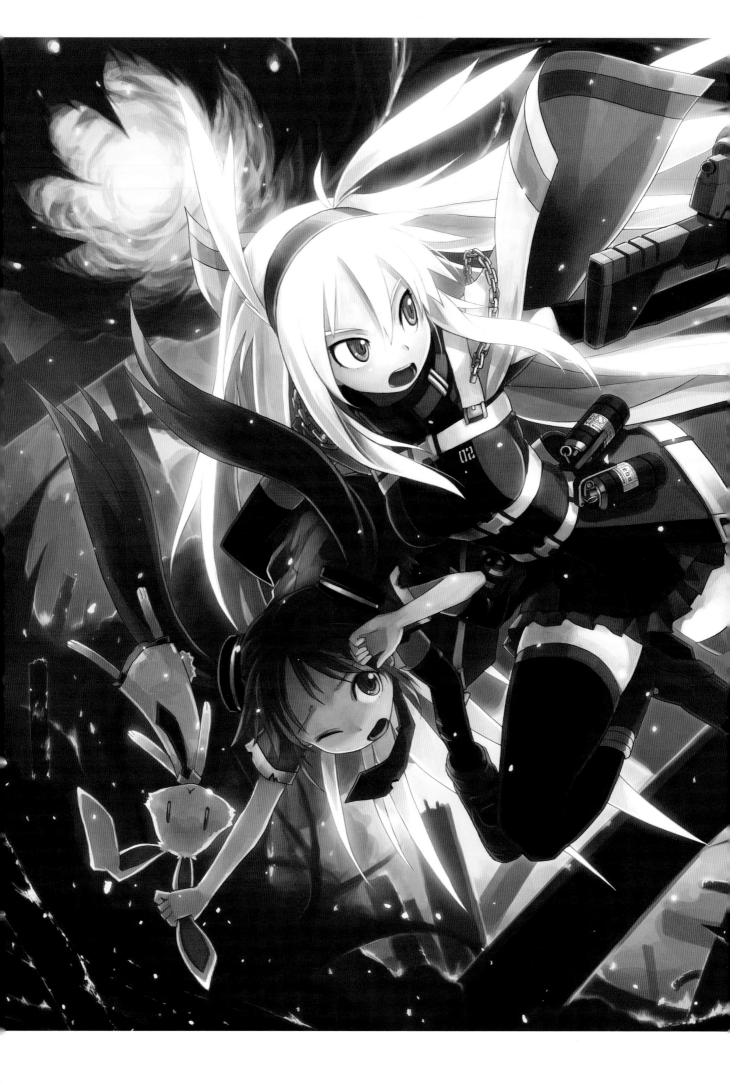

MYSTIQUE

ANMI

Nickname: Anmi
Real Name: Ahn Hyun-Mi
Website: http://sikky.egloos.com
E-mail: ahnanmi@gmail.com
Circle Name: I want to name it "Yut Sa Mo", but a lot of people are against that.

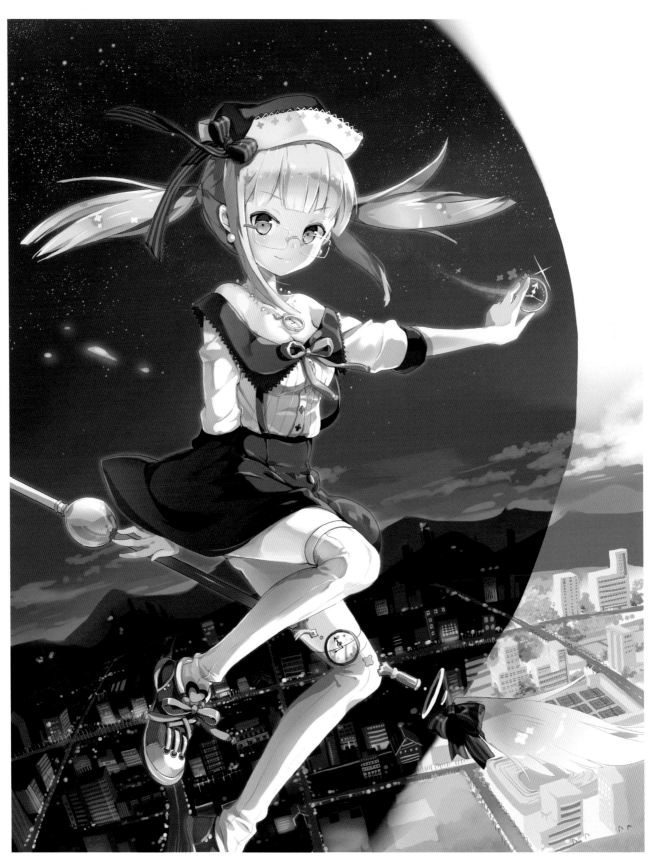

MYSTIQUE

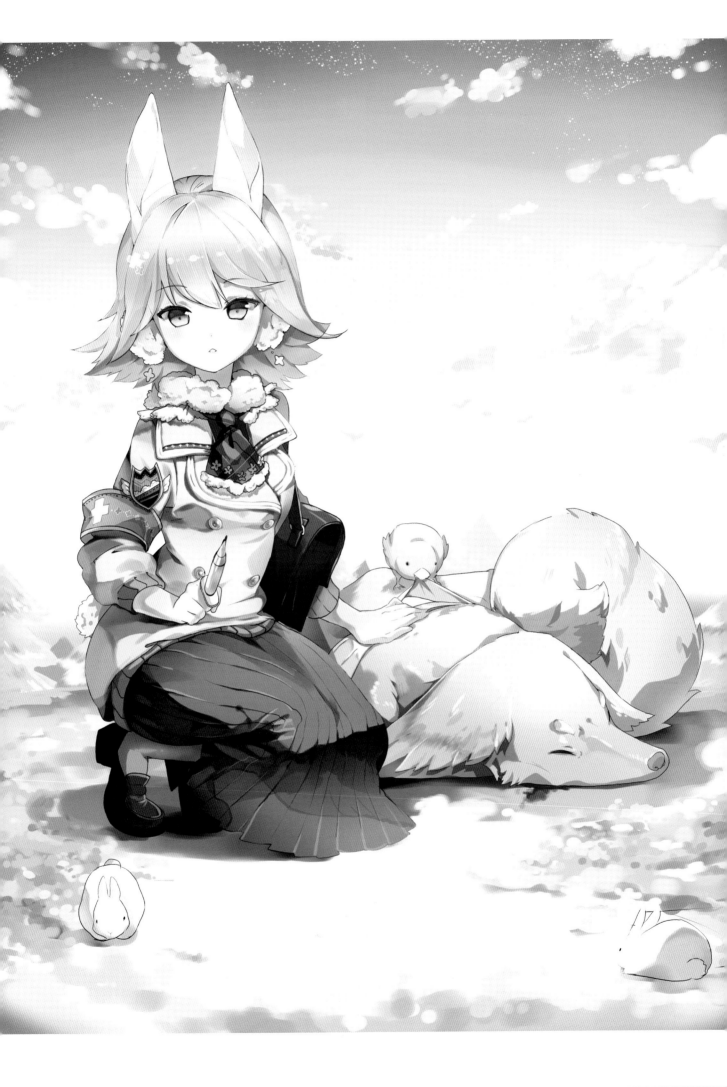

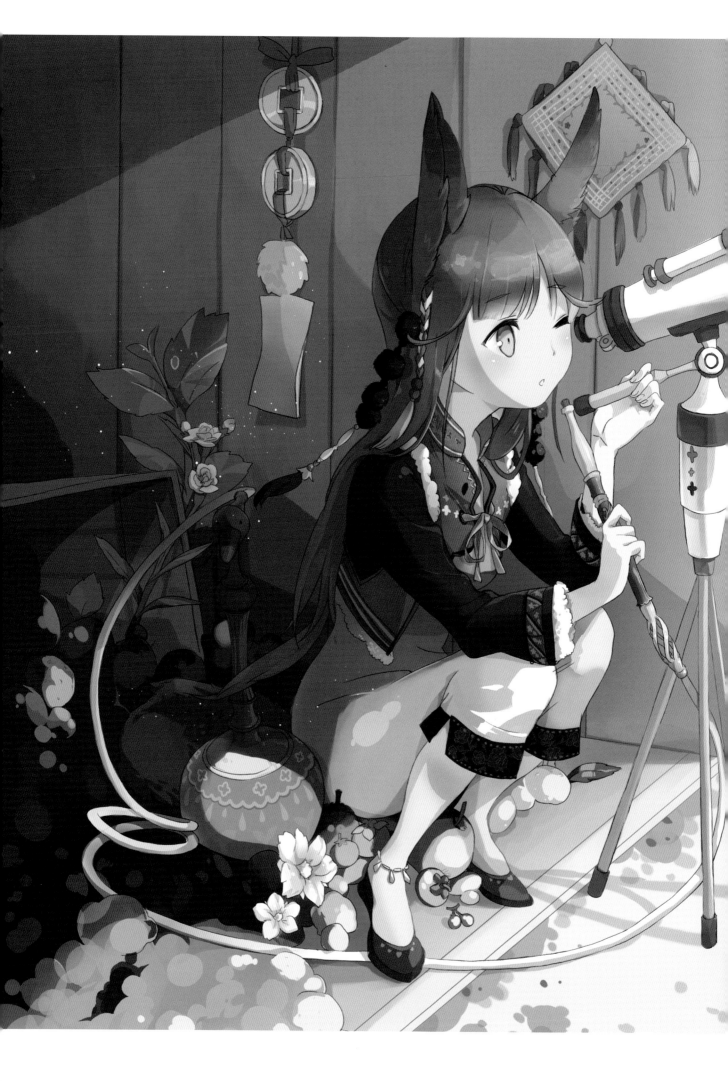

MYSTIQUE

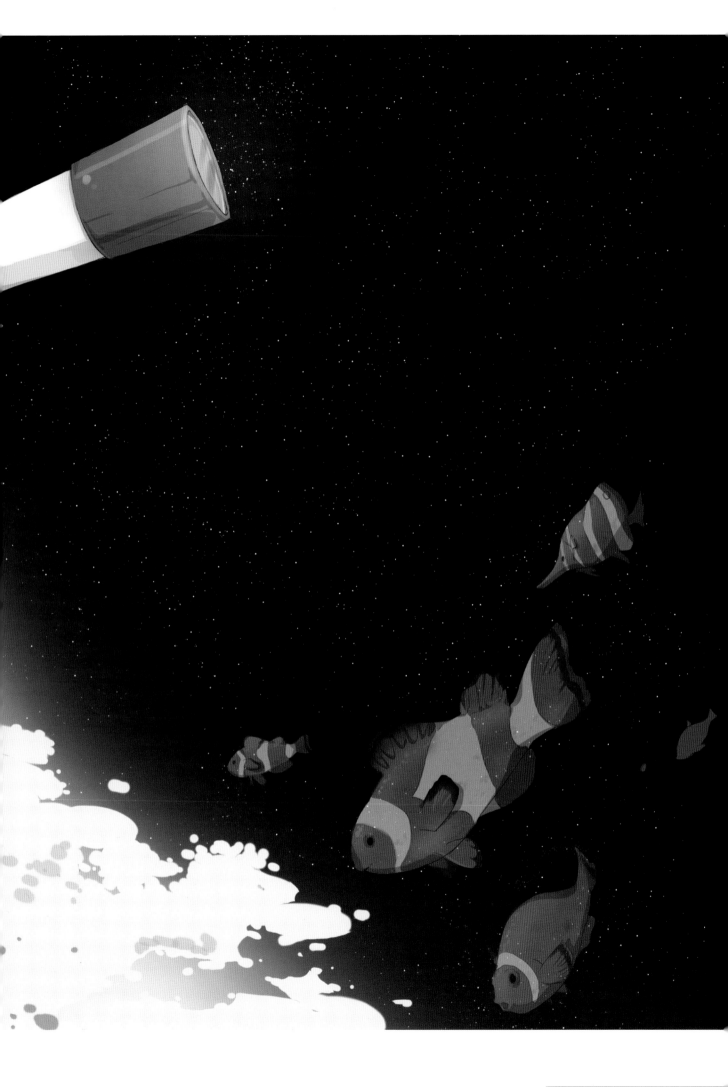

I LIKE EATING COW INTESTINES AND RAMEN AS WELL. ~ DO I GENERALLY LIKE GREASY FOOD?

DID NOT LEAVE A SINGLE DROP OF SOUP! -HARAJUKU ZANGARA RAMEN

I LIKE TO EAT, DRINK, DRAW, AND TAKE PICTURES OF CAKES AND OTHER DESSERTS.

I LOVE THE RECTANGULAR-NESS OF MY WORK PARTNER, THE X200T THINKPAD!

BF's Present Situation

- I feel disappointed because the amount of my personal work has decreased this year; my daily life has just been me going back and forth between the office and home… I have been refreshing myself from time to time with beer and stir fried noodles. I know I'm not acting like a mature adult.

- It has been awhile since I moved to Seoul. My family back home recently moved, and I am a little worried… especially about my cherry cat, who may be crying due to the sudden change in environment. When I called my family, they said she was indeed crying and throwing a tantrum. I hope they finish moving safely.

- I am working on the Project D' Light illustration, which was recently published by the company, and "swimsuit girl", which is my personal work. I have put my best efforts into both pictures, so please enjoy.

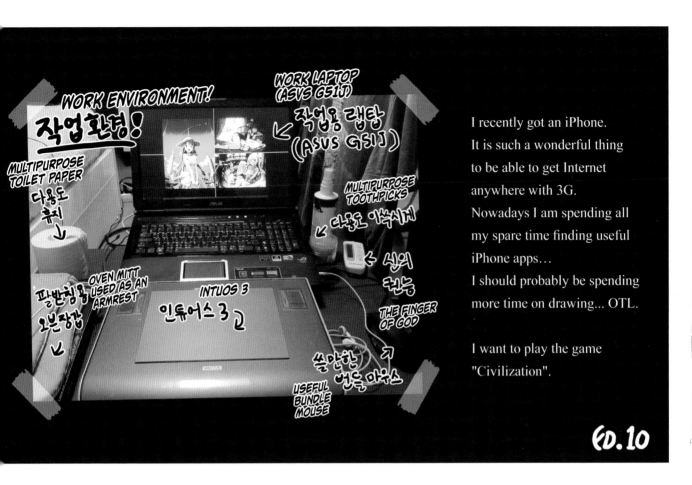

WORK ENVIRONMENT!
작업환경!

WORK LAPTOP
(ASUS G51J)
작업용 랩탑
(ASUS G51J)

MULTIPURPOSE
TOILET PAPER
다용도 휴지

MULTIPURPOSE
TOOTHPICKS
다용도 이쑤시개

OVEN MITT
USED AS AN
ARMREST
팔받침용 오븐장갑

INTUOS 3
인튜어스 3

THE FINGER
OF GOD
신의 권능

USEFUL
BUNDLE
MOUSE
쓸만한 번들 마우스

I recently got an iPhone. It is such a wonderful thing to be able to get Internet anywhere with 3G. Nowadays I am spending all my spare time finding useful iPhone apps… I should probably be spending more time on drawing… OTL.

I want to play the game "Civilization".

ED.10

ANMI'S SUBSTITUTE

Anmi

*THANK YOU, CHIYOPAPA, FOR APPEARING WITH SUCH SHORT NOTICE

IT WAS LG'S SLIM COMPUTER. BEFORE REPLACING THE RAM, IT WAS TREATED ROUGHLY FOR HALF A YEAR. HOWEVER, EVEN NOW, THE MONITOR COLOR STILL MAKES IT LOOK LIKE A "REPLENISHED ITEM", SO IT IS BEING USED AS THE PRINCIPLE EQUIPMENT. THE TABLET IS AN INTUOS 3. THE BACKGROUND IS DDAL'S AWESOME PICTURE.

DIRTY BED. I SLEEP ON IT JUST THE WAY IT IS (I CAN SLEEP ANYWHERE AS LONG AS IT IS SOFT). IT IS AN OLD DORMITORY, NOTHING MUCH TO SEE.

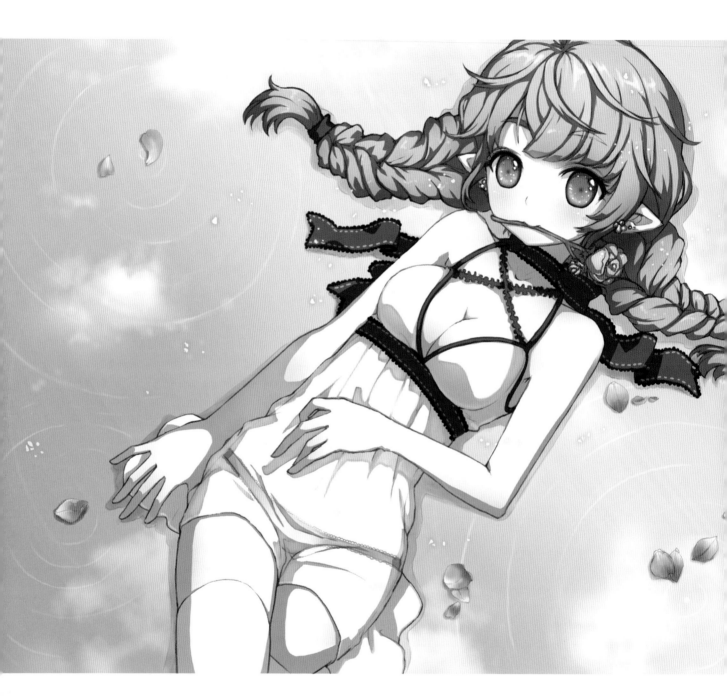

JUKE

Nickname: Juke
Website: http://najuke.com
E-mail: perfectblood@naver.com

Comment:
Currently working as a concept artist at a game company, and have
been for a few years now. I am an artist who likes games and bikes.

MYSTIQUE

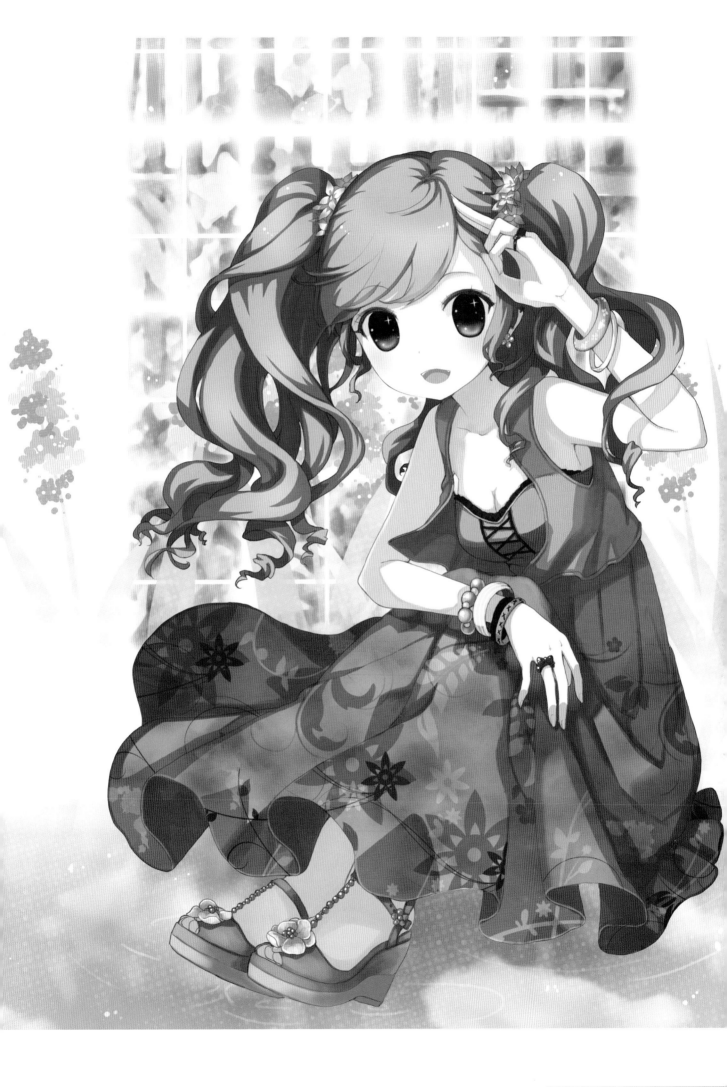

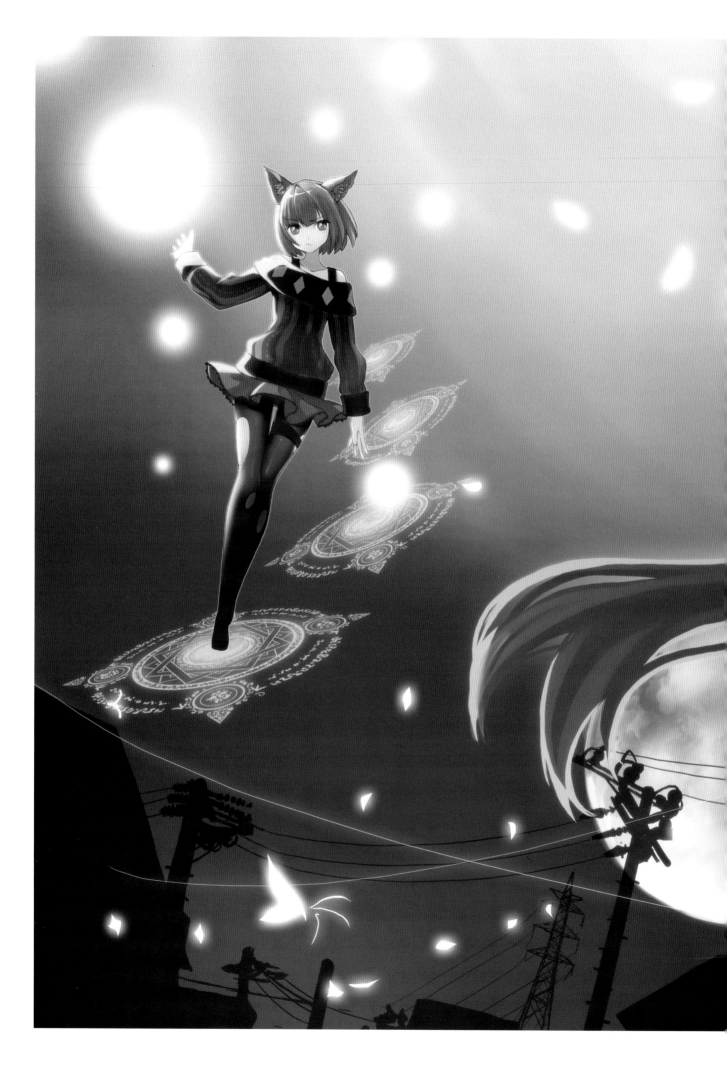

MYSTIQUE

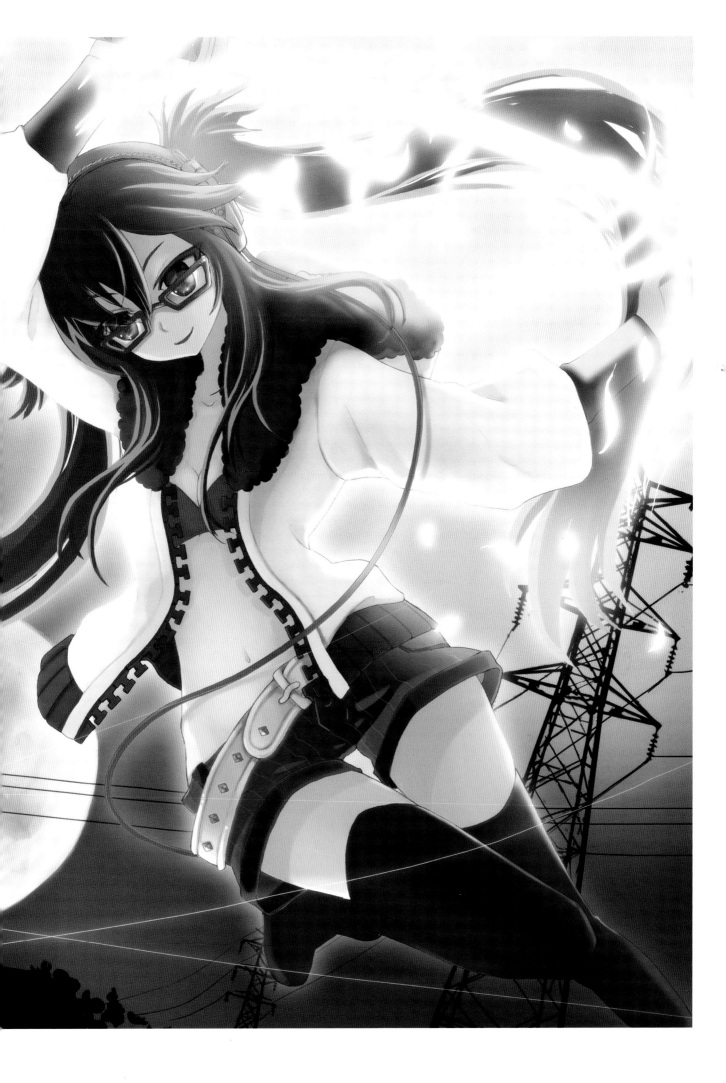

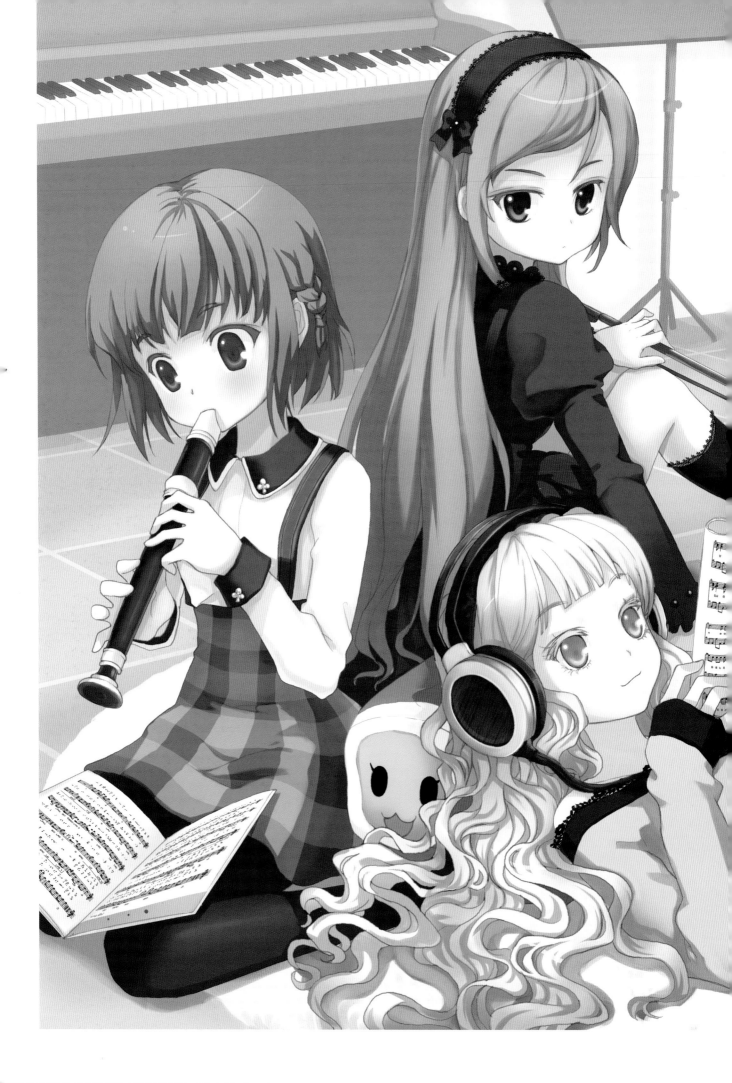

MYSTIQUE

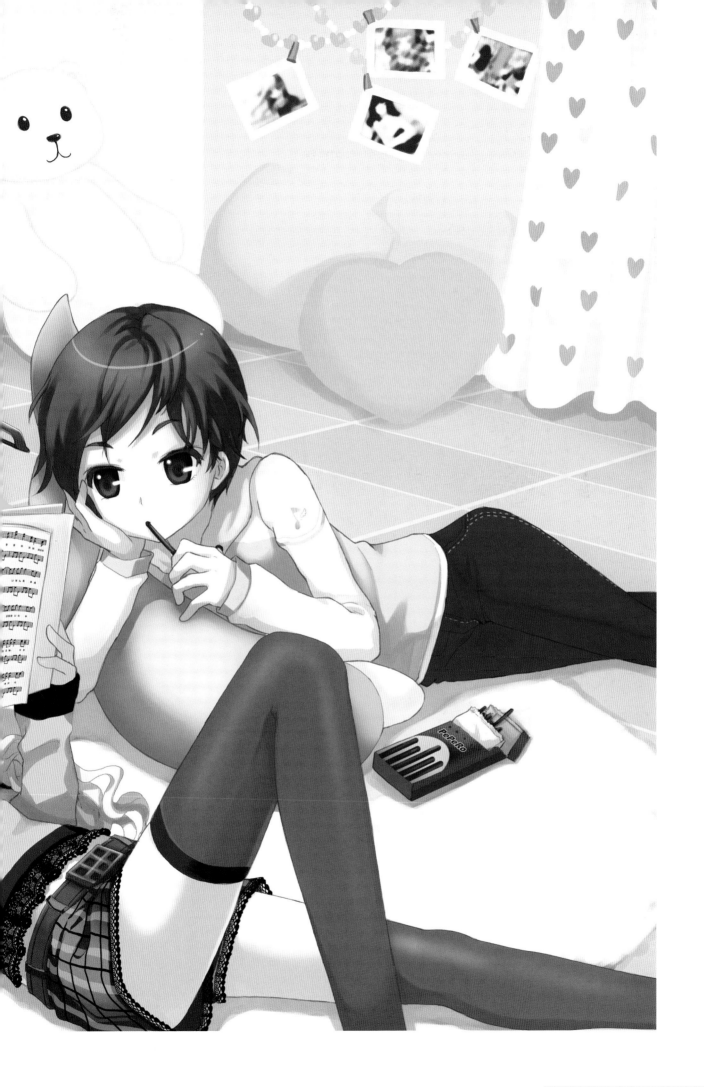

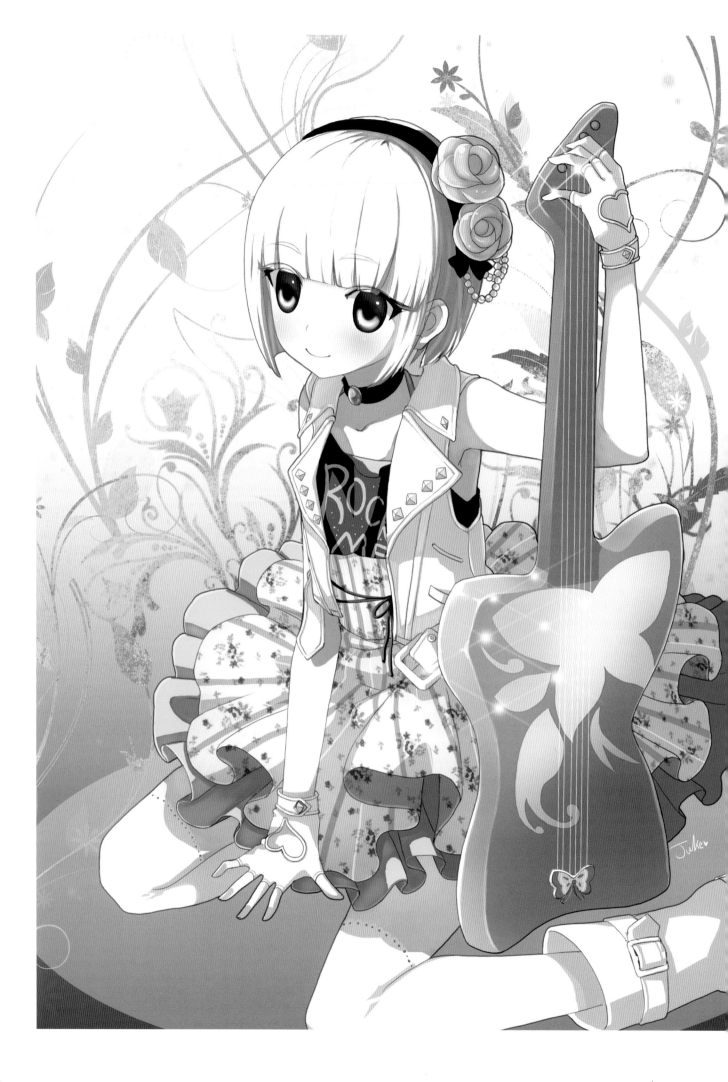

MYSTIQUE

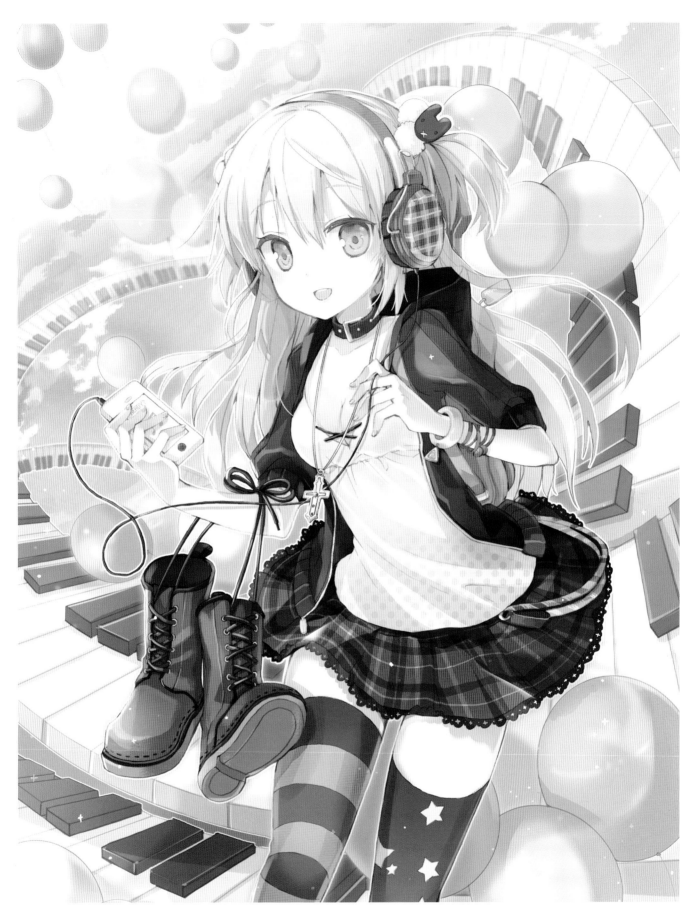

YOUNGIN

Nickname: Youngin
Real Name: Jo Myung-Eun
Website: http://reversed.kr
E-mail: mixjuice71@gmail.com
Main Credits:
Character concept. Currently working at M Game.

MYSTIQUE

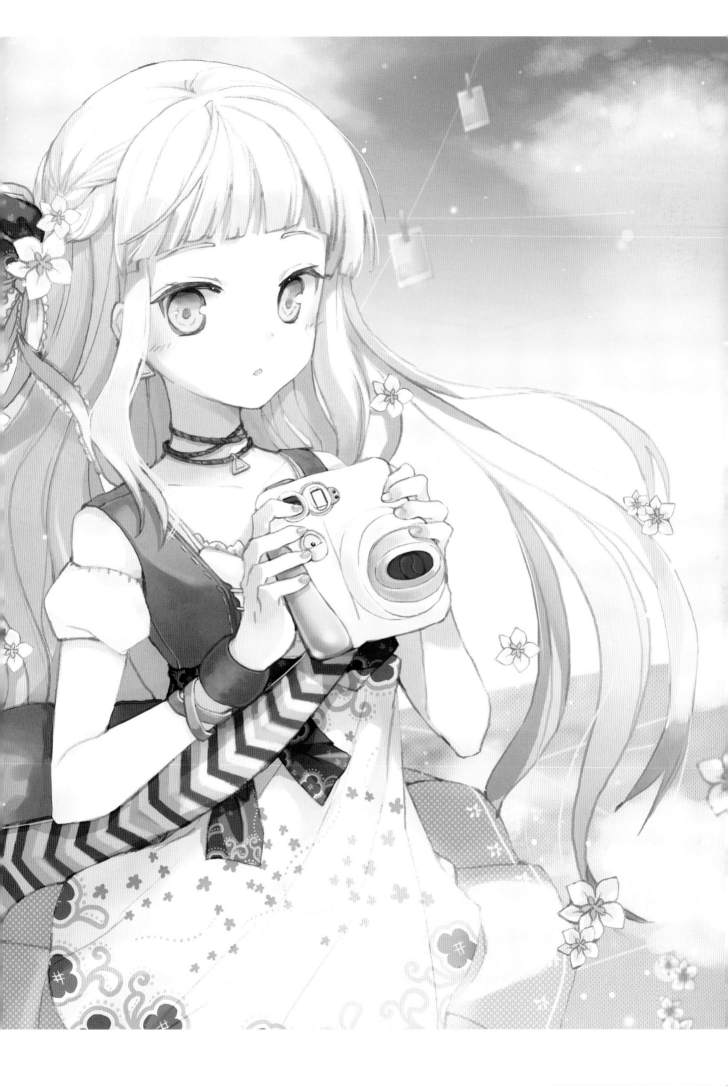

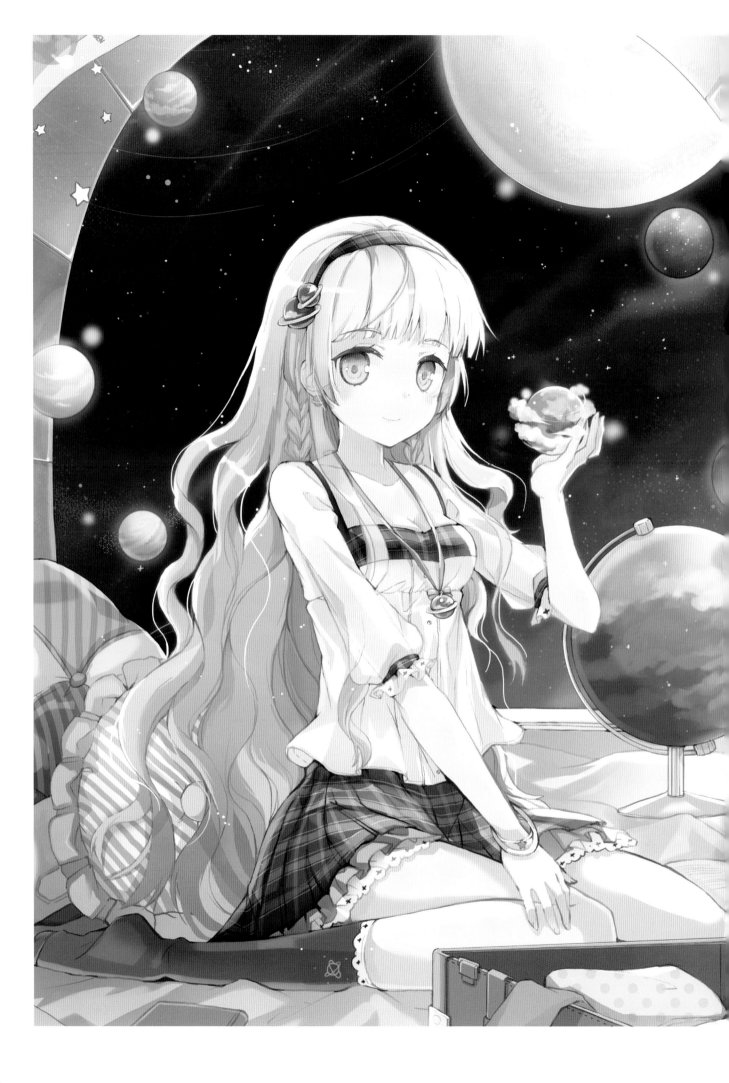

MYSTIQUE

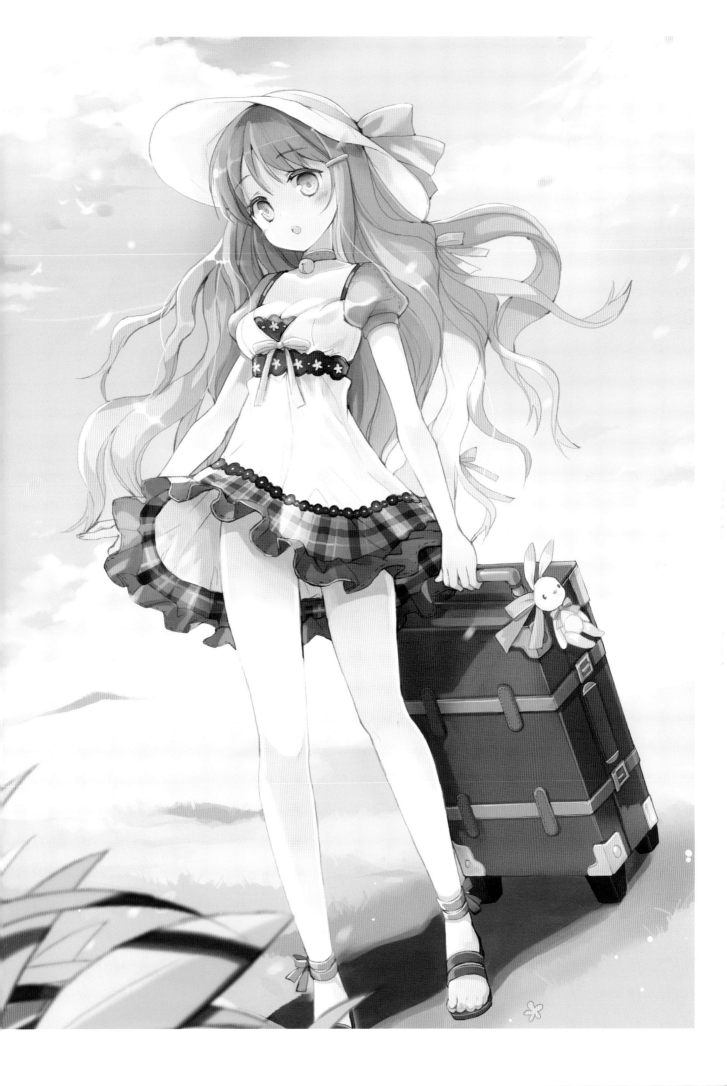

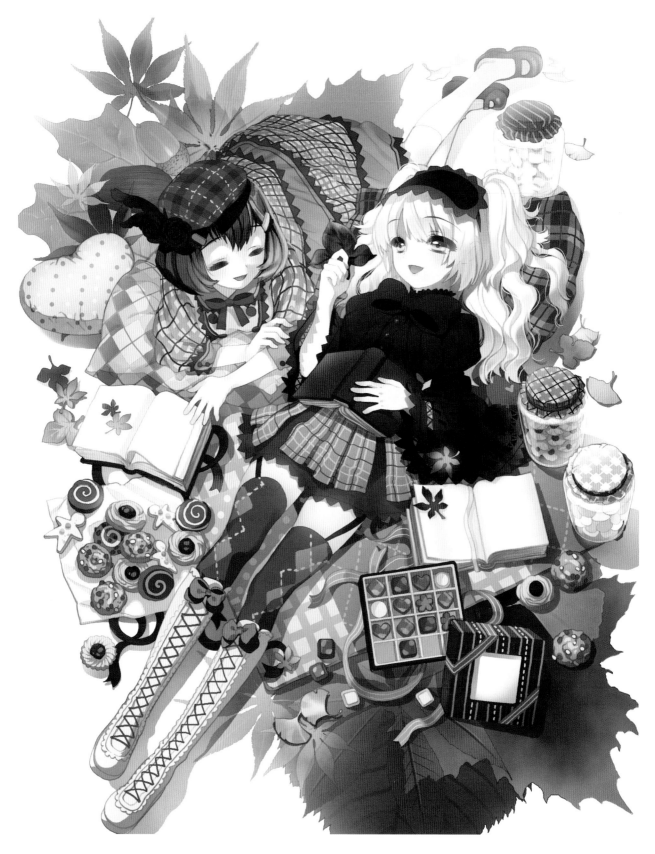

CHERRYPIN

Nickname: Cherrypin
Real Name: Kim Hyun-Ah
Website: http://www.cherrypin.com
E-mail: cherrypin88@naver.com
Circle Name: cherrypin
Main Credits:

Korea
- Currently working on Atoonz New Game <Star Project>
- Poppic volume 2 color illustration participation
- SeedNovel "Please find my tail" character design, illustration
 advertisement video, and MV animation production
- Eyasoft Titan Online NPC design
- Attonz "Jewelry Girl Elezu" character design and illustration
- Monthly GamerZ color illustration series

Comment:
I am a freelance illustrator who likes black tea and whales. Any works related to beautiful girls are always welcome.

Japan
- Gameloft iPod/mobile game
- Webservice illustration
- Monthly <Pasocon Paradise> mascot character design and cartoon work

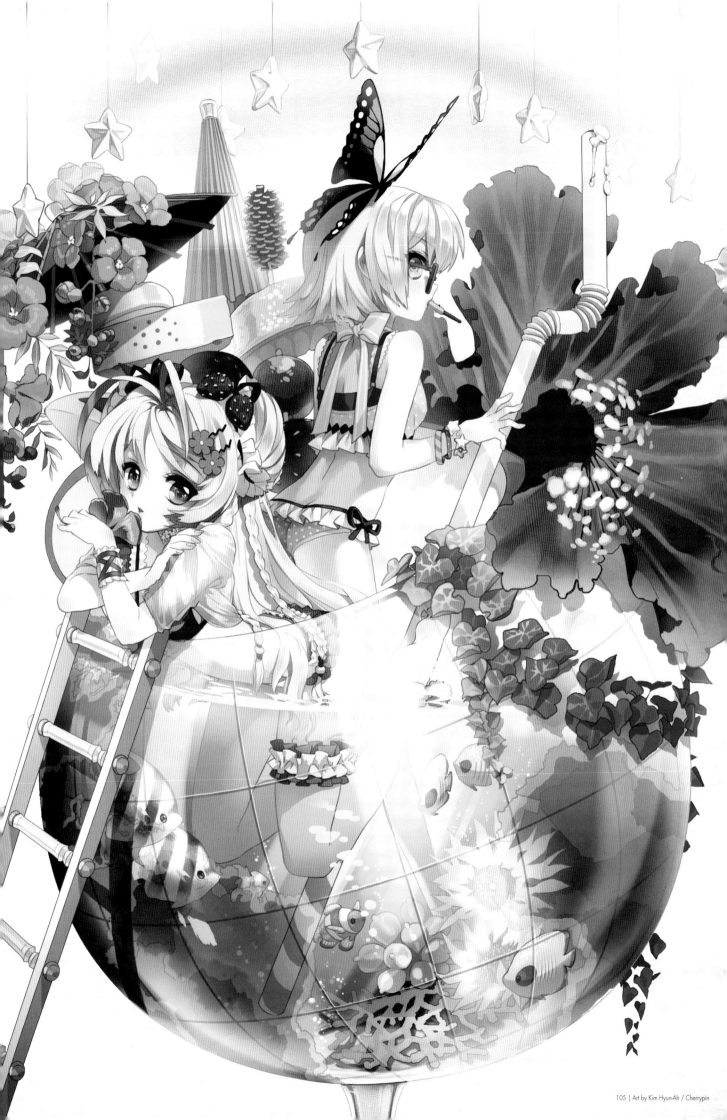

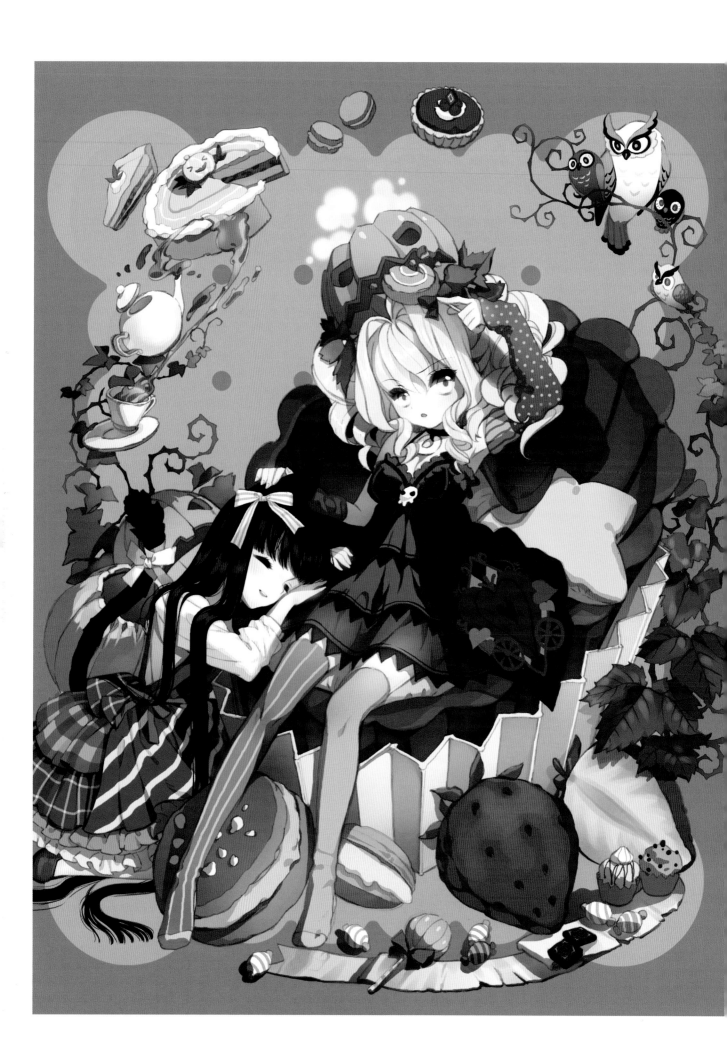

MYSTIQUE

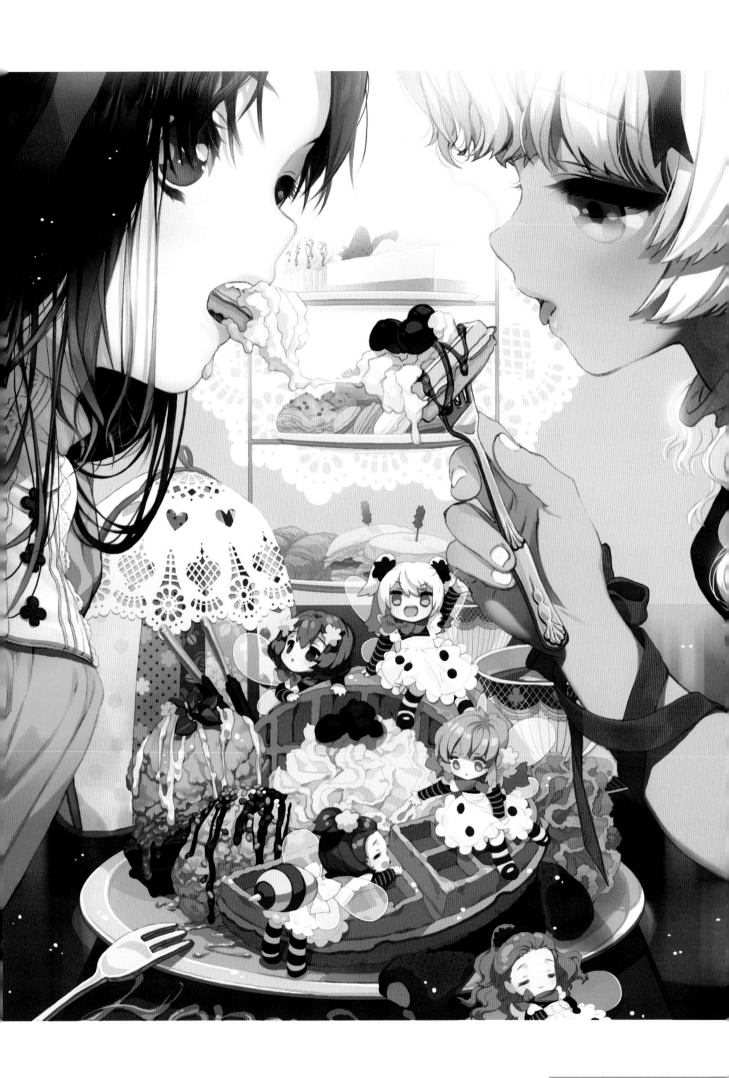

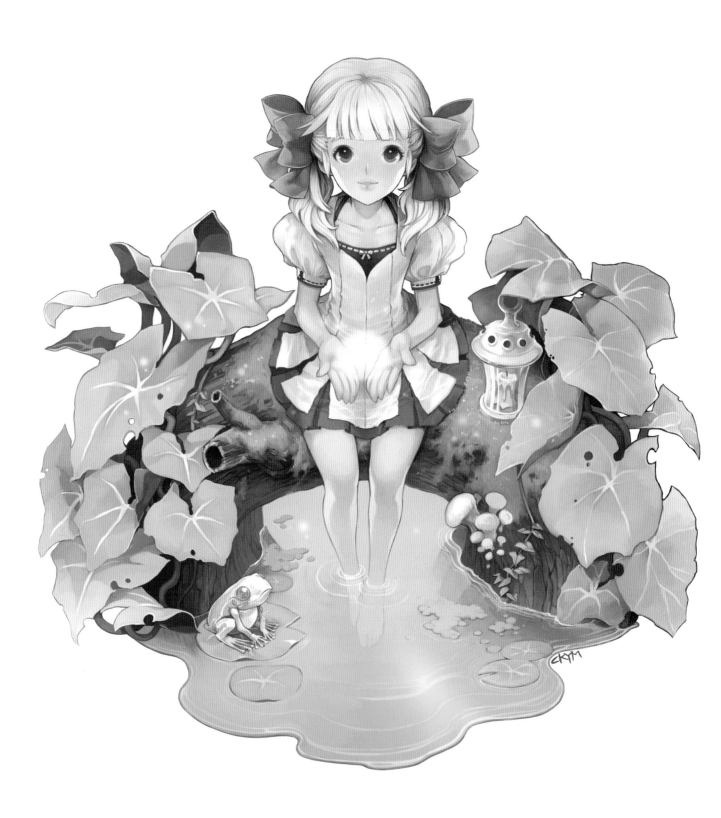

CKYM

Nickname: Cheukuyomi
Real Name: Choi Yoon-Jung
Website: http://chku.x-y.net
E-mail: chkuyomi@naver.com
Circle Name: CINC
Main Credits:
2004.07-2009.04 - Nexon original concepts/illustrations
2009.05 - currently working as a concept artist/illustrator at Nextoric

Comment:
I am CKYM, and I work as a game character concept artist and illustrator. Not CMYK (...).

MYSTIQUE

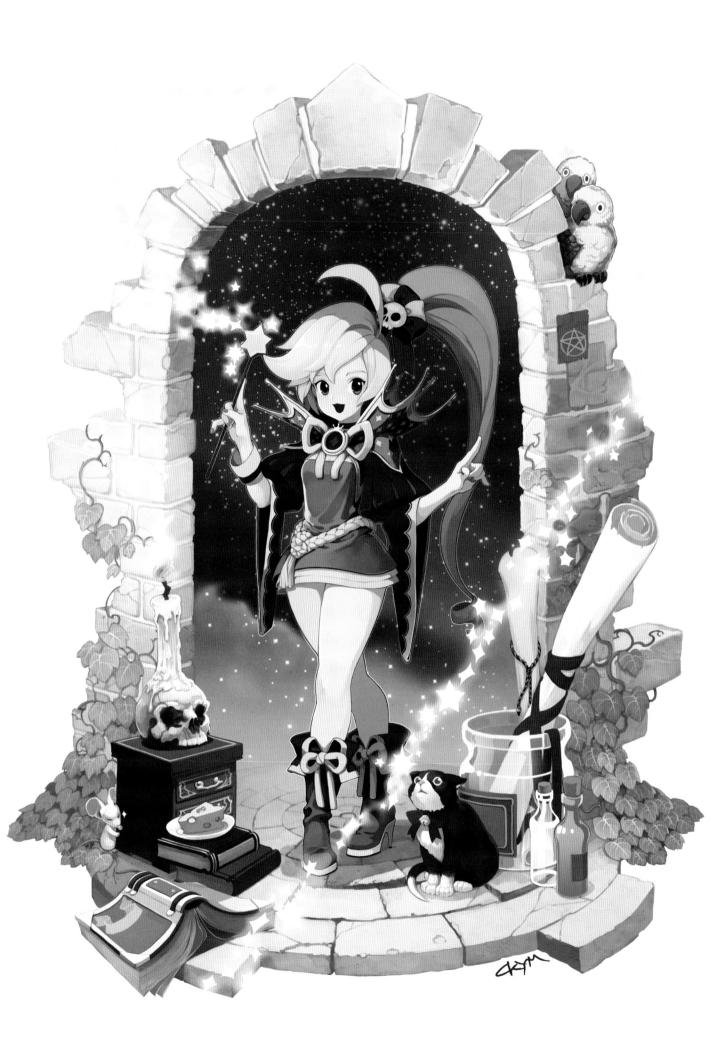

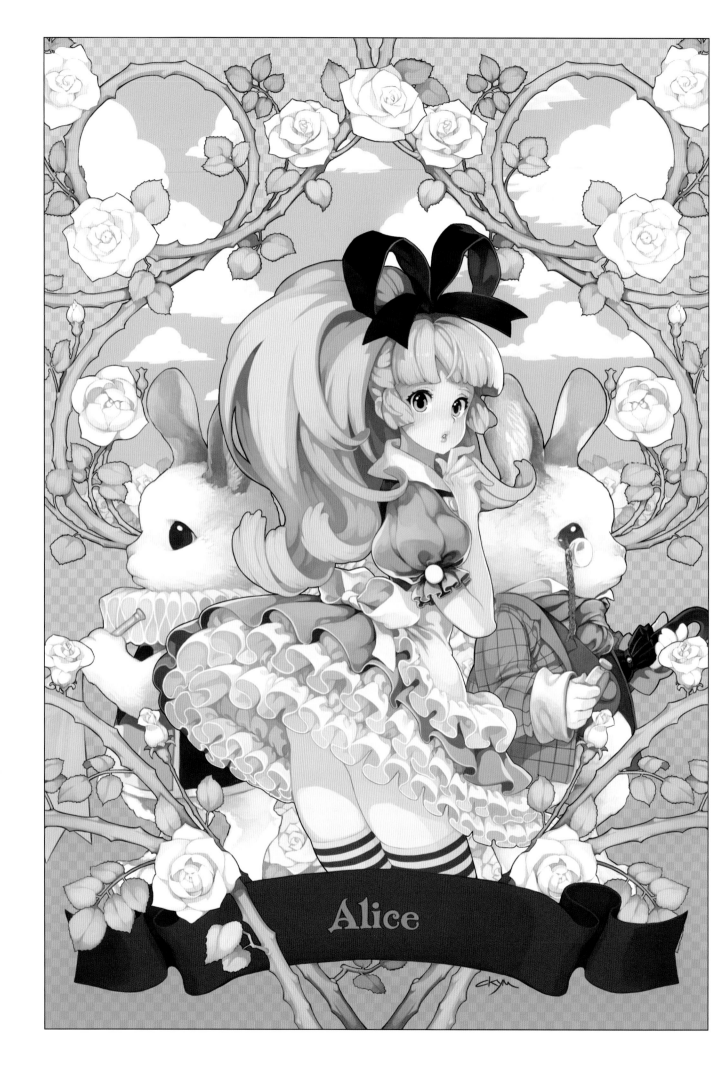

Alice

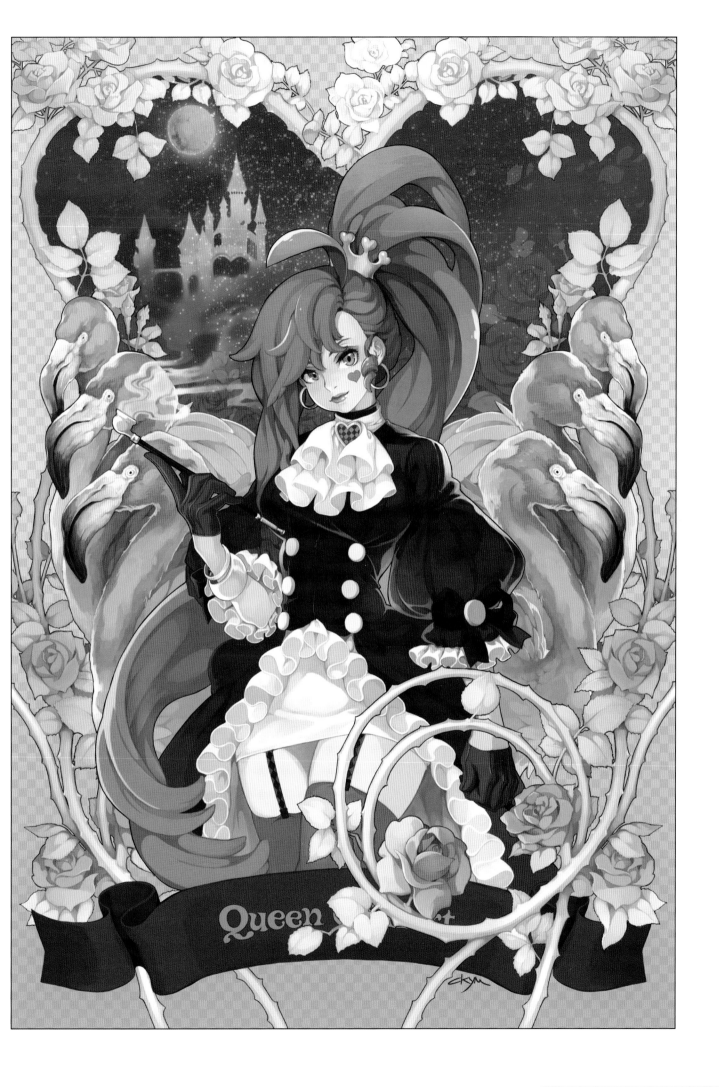

Queen

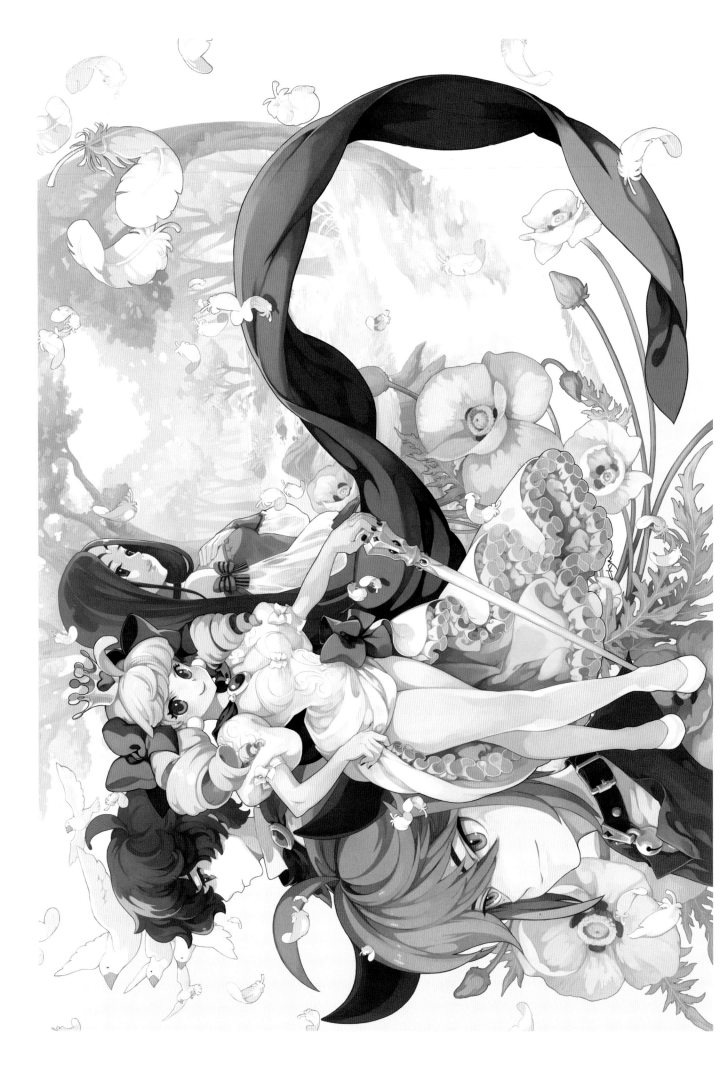

MYSTIQUE

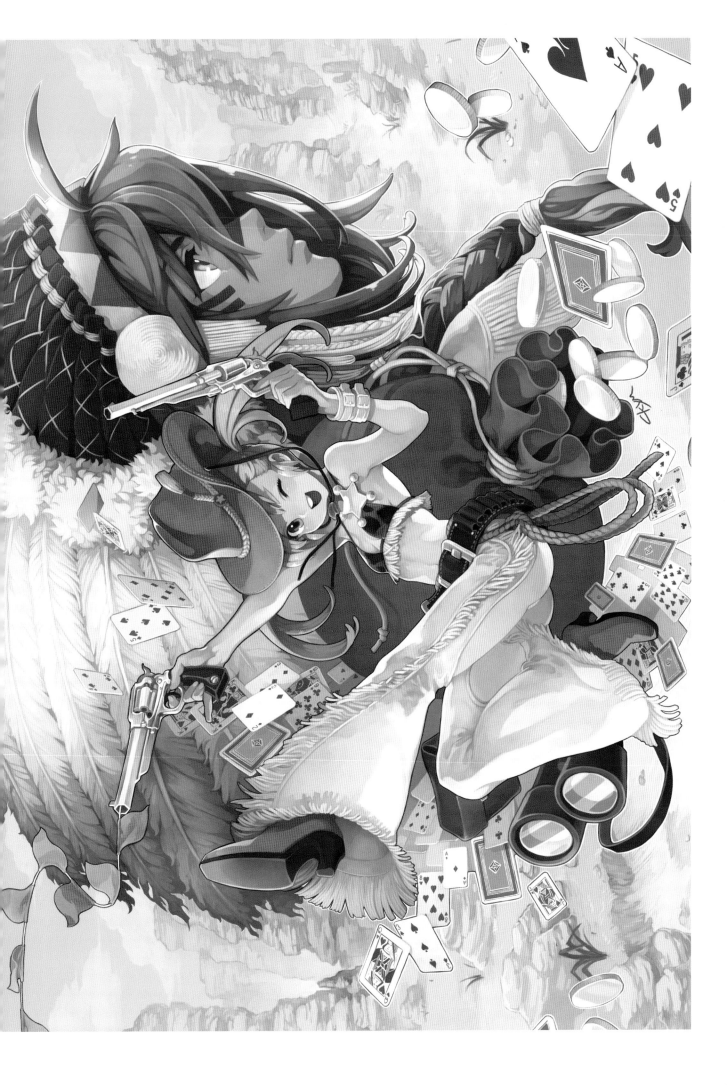

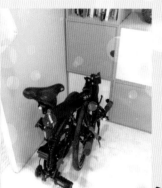

I HAVE BEEN COLLECTING ONE CHARACTER TOY AFTER ANOTHER, AND NOW THEY HAVE CONQUERED MY BED... BUT I STILL WANT TO COLLECT EVEN BIGGER DOLLS!!!! MY CURRENT GOAL IS TO FIND A RILAKKUMA DOLL.

I HAVE RECENTLY BOUGHT (?!) A CHUBBY TAIL TO CARRY AROUND FOR RELAXATION. IT MAKES ME FEEL GOOD TO PLAY WITH CHUBBY, FURRY THINGS.

I LIKE BIKES! (THE PICTURE IS OF LOVELY ORIBIKE -C8 ECO) THIS BIKE IS SMALL, FAST, AND FOLDABLE SO I CAN CARRY IT TO THE SUBWAY IN THE MORNING AND RIDE IT HOME AFTER WORK.

IT IS GREAT FOR RELIEVING WORK-RELATED STRESS! IT FEELS GREAT TO RIDE ON THE BICYCLE ROAD NEAR THE HAN RIVER ON A SUNNY DAY. SOMETIMES I EVEN GO NEAR THE HAN RIVER AT NIGHT AND DRINK A CAN OF BEER~!

2010.10
Juke ♭

· JUKE ·

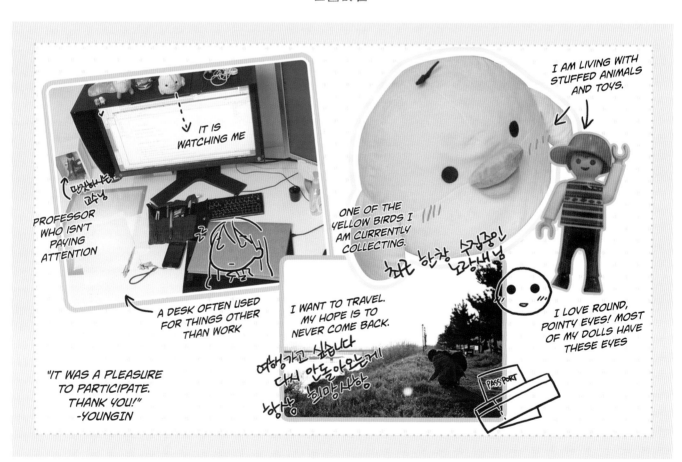

IT IS WATCHING ME

I AM LIVING WITH STUFFED ANIMALS AND TOYS.

PROFESSOR WHO ISN'T PAYING ATTENTION

ONE OF THE YELLOW BIRDS I AM CURRENTLY COLLECTING.

A DESK OFTEN USED FOR THINGS OTHER THAN WORK

I WANT TO TRAVEL. MY HOPE IS TO NEVER COME BACK.

PASS PORT

I LOVE ROUND, POINTY EYES! MOST OF MY DOLLS HAVE THESE EYES

"IT WAS A PLEASURE TO PARTICIPATE. THANK YOU!" -YOUNGIN

· YOUNGIN ·

MYSTIQUE

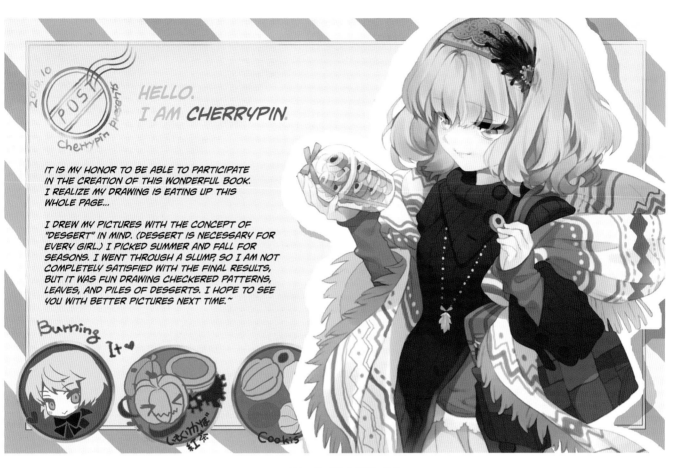

2019. 10 POST
Cherrypin Presents

HELLO.
I AM CHERRYPIN.

IT IS MY HONOR TO BE ABLE TO PARTICIPATE IN THE CREATION OF THIS WONDERFUL BOOK. I REALIZE MY DRAWING IS EATING UP THIS WHOLE PAGE...

I DREW MY PICTURES WITH THE CONCEPT OF "DESSERT" IN MIND. (DESSERT IS NECESSARY FOR EVERY GIRL.) I PICKED SUMMER AND FALL FOR SEASONS. I WENT THROUGH A SLUMP, SO I AM NOT COMPLETELY SATISFIED WITH THE FINAL RESULTS, BUT IT WAS FUN DRAWING CHECKERED PATTERNS, LEAVES, AND PILES OF DESSERTS. I HOPE TO SEE YOU WITH BETTER PICTURES NEXT TIME.~

Burning It♥

Cookis

· CHERRYPIN ·

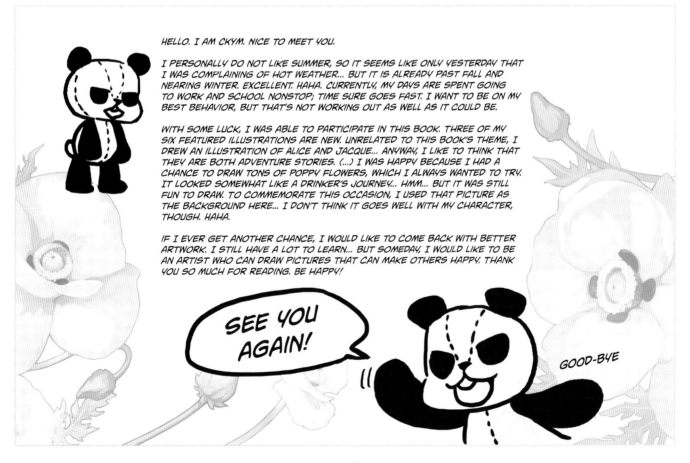

HELLO. I AM CKYM. NICE TO MEET YOU.

I PERSONALLY DO NOT LIKE SUMMER, SO IT SEEMS LIKE ONLY YESTERDAY THAT I WAS COMPLAINING OF HOT WEATHER... BUT IT IS ALREADY PAST FALL AND NEARING WINTER. EXCELLENT. HAHA. CURRENTLY, MY DAYS ARE SPENT GOING TO WORK AND SCHOOL NONSTOP; TIME SURE GOES FAST. I WANT TO BE ON MY BEST BEHAVIOR, BUT THAT'S NOT WORKING OUT AS WELL AS IT COULD BE.

WITH SOME LUCK, I WAS ABLE TO PARTICIPATE IN THIS BOOK. THREE OF MY SIX FEATURED ILLUSTRATIONS ARE NEW. UNRELATED TO THIS BOOK'S THEME, I DREW AN ILLUSTRATION OF ALICE AND JACQUE... ANYWAY, I LIKE TO THINK THAT THEY ARE BOTH ADVENTURE STORIES. (...) I WAS HAPPY BECAUSE I HAD A CHANCE TO DRAW TONS OF POPPY FLOWERS, WHICH I ALWAYS WANTED TO TRY. IT LOOKED SOMEWHAT LIKE A DRINKER'S JOURNEY... HMM... BUT IT WAS STILL FUN TO DRAW. TO COMMEMORATE THIS OCCASION, I USED THAT PICTURE AS THE BACKGROUND HERE... I DON'T THINK IT GOES WELL WITH MY CHARACTER, THOUGH. HAHA.

IF I EVER GET ANOTHER CHANCE, I WOULD LIKE TO COME BACK WITH BETTER ARTWORK. I STILL HAVE A LOT TO LEARN... BUT SOMEDAY, I WOULD LIKE TO BE AN ARTIST WHO CAN DRAW PICTURES THAT CAN MAKE OTHERS HAPPY. THANK YOU SO MUCH FOR READING. BE HAPPY!

SEE YOU AGAIN!

GOOD-BYE

· CKYM ·

BITTERSWEET

Nickname: Bittersweet
Real Name: You Eun-Young
Website: http://bittersweet.blog.me
E-mail: bittersweet@naver.com

Comment:
Game concept artist, 20-something years old, loves small cute things, female, office worker.

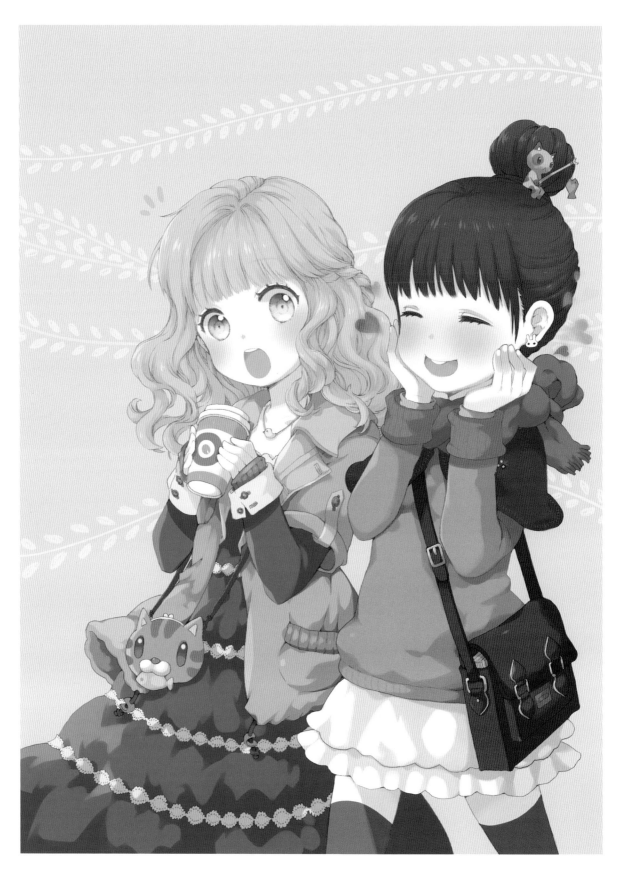

MYSTIQUE

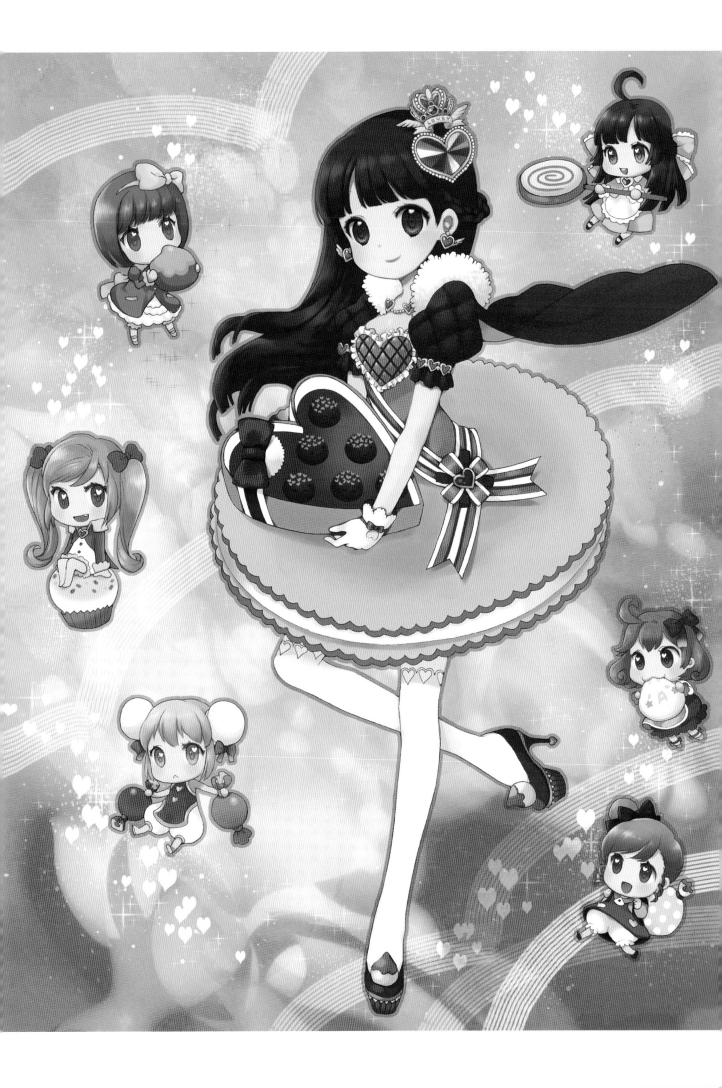

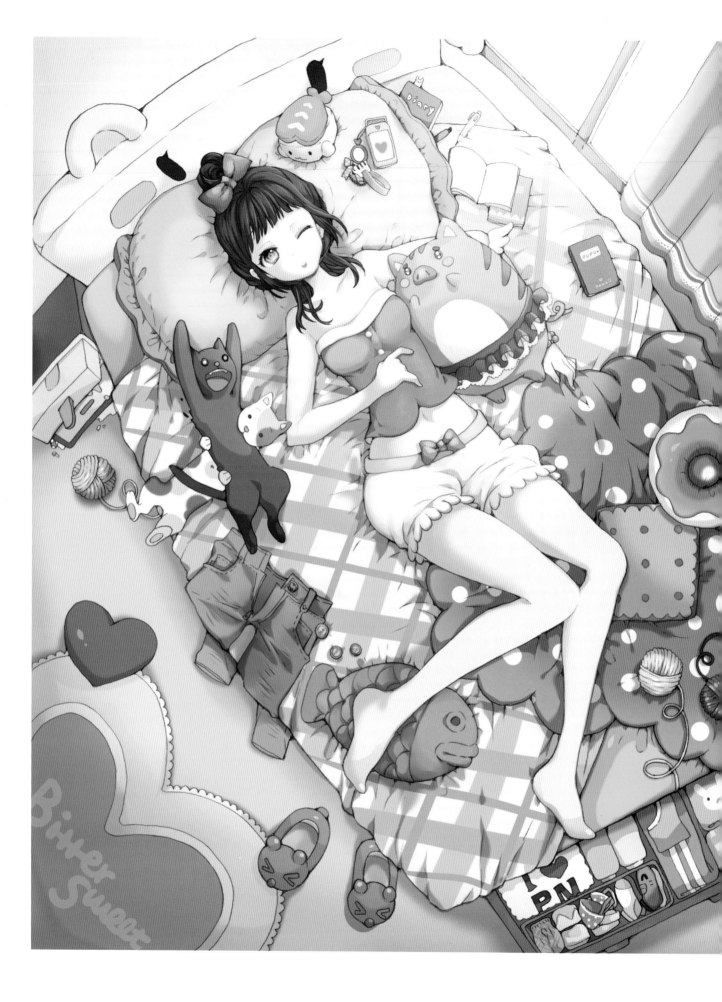

MYSTIQUE

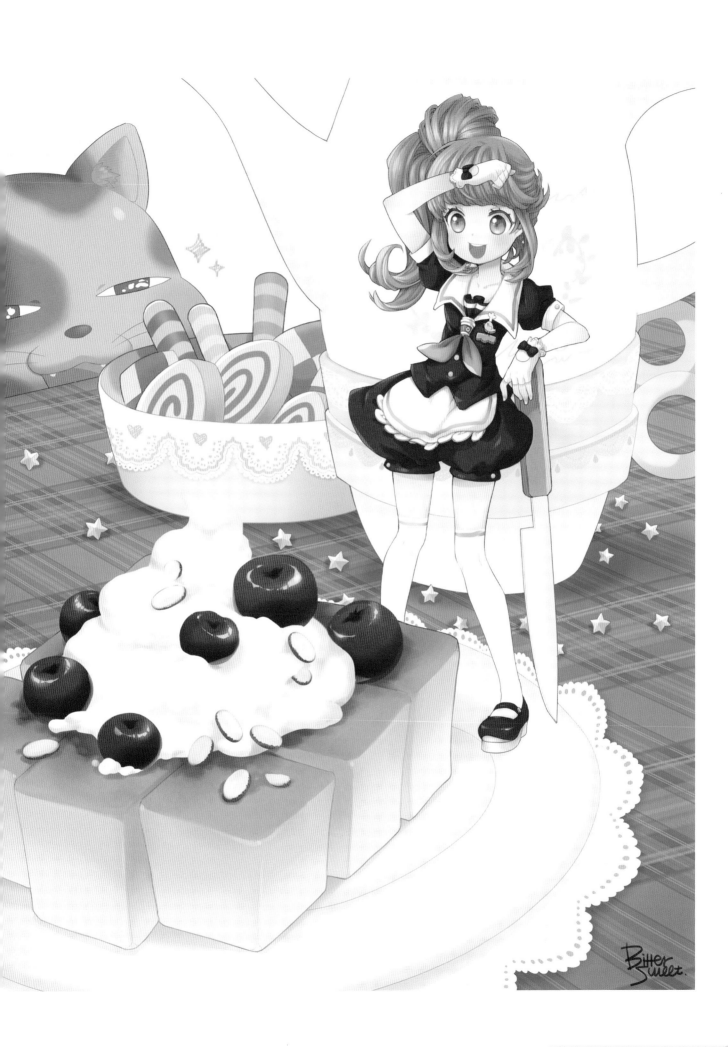

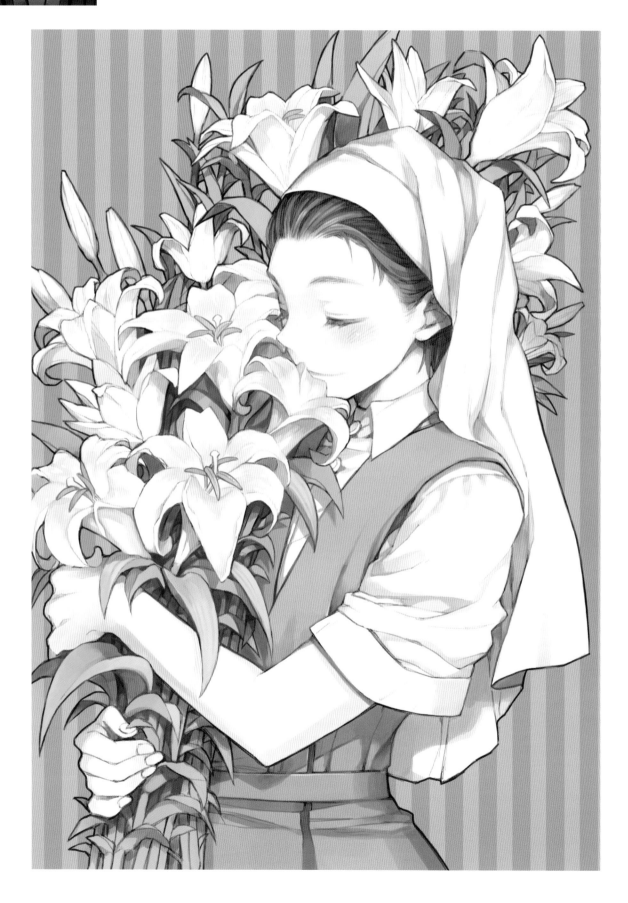

RUSSEL

Nickname: Russel
E-mail: yumeriku@paran.com
Main Credits: Concept artist

MYSTIQUE

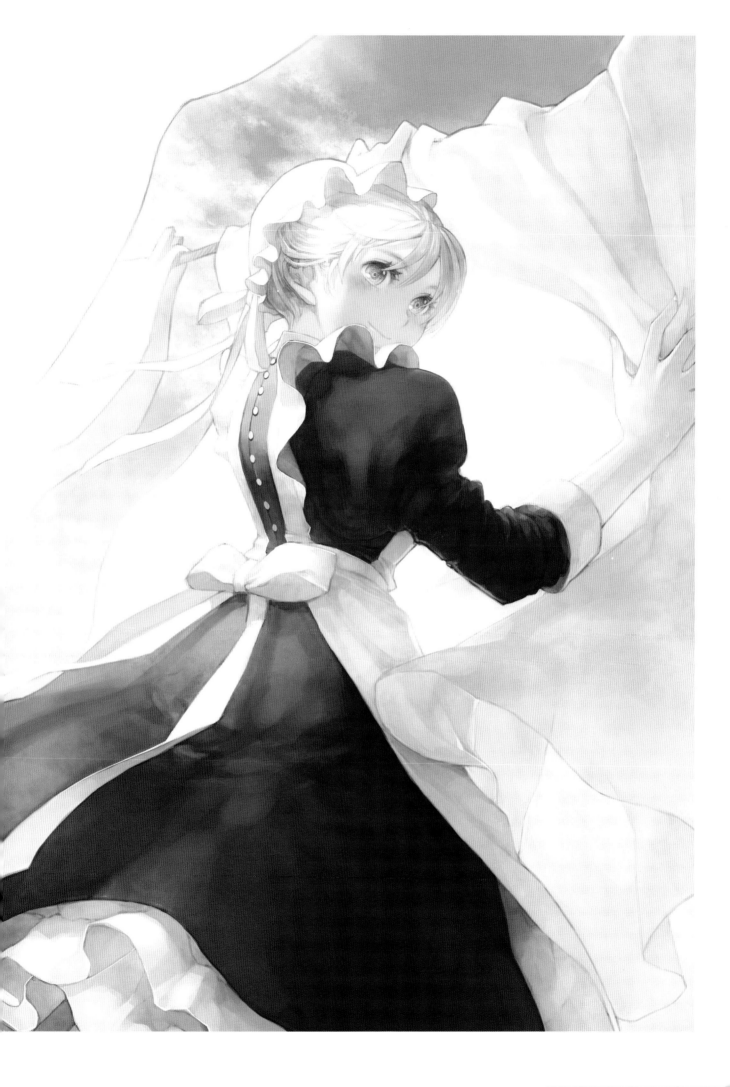

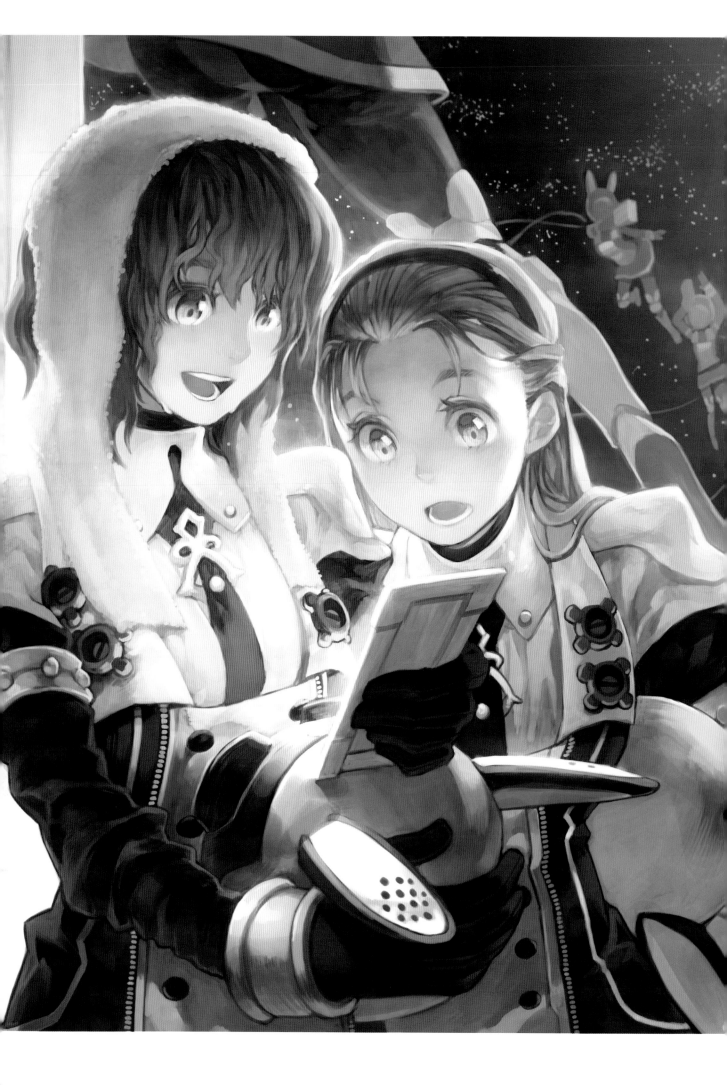

MYSTIQUE

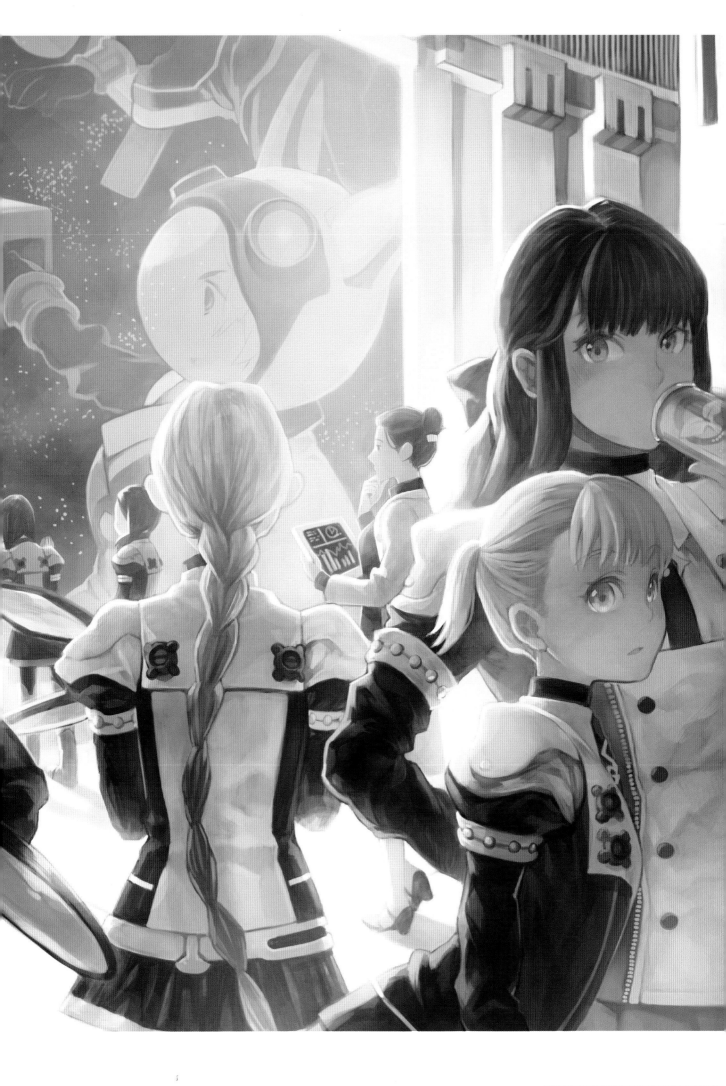

NYANYA

Nickname: Nyanya
Website: http://nyanya.egloos.com
E-mail: nyanyaling@gmail.com
Circle Name: Cat hot spring
Main Credits:
Ntreev Soft; Pang-Ya team concept artist & illustrator

Comment:
I am an office worker who sometimes publishes art books.

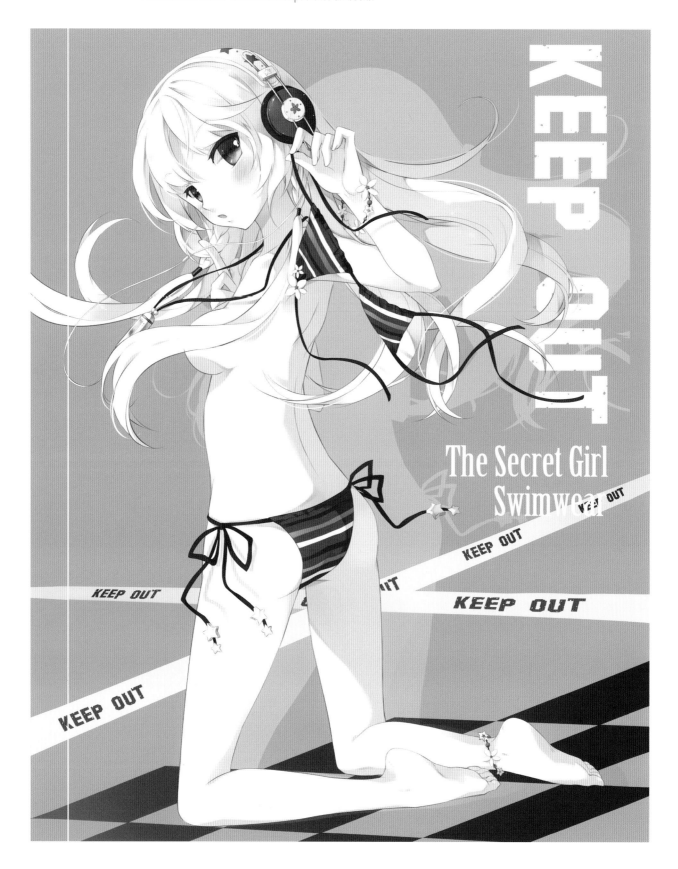

MYSTIQUE

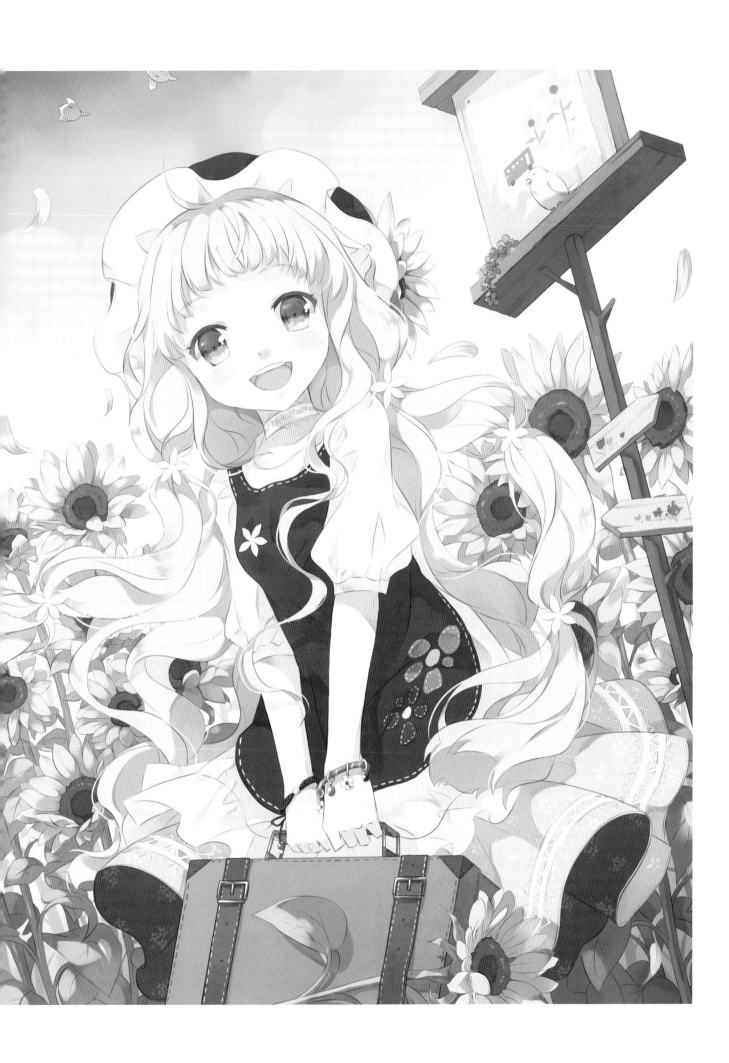

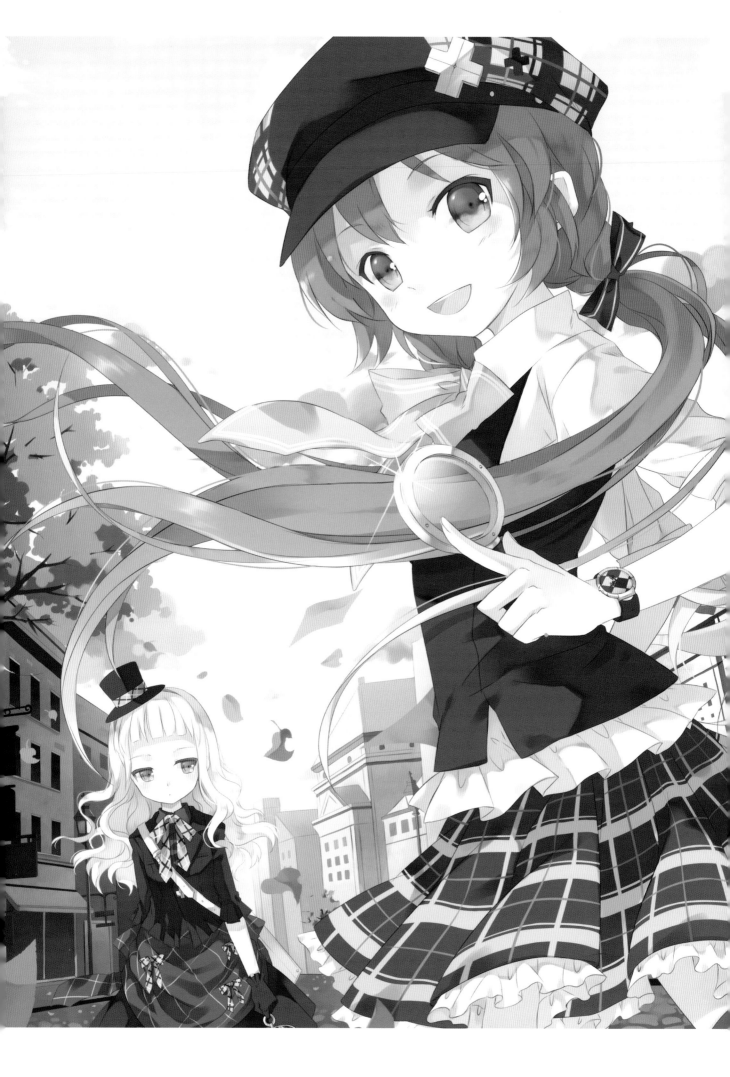

MYSTIQUE

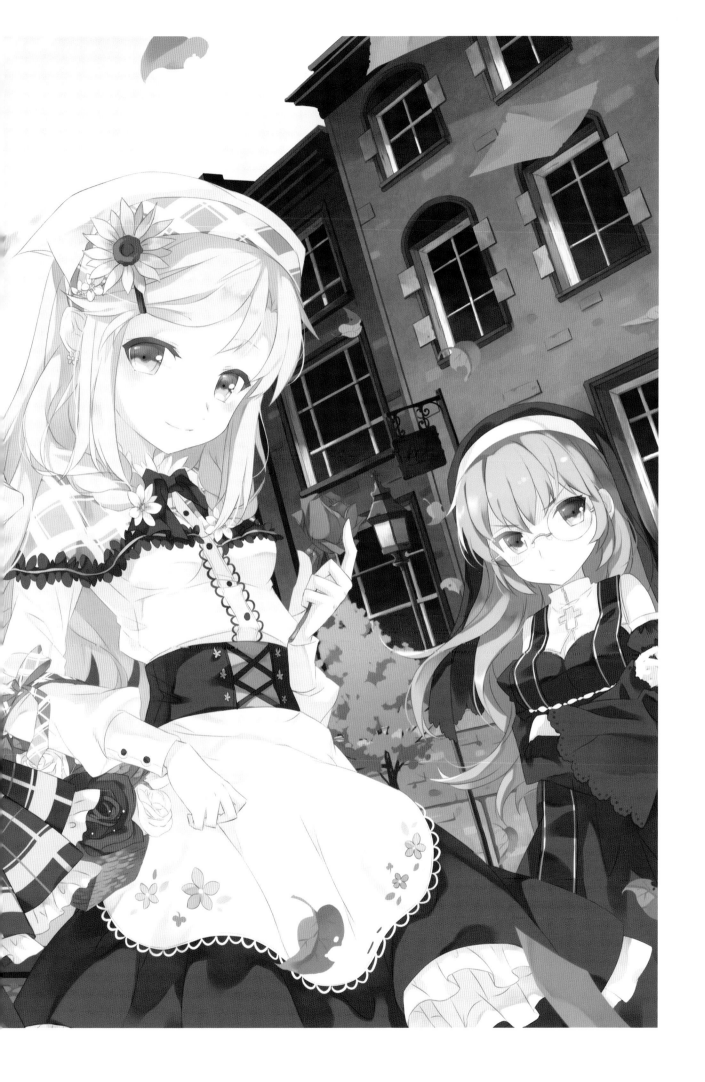

GWAYOM

Nickname: Gwayom
Real Name: Jo Eun-Hye
Website: http://omyo.mireene.com

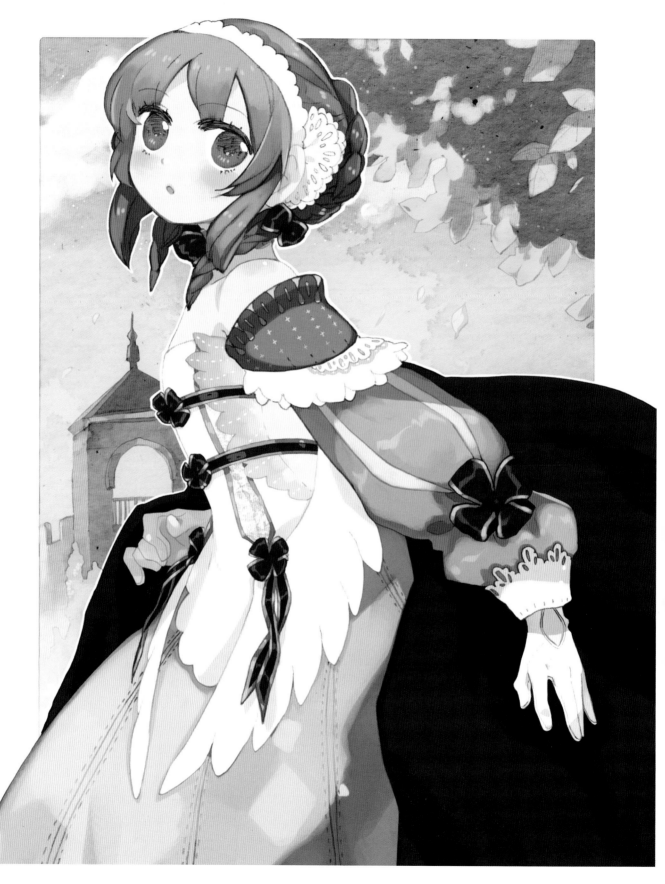

MYSTIQUE

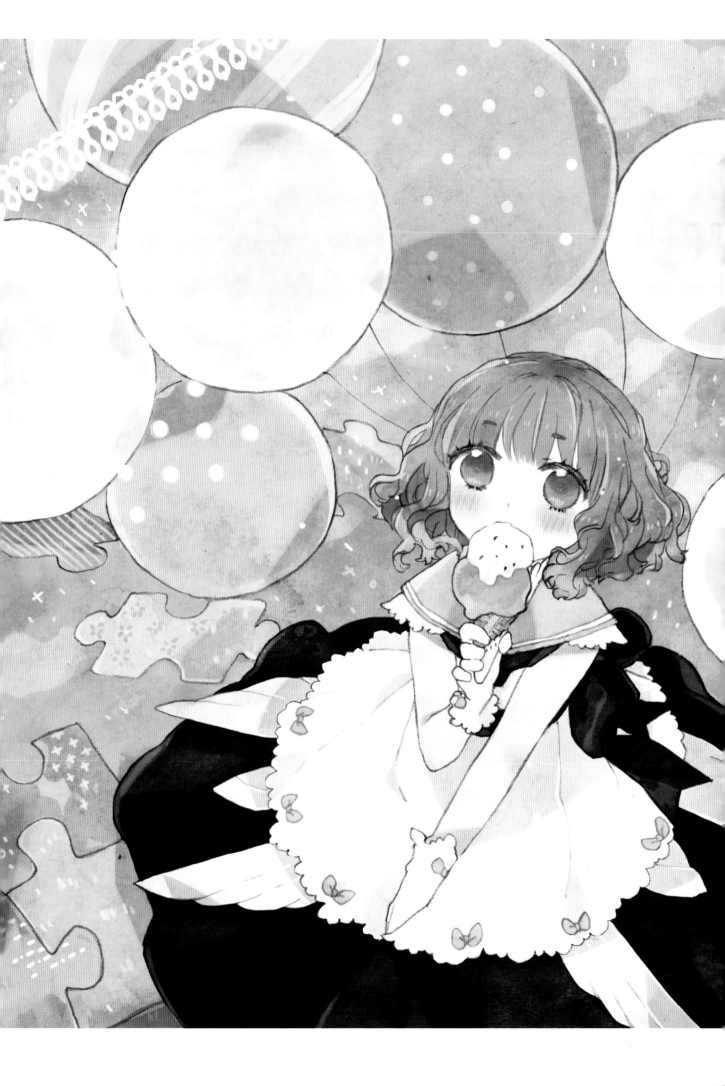

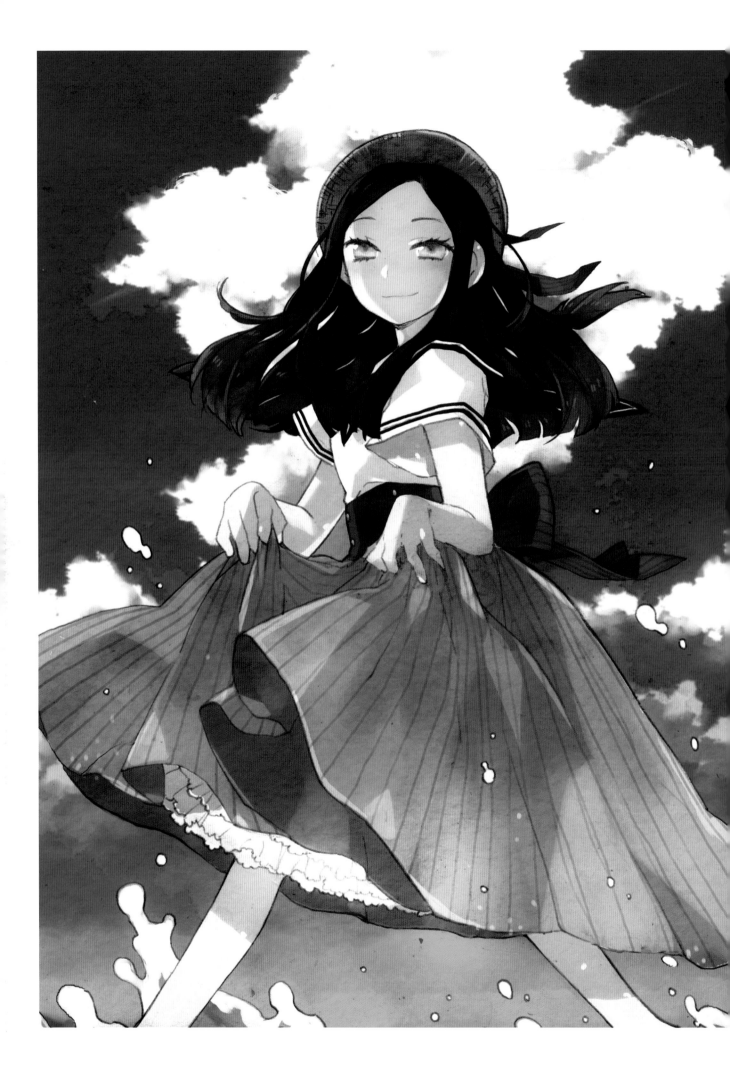

MYSTIQUE

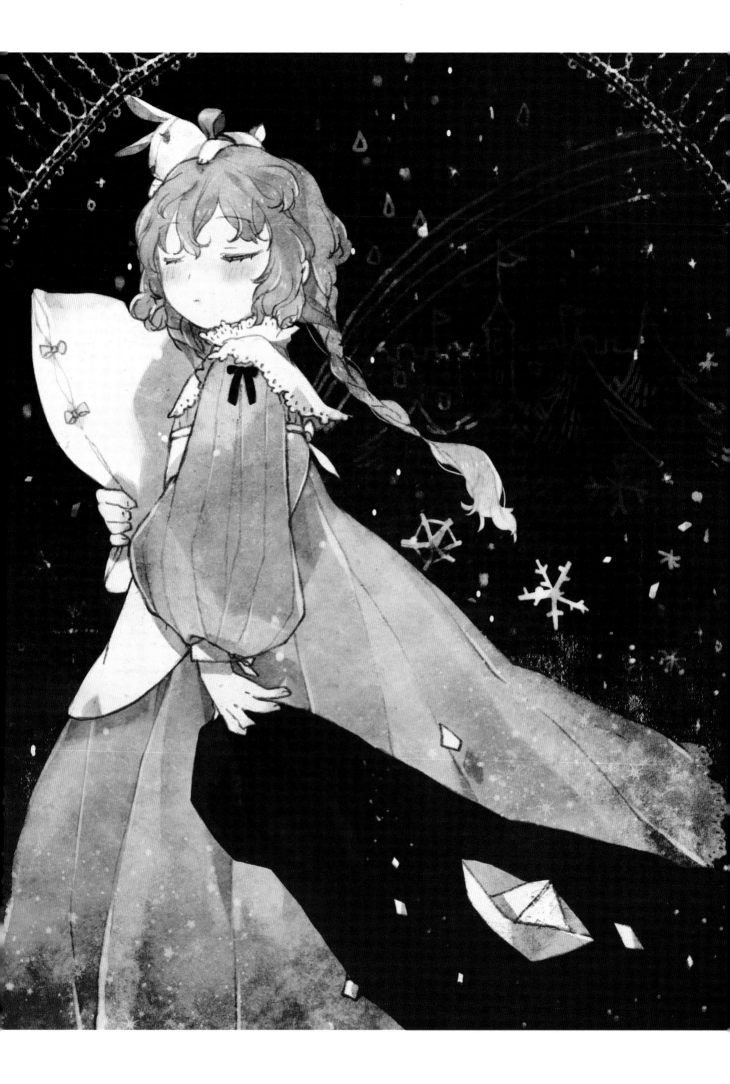

From. BitterSweet

HELLO!
I DIDN'T KNOW WHAT TO WRITE IN THIS BIG SPACE, SO I STARTED WITH PULLING OUT SOME OLD ARTWORK TO FILL IT. BUT EVEN AFTER ADDING THE PICTURES, THERE IS STILL SO MUCH SPACE LEFT!
THE ONLY TIME I EMBELLISH IS WHEN I WRITE IN MY DIARY, SO WHEN GIVEN SUCH A BIG, EMPTY PAGE TO FILL, MY MIND GOES BLANK.

FIRSTLY, I STARTED TO DECORATE WITH BLOG SKIN DESIGN. ONCE I FINISH SOME OF MY PRIORITY PIECES, I WOULD LIKE TO MAKE A FRESH START. ~
BY THAT, I MEAN THAT AFTER THIS FRESH START, THE ONLY PLACE I WOULD GET TO SEE MY OLD ILLUSTRATIONS IS THIS BOOK. +_+

NOWADAYS, I AM COMPLETELY INTO WRITING UTENSILS AND DOODLING. I AM ALSO INTERESTED IN FOUNTAIN PENS.

I WANTED TO DRAW SOMETHING WITH MY FOUNTAIN PEN ON THIS PAGE, BUT AS A NOVICE, IT IS HARD TO CONTROL THE PEN. I WANT TO GET USED TO IT SOON AND TRY DRAWING WITH IT.

AS THE WORLD BECOMES MORE DIGITALIZED, I SEEM TO FIND MYSELF ATTRACTED TO OLD-FASHIONED THINGS. I WANT MY ARTWORK TO HAVE THAT OLD-FASHIONED FEELING AS WELL, SO I WILL PRACTICE DIFFERENT METHODS OF DRAWING WITH THAT "ROMANTIC VINTAGE" CONCEPT IN MIND~.

THE WORLD IS BIG AND THERE ARE SO MANY THINGS TO LEARN AND TRY.
I WANT TO BECOME A PERSON WHO TRIES MANY NEW THINGS, WITHOUT LOSING MY IDENTITY. ;)

THANK YOU TO EVERYONE WHO PURCHASED THIS BOOK!

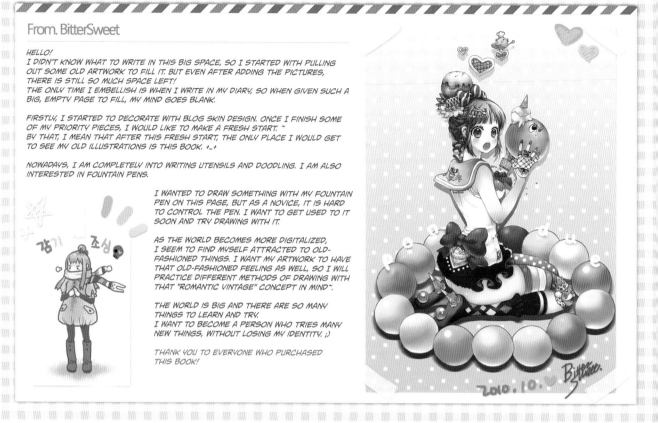

2010. 10.

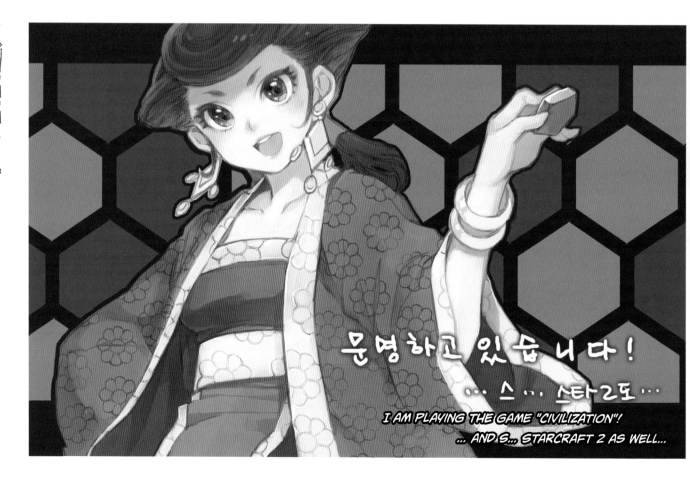

문명하고 있습니다!
··· 스··· 스타2도···
I AM PLAYING THE GAME "CIVILIZATION"!
... AND S... STARCRAFT 2 AS WELL...

MYSTIQUE

ROUGH DRAFT-!

ORIGINAL CHARACTER PLAN (HAHA)

I DREW THE ORIGINAL STORY CHARACTERS AS PART OF MY HOBBY (I'M A STREET ILLUSTRATOR, AFTER ALL). I TRIED TO KEEP THE TIMEFRAME CONSTANT AND ACCURATE, BUT AS I CONTINUED TO ADD ALL THE THINGS I LIKE, THE TIME PERIOD BECAME MORE AND MORE UNINTELLIGIBLE... SO I DECIDED TO CALL IT A FANTASY WORLD. (...) WHATEVER I SAY GOES, HAHA. HOORAY FOR PARALLEL WORLDS!

I HAVE BEEN SO BUSY WITH OFFICE WORK AND EVENT PLANNING THAT I JUST RECENTLY OPENED AND STARTED PLAYING THE GAME I BOUGHT ALMOST A YEAR AGO. O<-< THE TITLE IS "VETERAN WARRIOR"! THE SERIES WAS SO GREAT THAT I BOUGHT IT WITH HIGH EXPECTATIONS, BUT NEVER HAD THE TIME TO PLAY UNTIL NOW; SORRY MITSURUGI!! IT'S A GREAT WAY TO SPEND TIME ON THE WAY TO WORK AND ON THE WAY HOME. MITSURUGI LOOKS HOT WHEN HE'S WALKING. CUTE! I USUALLY END UP PLAYING AFTER EVERYONE ELSE HAS ALREADY FINISHED THE GAME...
OTL

JUST RECENTLY (OR WAS IT A FEW MONTHS AGO?), I FOUND A NEW CULTURAL HOBBY IN THE MUSICAL "THE BALLERINA WHO LOVED B-BOY". FOR THOSE WHO HAVE NOT SEEN THIS MUSICAL, THE ENCORE SHOW IS THE ORIGINAL SHOW, SO PLEASE GO WATCH IT.

BELOW IS THE F1 EXHIBITION CURRENTLY BEING HELD AT THE SEOUL ARTS CENTRE. I KNOW I DON'T LOOK LIKE IT, BUT I DO ENJOY CARS. I MISS SAPO.

I WANTED TO MAKE A HOME PAGE, SO I CHECKED OUT NYANYA.COM AND NYANYA.NET, BUT BOTH ARE ALREADY IN USE!! (I THOUGHT THIS MIGHT HAPPEN.) SO I ENDED UP BUYING NYANYA.KR, BUT I'M NOT SURE WHEN I WILL GET TO FINISH MAKING MY HOME PAGE. HAHA. I MADE A HOME PAGE ONCE BEFORE... BUT I CAN'T REMEMBER HOW TO DO IT ANYMORE. O<-< I AM DOING IT BIT BY BIT, AND SOMEDAY I MIGHT... NO, I MUST FINISH IT!

P.S. I SHOULD ALSO BE GOING TO CAT CAFÉ
P.P.S. I REALLY ENJOYED THE ILLUSTRATION WORK. >_<

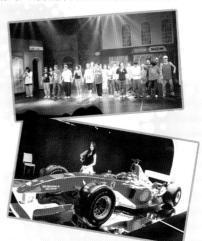

NYANYA

HELLO? I AM GWAYOM.

NOWADAYS MY HOBBY IS TO COLLECT PRETTY POST-ITS AND SMALL DOLLS. I CAN NEVER USE THEM, THOUGH, BECAUSE THEY ARE TOO PRETTY! JUST LOOKING AT THE DUCK AND THE FROG I PUT IN THE "AFTERTHOUGHT" SECTION MAKES ME PROUD.

IN A MOVIE I SAW RECENTLY, I NOTICED COLORFUL WALLPAPER THAT REMINDED ME OF AN AUTUMN FOREST. PERHAPS THAT WAS WHAT INSPIRED ME TO USE THE SEASONAL CONCEPT. I WANTED TO EXPRESS THE BEAUTY OF DIFFERENT SEASONS, AND I HOPE YOU LIKED IT~. I WAS ALSO HAPPY TO GET THE CHANCE TO DRAW LOTS OF LACES AND DRESSES!

GWAYOM

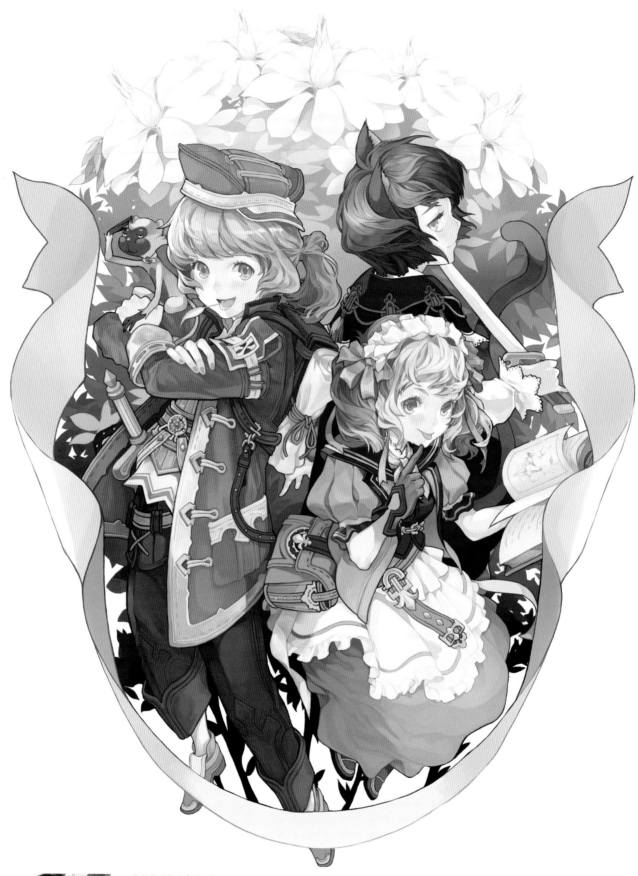

SERENADE

Nickname: Serenade
Website: http://sinohi.egloos.com
E-mail: hinoka00@naver.com
Circle Name: SERENADE
Main Credits:
Developing MMORPG Lime Odyssey

Comment:
I focus on character concept design and illustration works.

MYSTIQUE

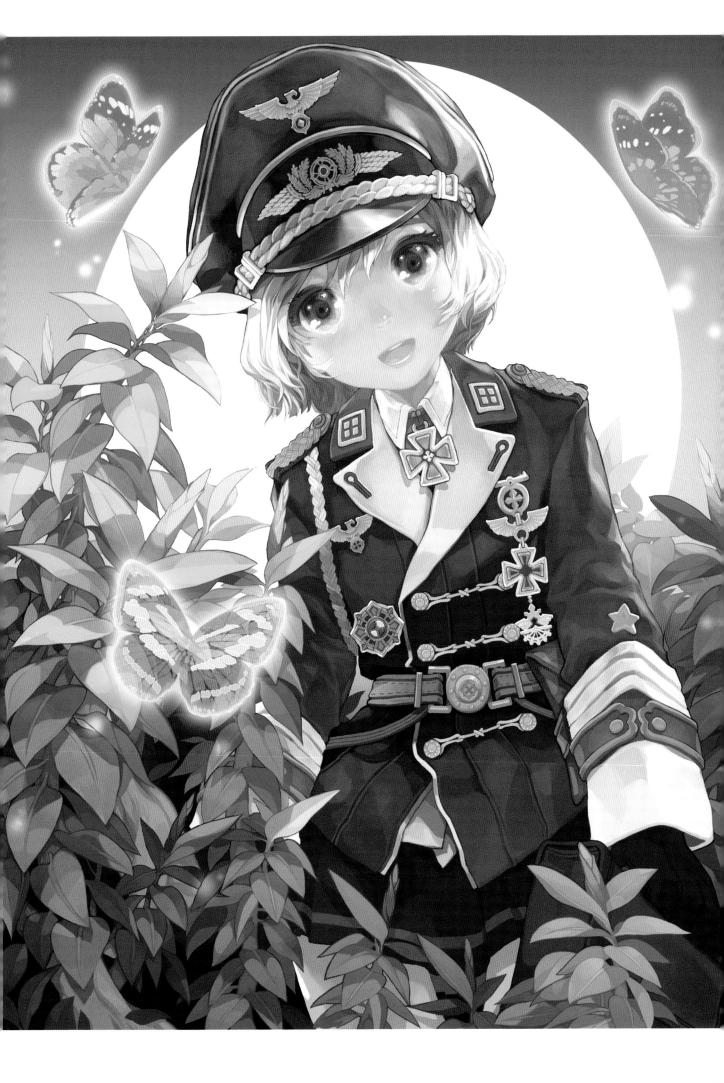

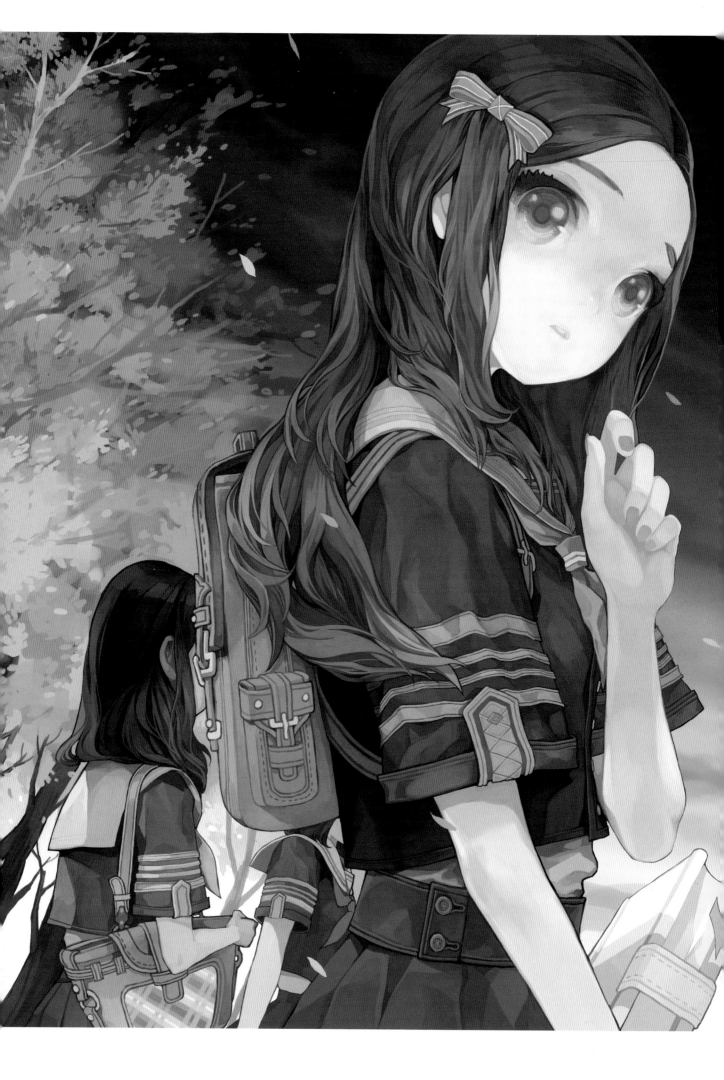

MYSTIQUE

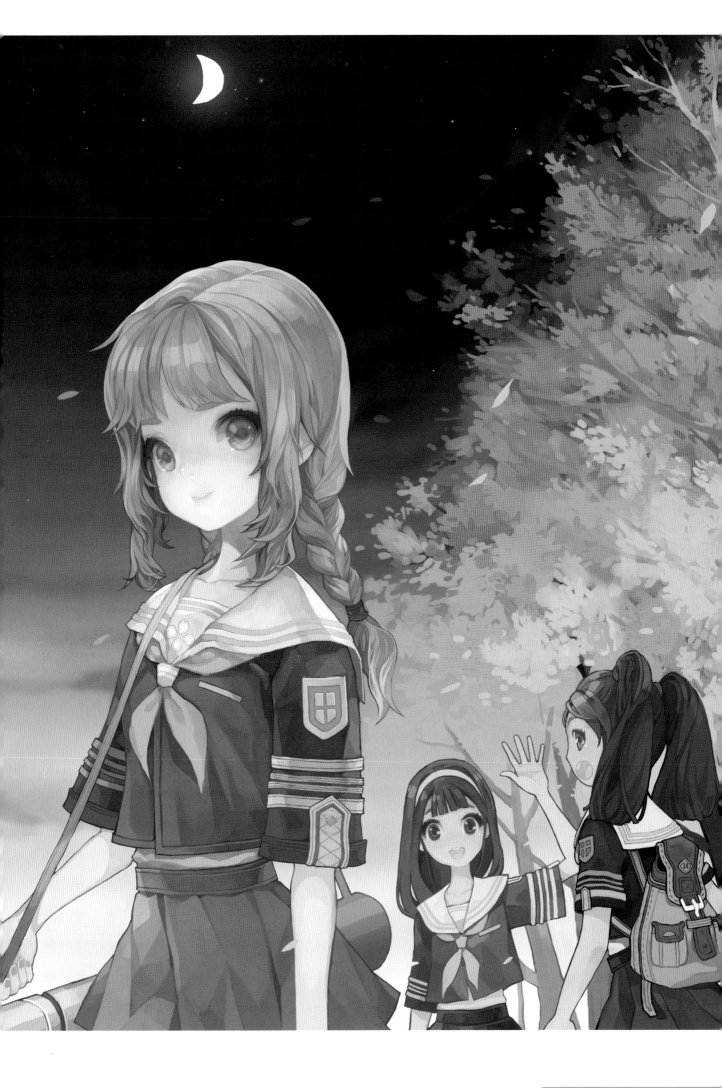

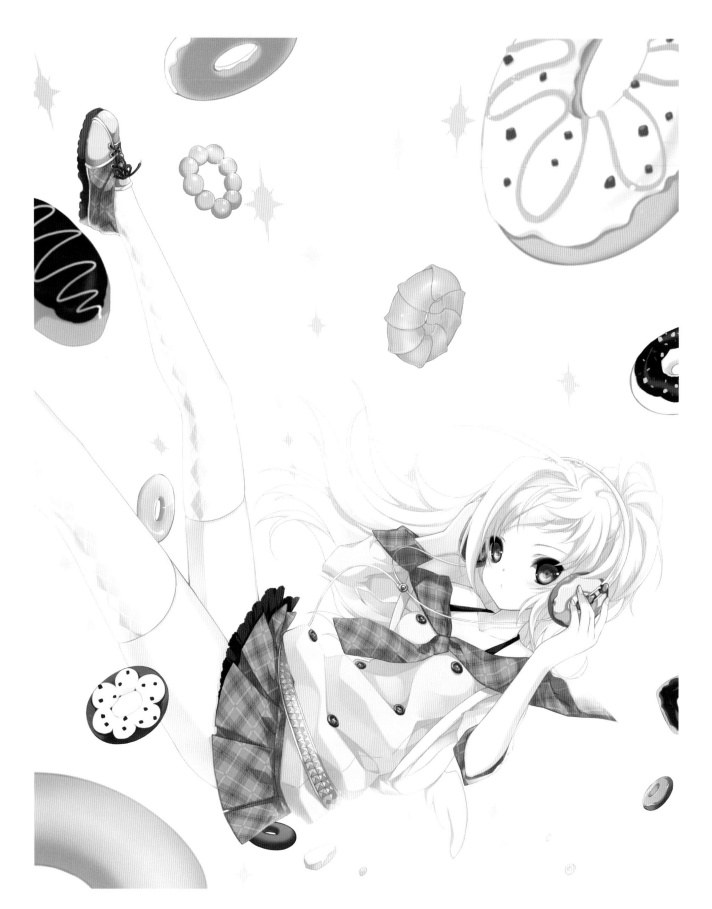

JUNA

Nickname: Juna
Website: http://juna.nazon.net
E-mail: k-juna@hotmail.com
Circle Name: SUGAR RING

Comment:
I have been a freelancer for four years. I am a butler who takes care of the prettiest cat in the world.

MYSTIQUE

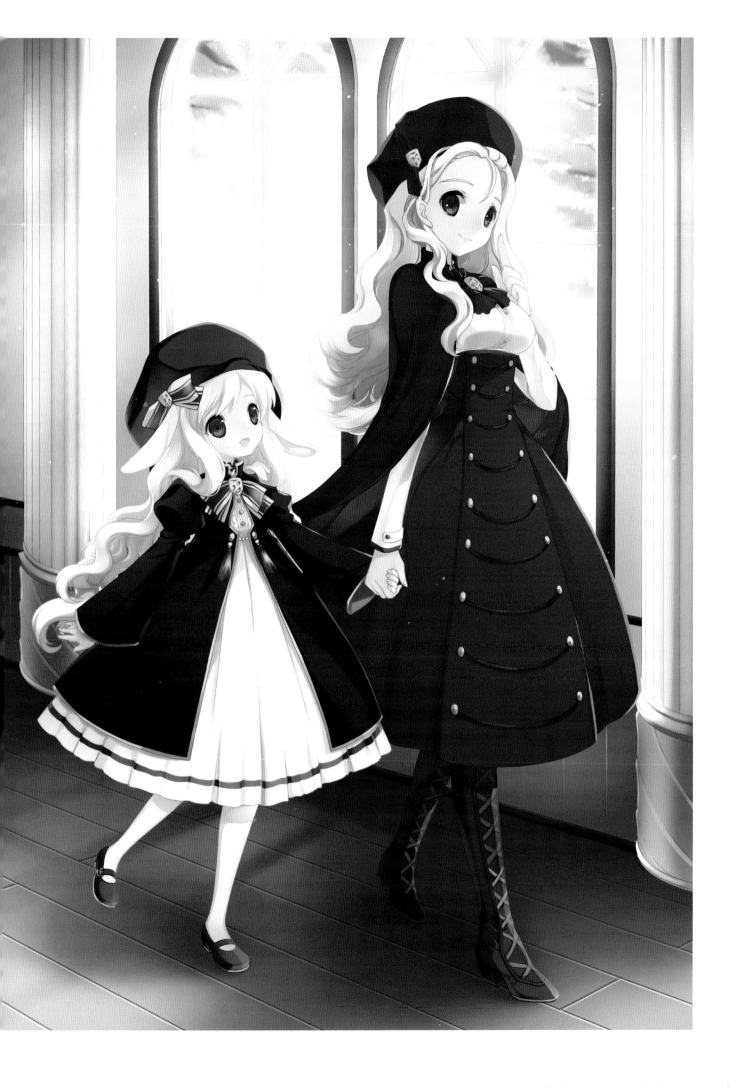

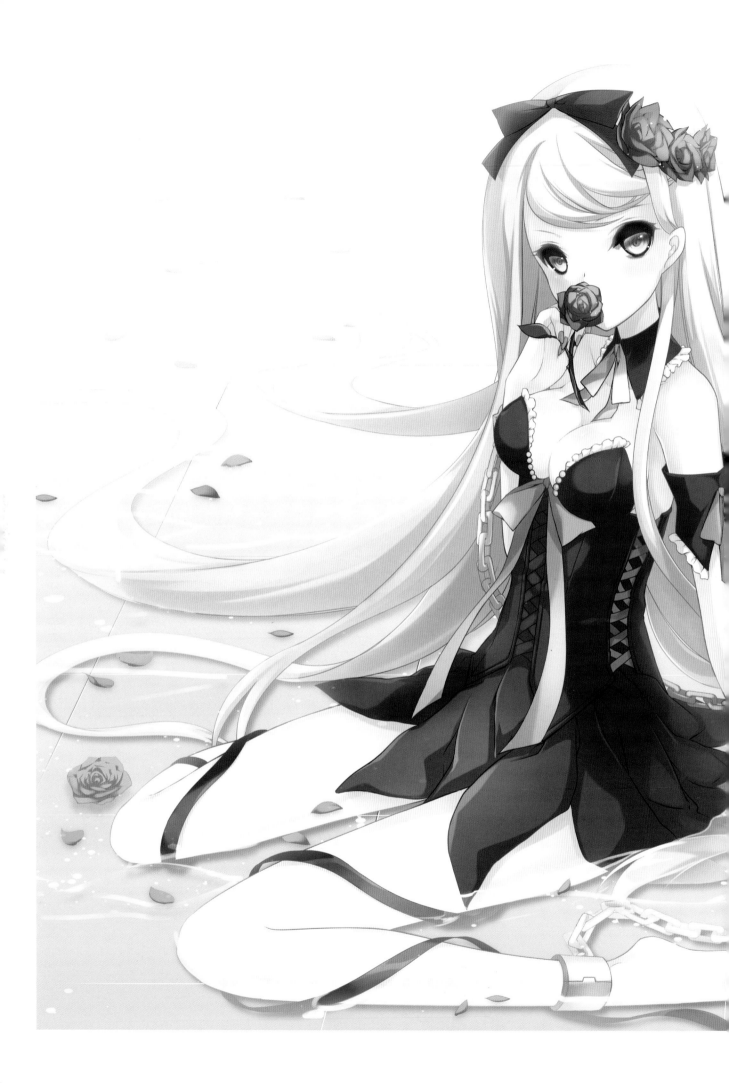

MYSTIQUE

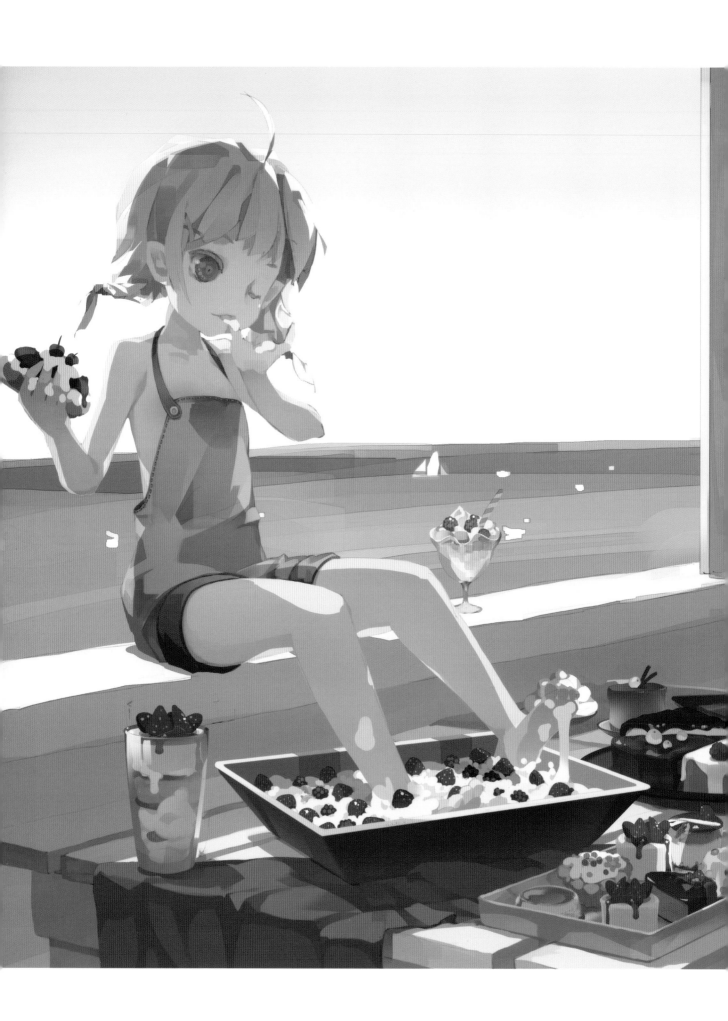

MYSTIQUE

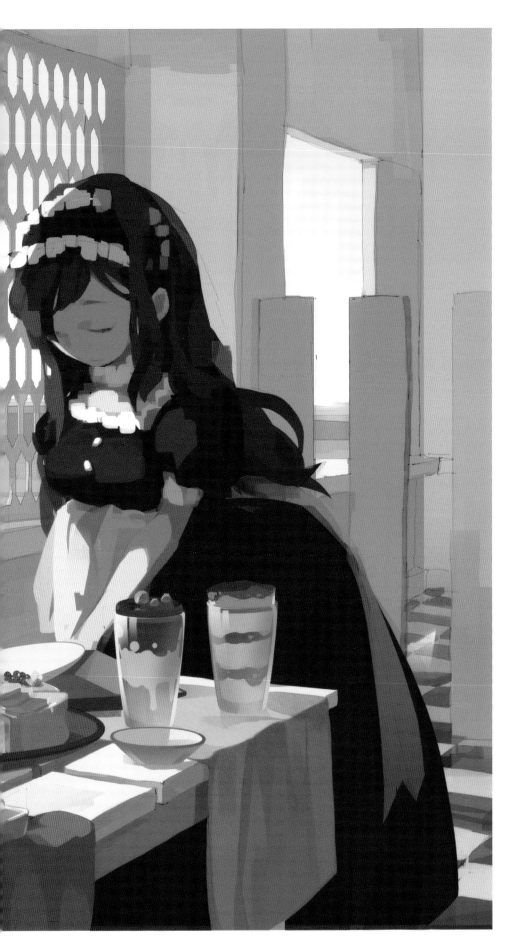

TAKO ASHIN

Nickname: Tako Ashin
Real Name: Ahn He-Jin
Website: http://ashingun.com
E-mail: ashingun@hotmail.com
Circle Name: code number
Main Credits:
Lineage 2 official cartoon
DJ MAX background animation
Irregular circle member activity
& game development for 6 years

Comment:
Landed a job at N- company after working
hard as a comic artist, animator, and
student. Currently developing a game.

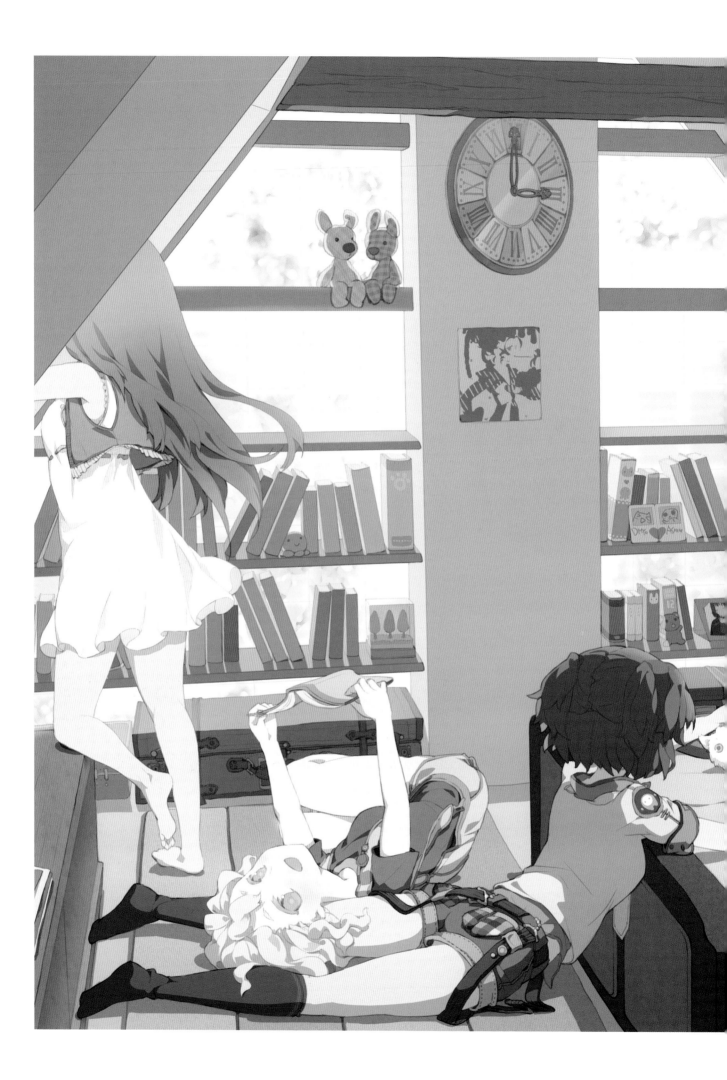

MYSTIQUE

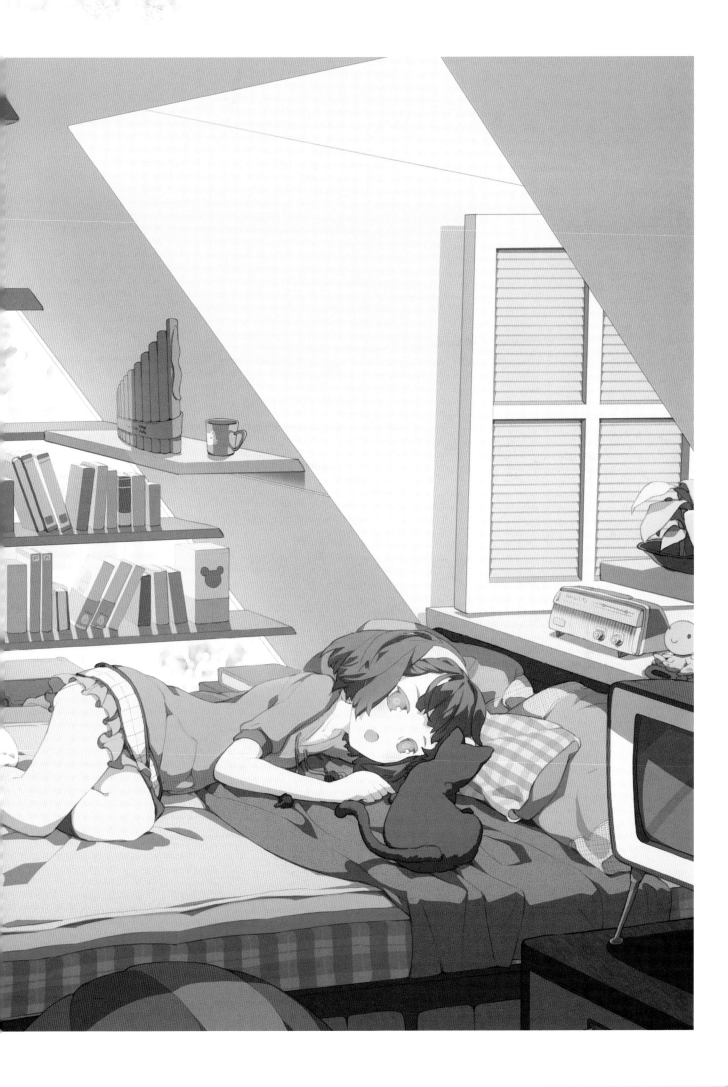

T.A.'s TUTORIAL by Tako Ashin

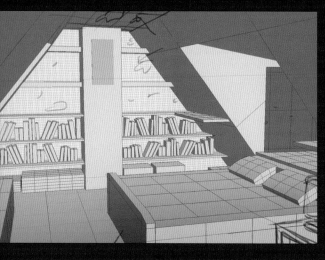

◀ BACKGROUND (3D STUDIO MAX)

Usually I start with the character and draw the background around it, but this time, for good practice, I did a 3D background first, and then added the characters. Anyone who can make a hexahedron on 3ds Max can do this too!

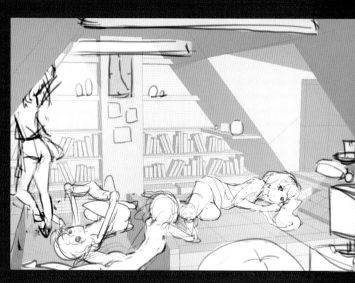

▶ MAKING ROUGH PLAN, SELECTING THEME (ADOBE PHOTOSHOP)

Keeping in mind the usual items you find in a room (while also collecting data), select rough positions for each item. When I decide to use the "school life" theme, I always think of when I was in middle school, around 15 years old, probably because that was when I had no worries, and spending time with friends was my favorite pastime. I've always wanted to try an attic room theme, so that is what I did this time!

Antique clock you hang on the wall

Classic radio by the bed

The pan flute you used to learn and play as a child. I really wanted to draw this.

Elegant wooden sound

Essential stuffed animals

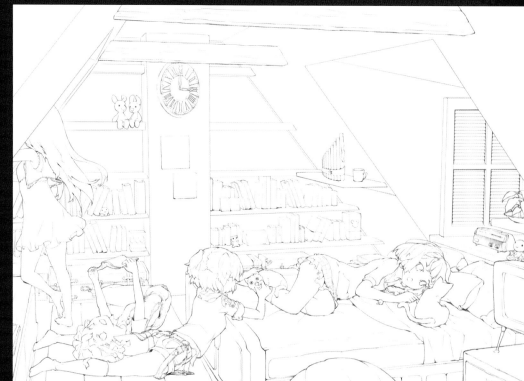

▲ SKETCH (ADOBE PHOTOSHOP)

Because it is in cell diagram format, I decided that color is the most important factor; for the sketch part, my goal was to have uniform, clean lines. At this stage, I worked on the sketch without a detailed rough draft. This part takes the longest.

▲ DETAILS

Adding shadows to your sketches creates clearer forms.

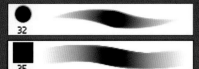

MAIN BRUSHES

Round brush		32
Square brush		35

Select the shape, and then use it with the "Shape Dynamics" and "Other Dynamics" functions turned on. I mostly used the round brush for the girls' attic room, and the square brush for the dessert room. The round brush is easy to use, but it has less of an effect than you would expect, while the square brush is more difficult to use but is better for expressing mass.

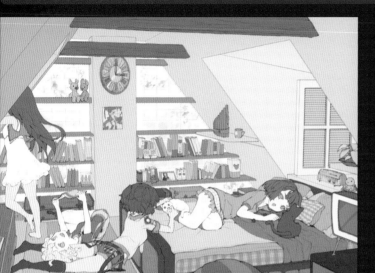

◀ MASKING & SELECTING COLOR

This is the stage where you define different color areas and select colors. My goal was to choose colors that provide calmness and warmth. (But the result turned out to be even calmer than I expected, so perhaps I should have used more vivid colors...)

I don't believe that there is one right color for anything. I always try to feel for it, and find the color that suits the picture! With the cell diagram format, it is easy to change colors; and I work on a computer, which also makes things easier and more convenient! Even if you choose to diffuse color, you cannot preserve that color to the end. Perhaps after adding ambient color... You have to check often.

Recycling previous picture Affectionate gesture Self-realization

◀ SHADOW

This stage is where you designate the objects' ambience. This time I drew in one layer as a bundle. I kept the direction of light in mind when drawing. As a personal preference, I didn't add in too many details.

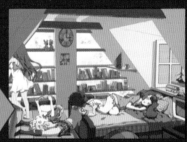

▲ When working on shadows, I usually use the square brush with stroke pressure turned off.

◀ On top of the picture with selected colors, place as multilayer and confirm.

◀ SHADOW COLOR

The colors from the previous stage look too simple, so now I find and add the appropriate ambience to each color. The skin colors are especially important, so I'm very detailed with them.~

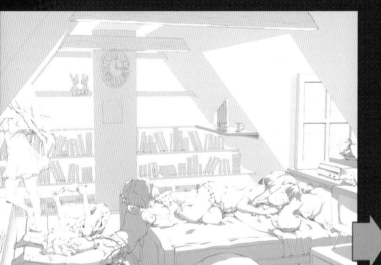

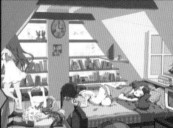

▲ **HUE/SATURATION**
This is convenient when changing finely detailed colors.~

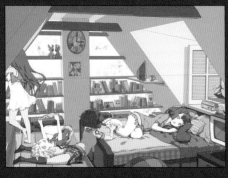 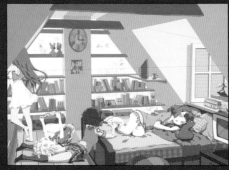 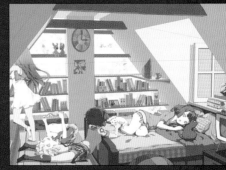

▲ FINISHING

This stage is about organizing the space. An environment color can be applied to the areas behind objects to emphasize those objects in the foreground. Initially, the goal is to have strong contrasts and details. As you get to the end, however, those details become lighter, etc... Finally, in the last stage, all the intricate layers come together as one, and the final touches and edits are made.

 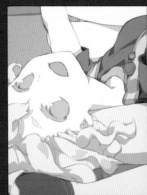

▲ Just changing the color of the line makes a big difference.

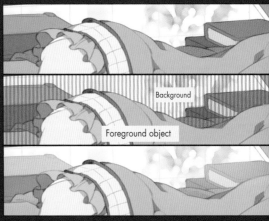

Background

Foreground object

▲ Adding environment color to the back of the object.

◀ TEXTURE

Overlays are being used passively to express texture.

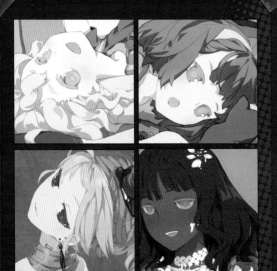

This much? More....? Too much...

When drawing faces, I like to draw them without noses (and I never put nostrils...). Even when drawing profiles, I usually draw noses relatively flat.

AFTERTHOUGHT

I wasn't trying to give a tutorial... this was more of a description of the different stages I go through when I work. I tried to make it look nice. It wasn't about "How you should draw!" but rather "How I draw."

ashingun@hotmail.com
http://ashingun.com

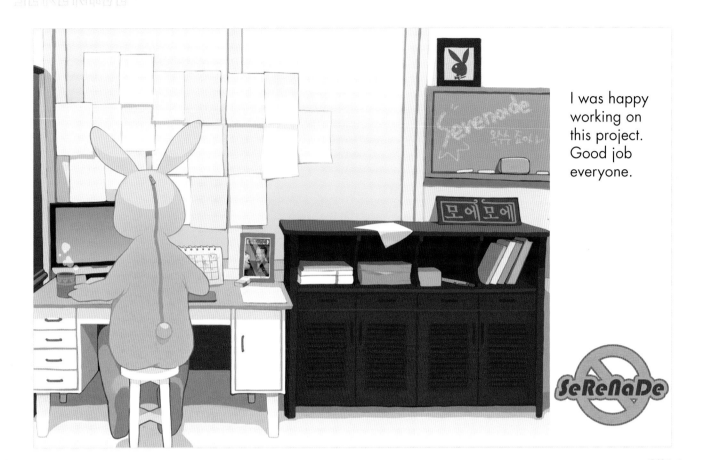

I was happy working on this project. Good job everyone.

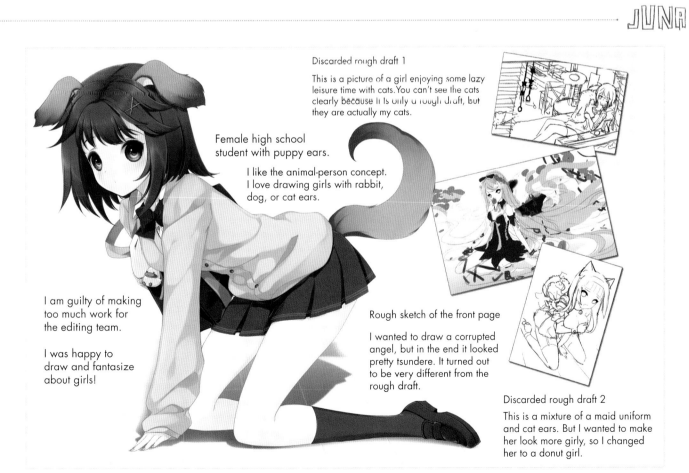

Discarded rough draft 1

This is a picture of a girl enjoying some lazy leisure time with cats. You can't see the cats clearly because it is only a rough draft, but they are actually my cats.

Female high school student with puppy ears.

I like the animal-person concept. I love drawing girls with rabbit, dog, or cat ears.

I am guilty of making too much work for the editing team.

I was happy to draw and fantasize about girls!

Rough sketch of the front page

I wanted to draw a corrupted angel, but in the end it looked pretty tsundere. It turned out to be very different from the rough draft.

Discarded rough draft 2

This is a mixture of a maid uniform and cat ears. But I wanted to make her look more girly, so I changed her to a donut girl.

152-155　　HAYEON / 하연

황하연 / Hwang Ha-yeon

156-157　　Susansijang / 수산시장

이윤숙 / Lee Yun-suk
Actoz Soft 'Latail' character original picture
WinnerWon Soft background original picture

158　　ming / 민지

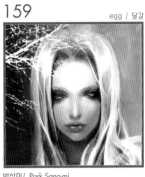

이민지 / Lee Min-ji
International Color Design contest winner
DaeGu environment character design, etc.

159　　egg / 달걀

박상미/ Park Sang-mi

160　　fillsupply / 일필무적

김명성/ Kim Hyeong Seong
Game concept artist & illustrator

161　　Apecs / 에이펙스

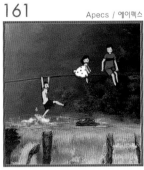

김진실/ Kim Jin-sil

162-163　　Diesel / 디젤

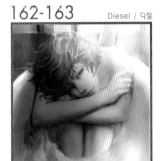

김동혁/ Kim Dong-hyuk
AniPark

164-165　　Almondu / 아몬드

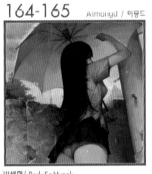

박세혁/ Park Se-Hyeok

166-167　　iinsa / 진사

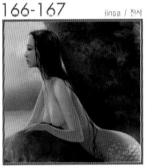

황지영/ Hwang Ji-young

168-169　　clubhada / 클럽이다

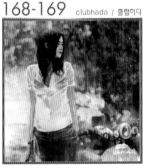

신용/ Shin Yong
Seoul Art University advertisement creation course graduate
Unimation Korea (Inc.) Contents production team leader

170-171　　ddae park / 때박

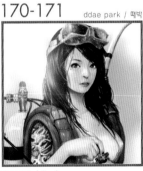

박대훈/ Park Dae-hun

172-173　　Kiru / 키루

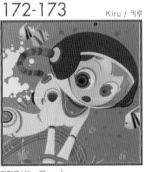

김창규/ Kim Chang-kyu
Myat Entertainment
Guns2 team background concept designs

174-175　　inzup / 인접

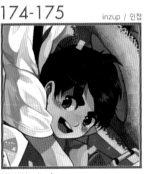

임인섭/ Lim In-sub

1/6　　kkso / 귀소

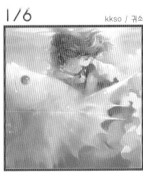

이경희/ Lee Kyung-hee

177　　guroom / 구름

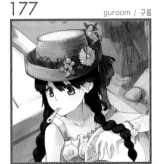

이송이/ Lee Song-yee

178-179　　민트초코 / Mintchoco

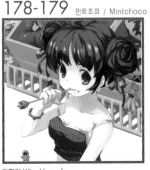

김현아/ Kim Hyun-ah
MixMaster2, Metal Slug Zero character designs

180-181　　ASK / 앙숭캉

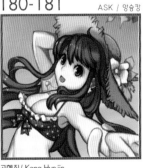

공예진/ Kong Hye-jin
Paper Man, Metal Slug Zero character designs

182-183　　1000marie / 전마리

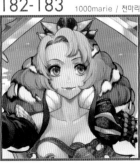

임가연/ Lim Ga-yeun
EonSoft character designs

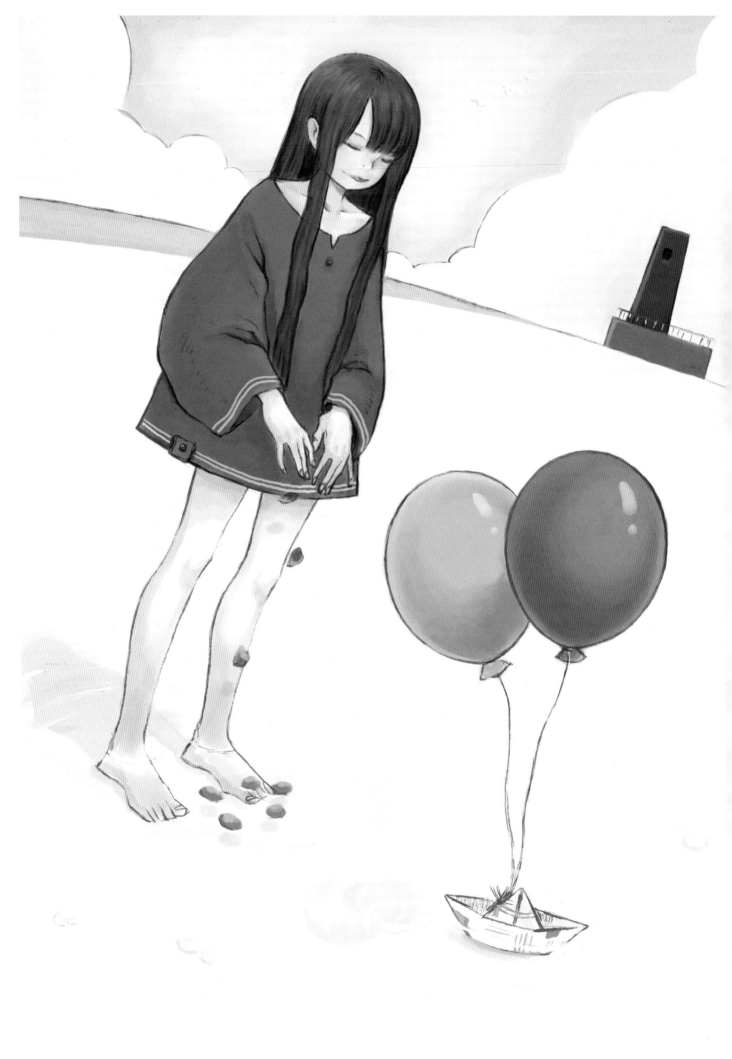

LAST SUMMER

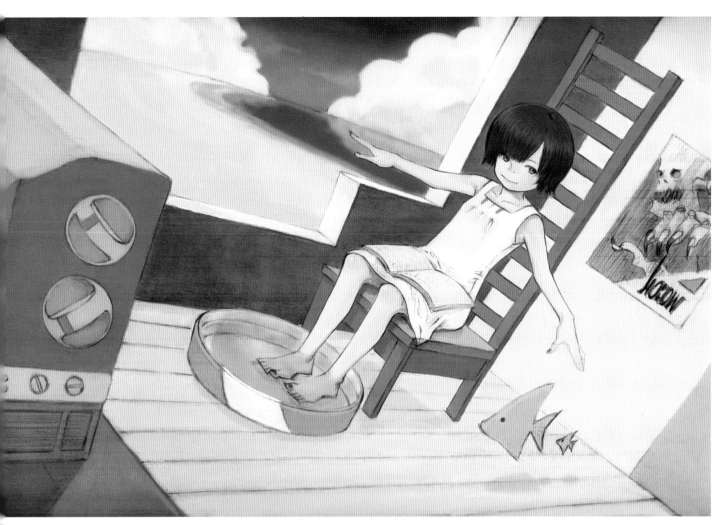

Profile
황하연/Hwang Ha yeon
하연/HAYEON
http://hayeon.woweb.net

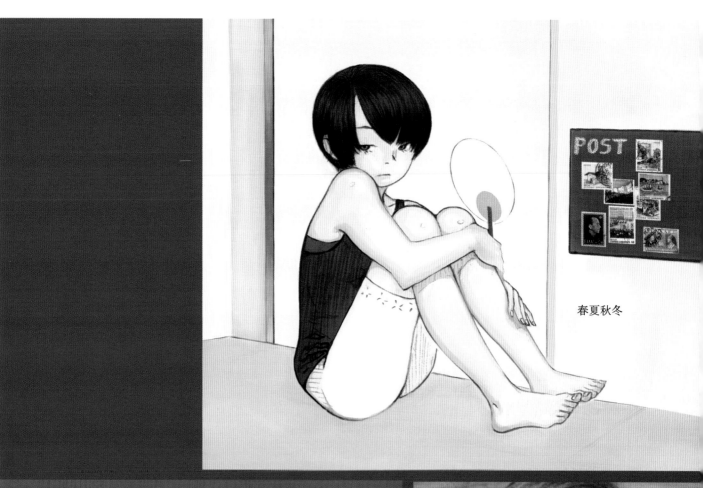

春夏秋冬

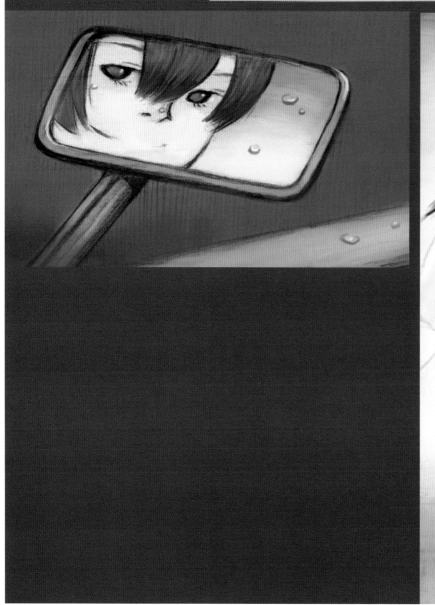

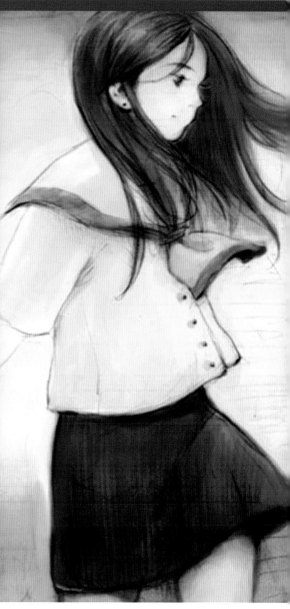

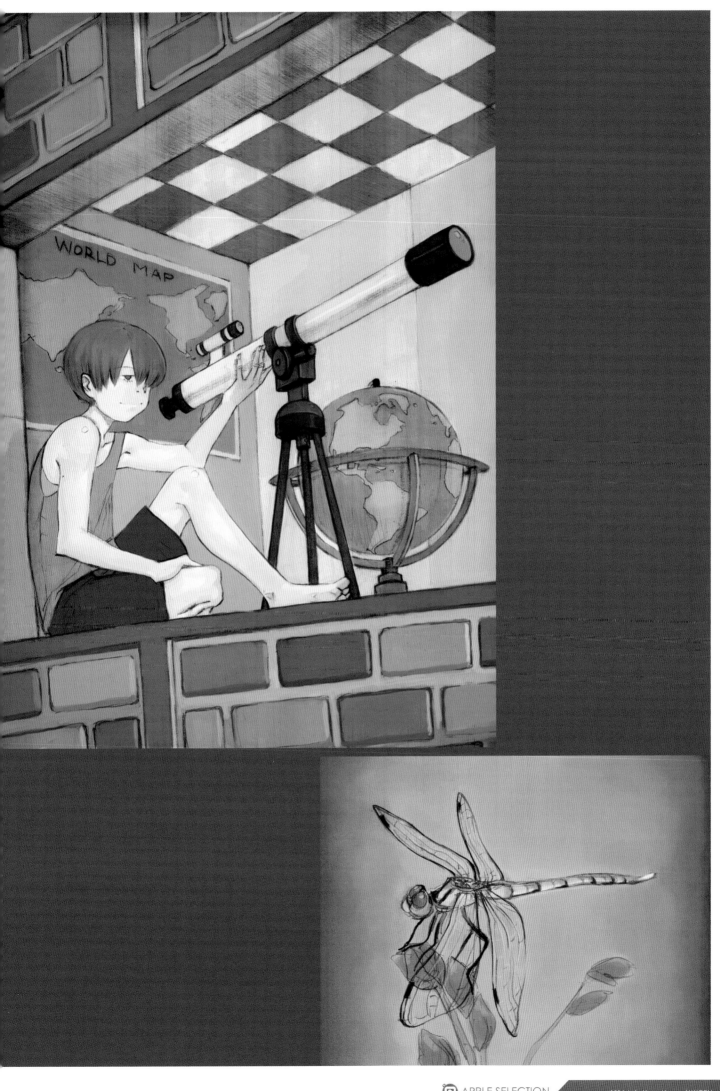

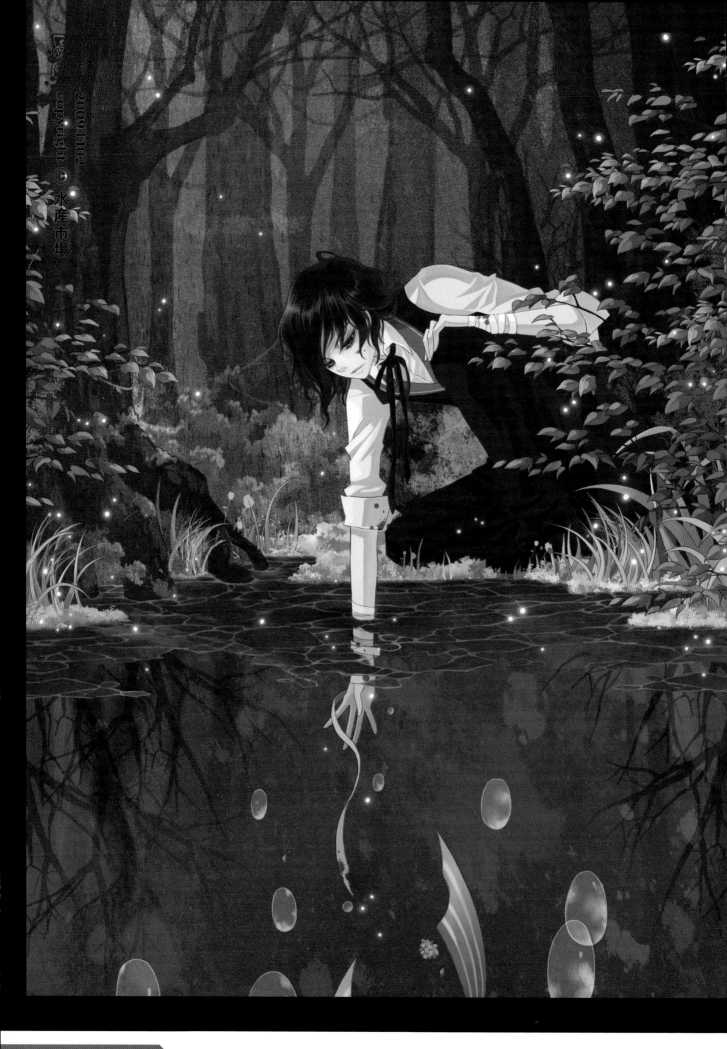

2009†102 copyright ⓒ 水産市場

LAST SUMMER

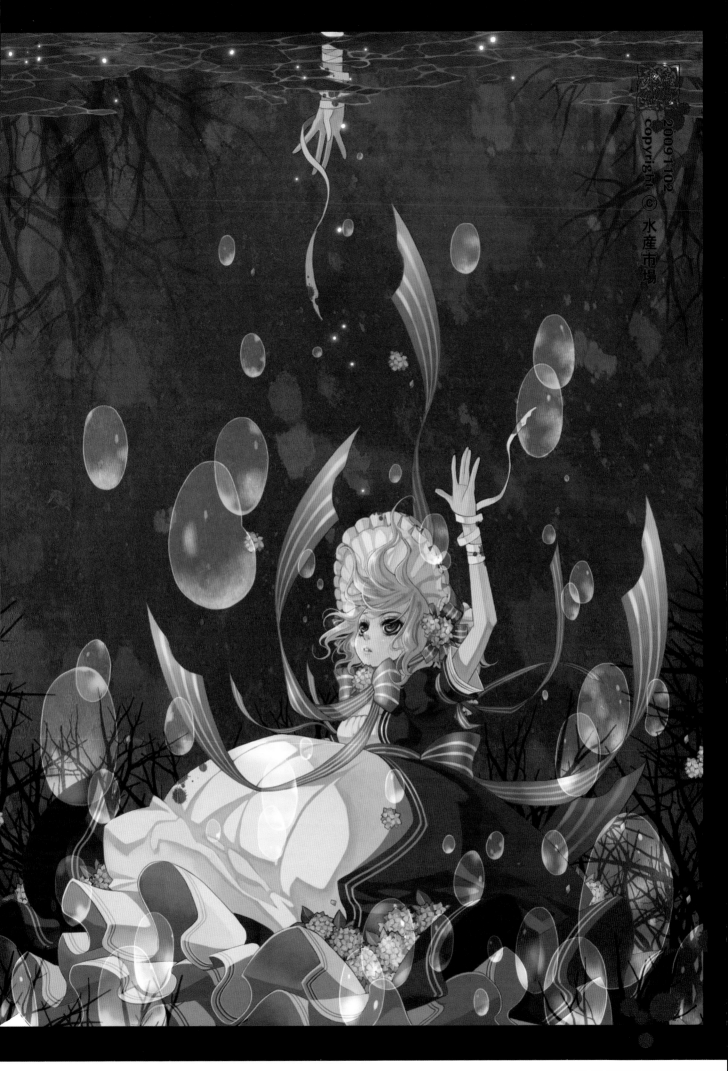

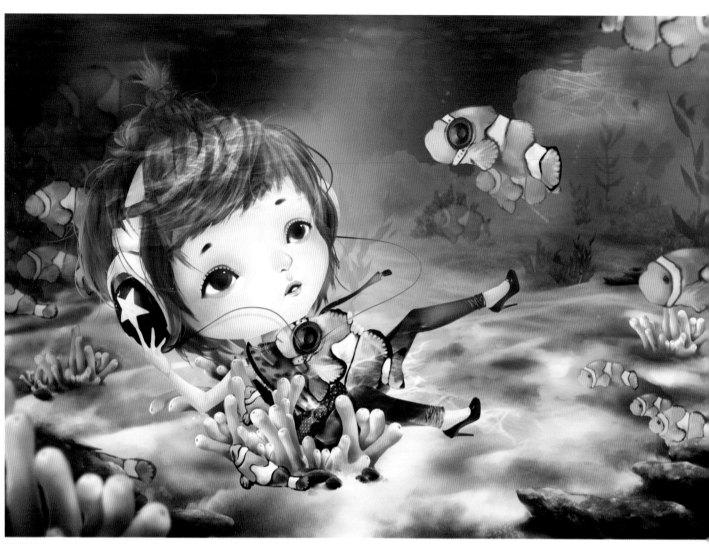

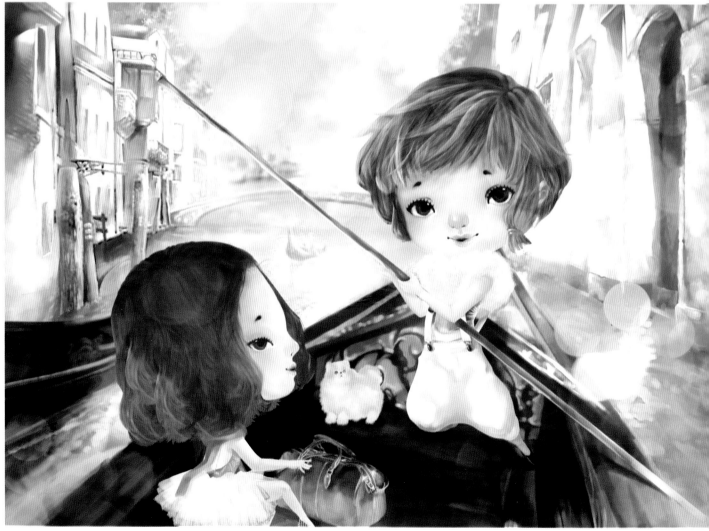

LAST SUMMER

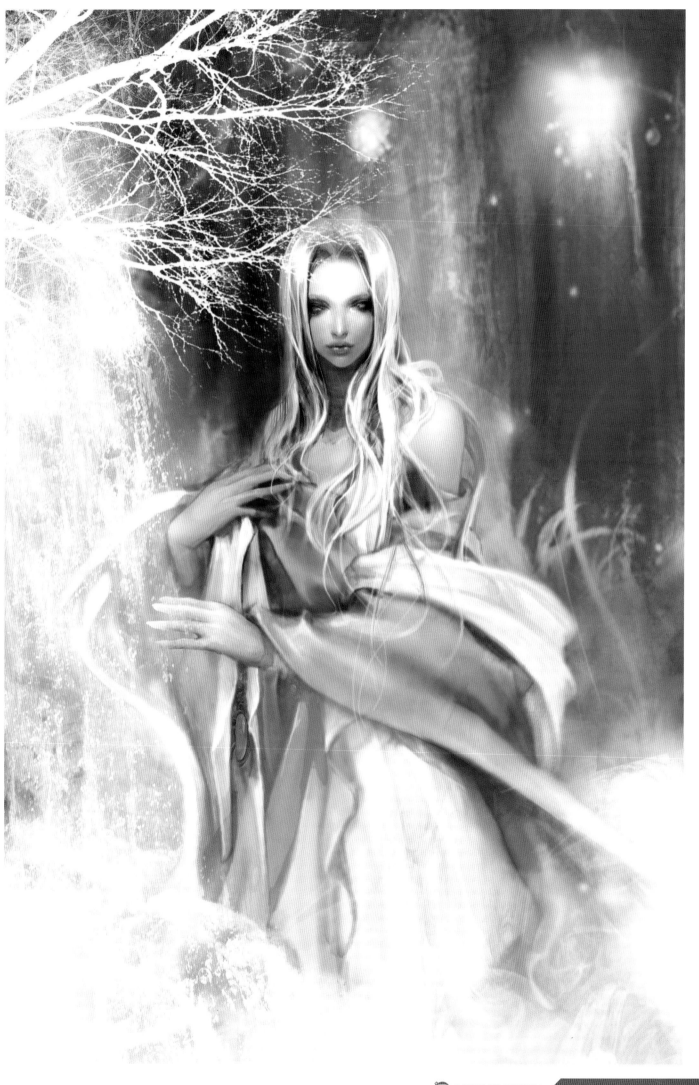

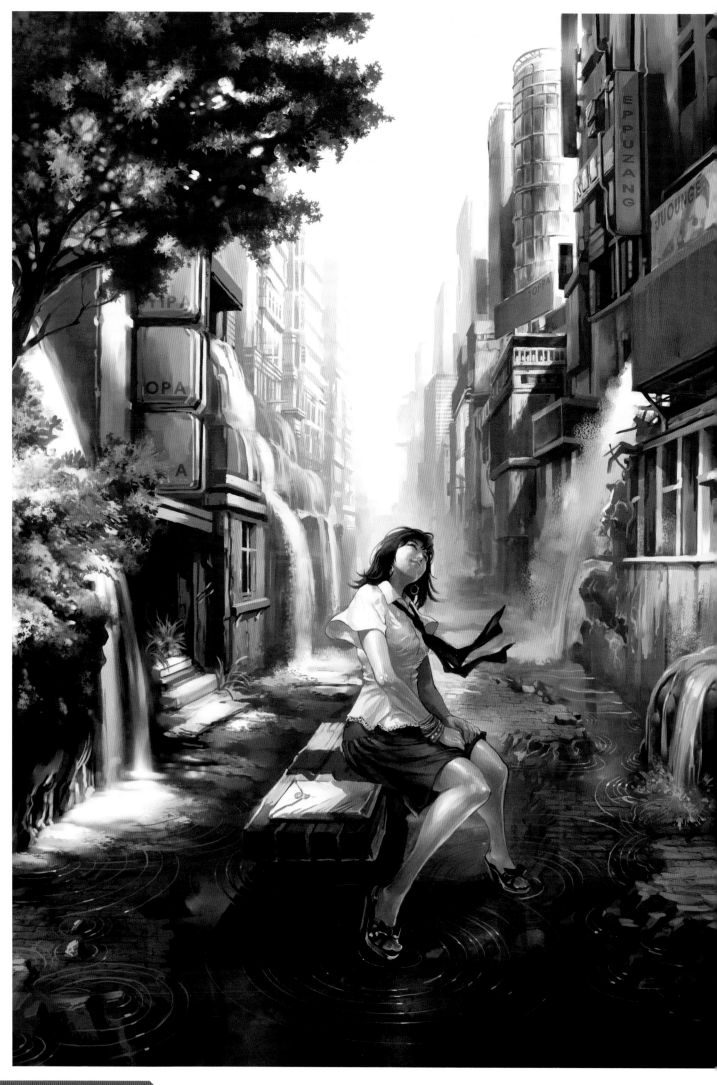

LAST SUMMER

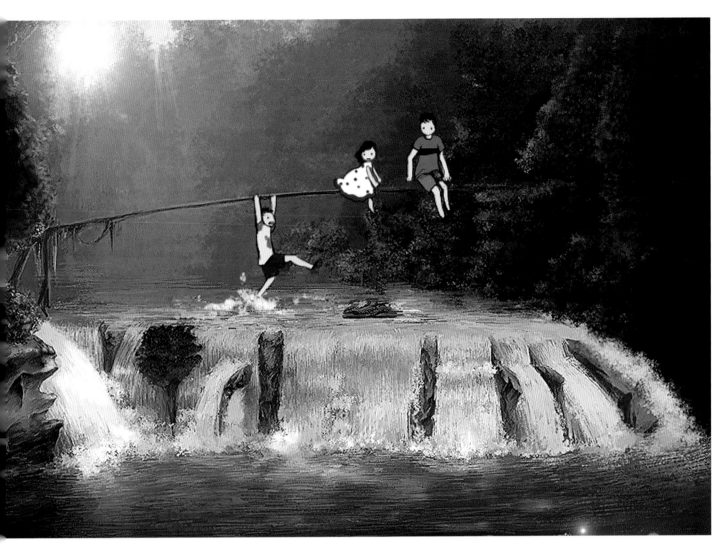

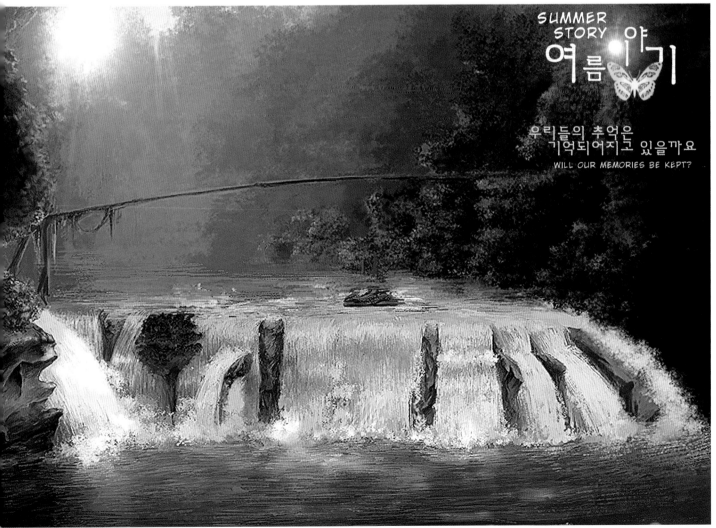

SUMMER
STORY
여름이야기

우리들의 추억은
기억되어지고 있을까요
WILL OUR MEMORIES BE KEPT?

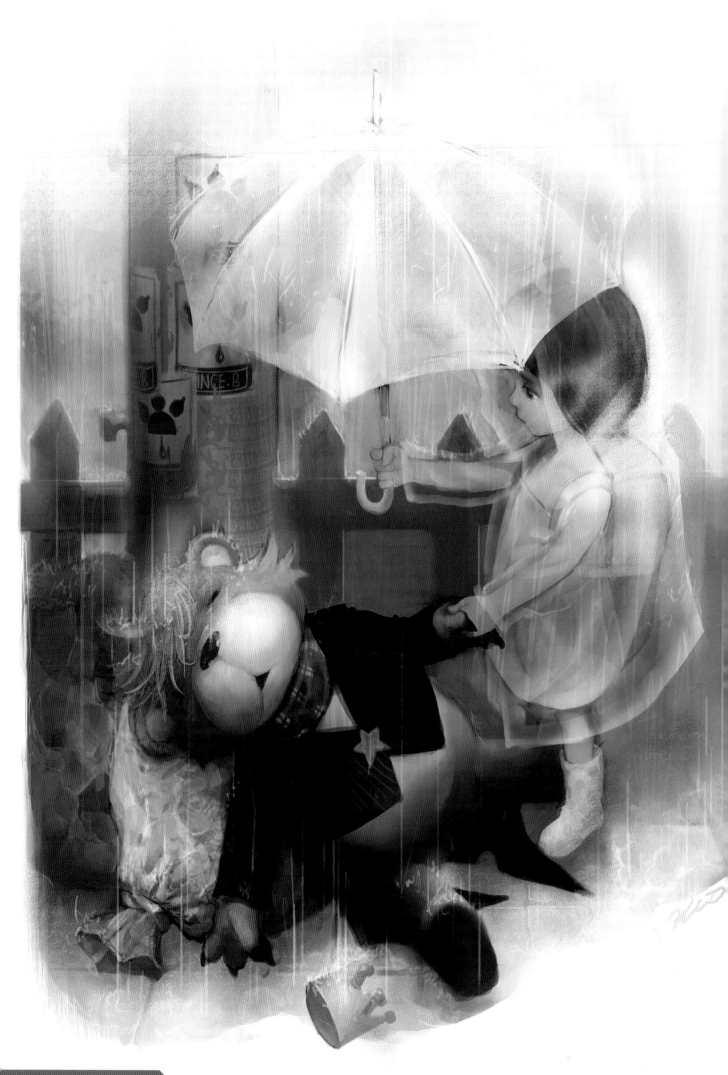

LAST SUMMER

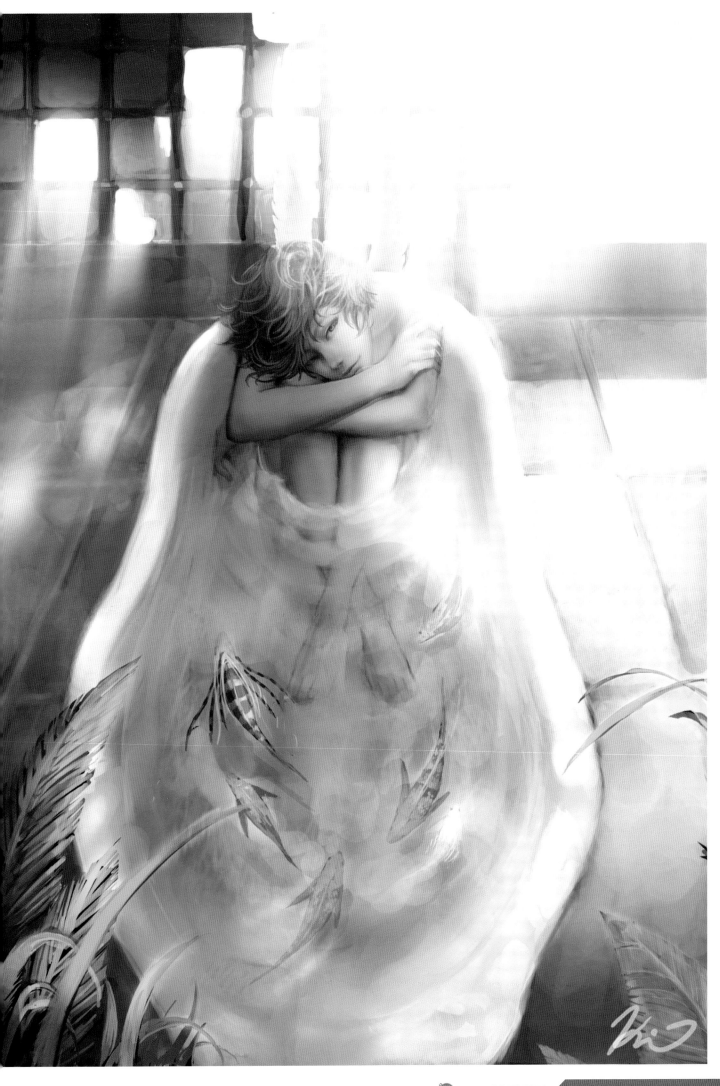

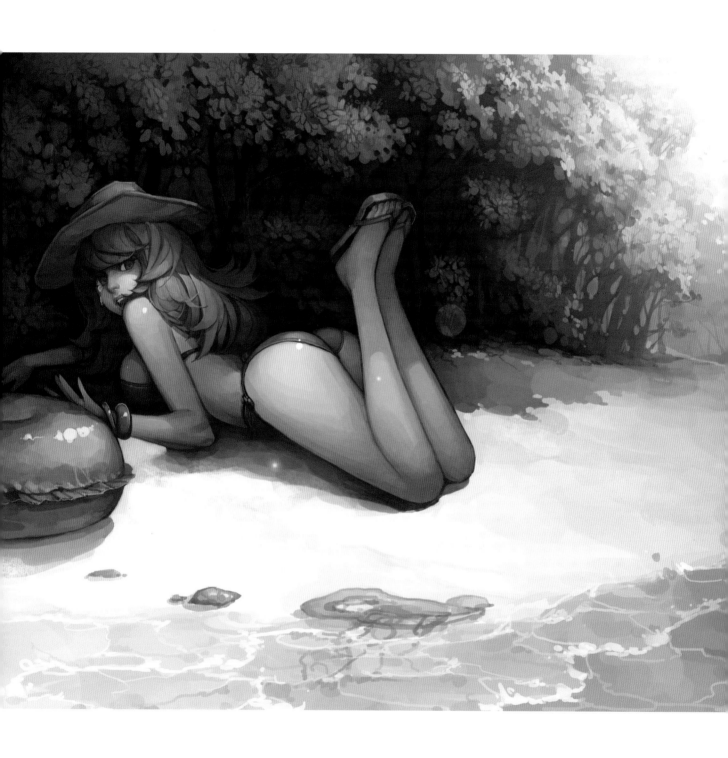

LAST SUMMER

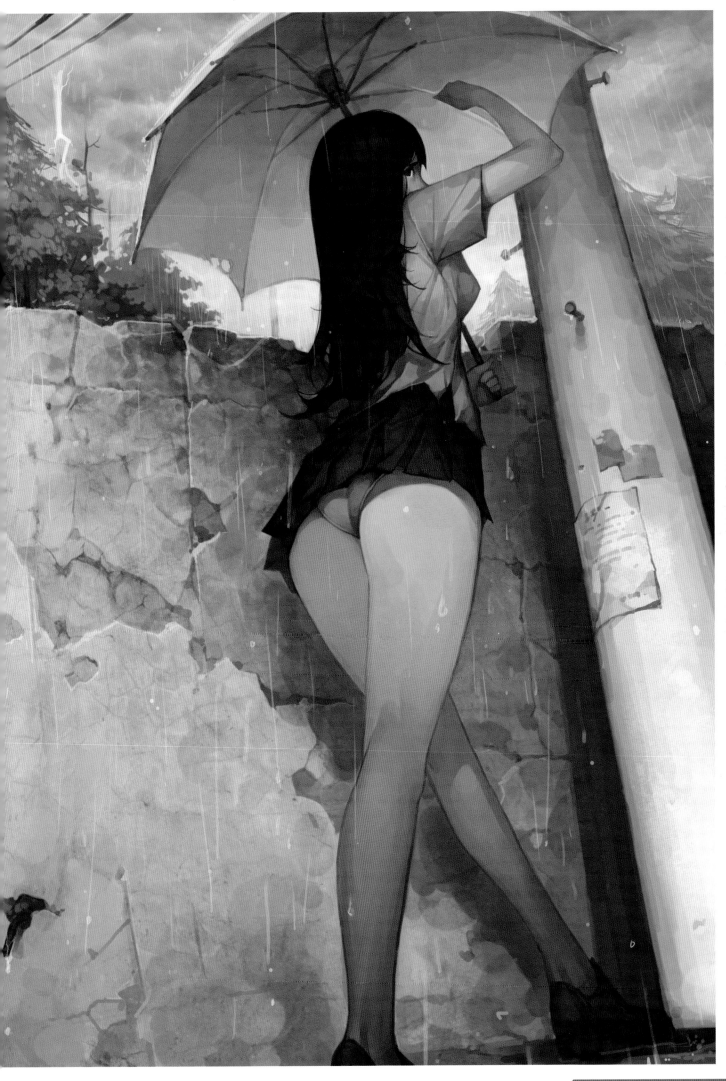

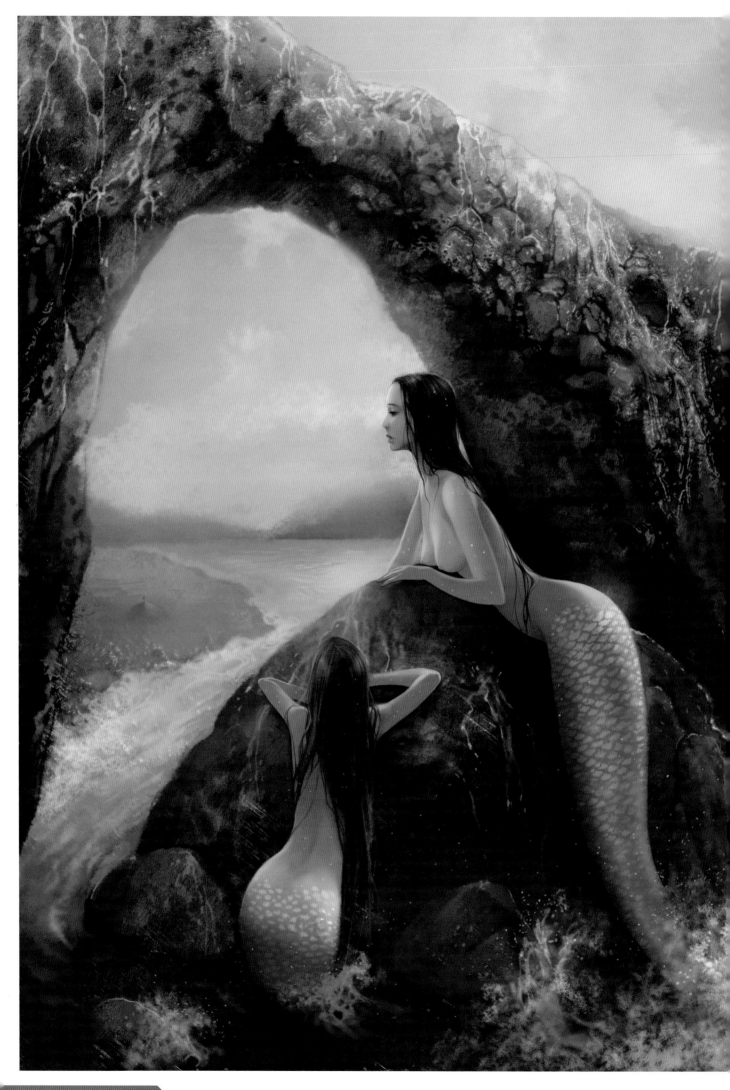

LAST SUMMER

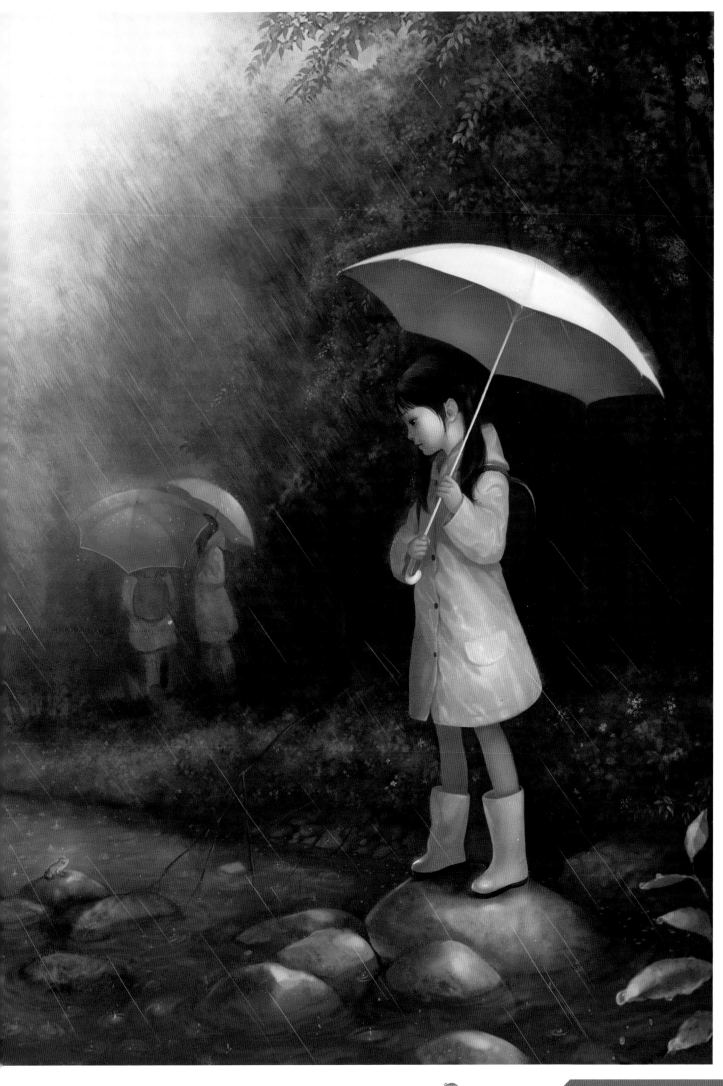

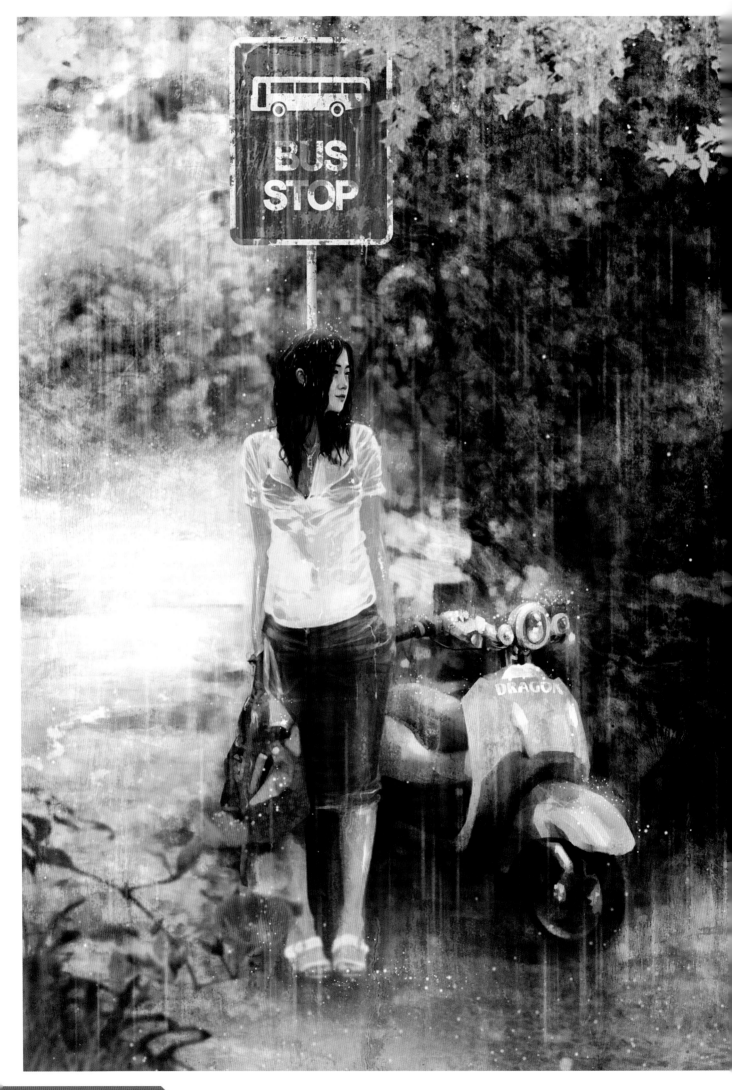

LAST SUMMER

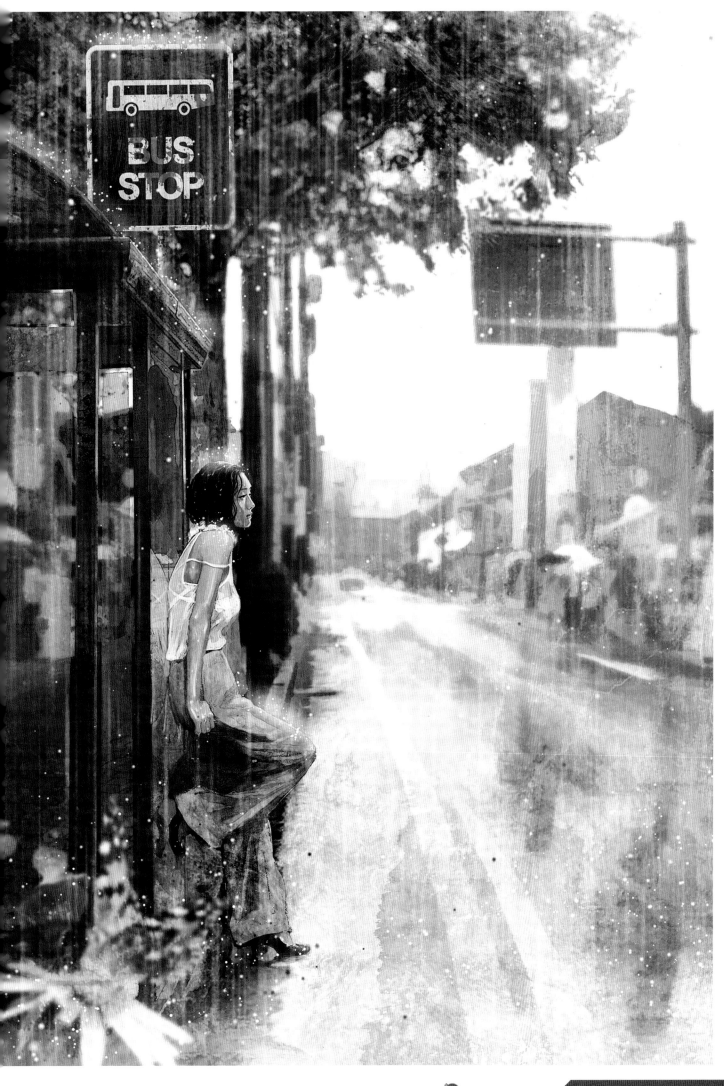

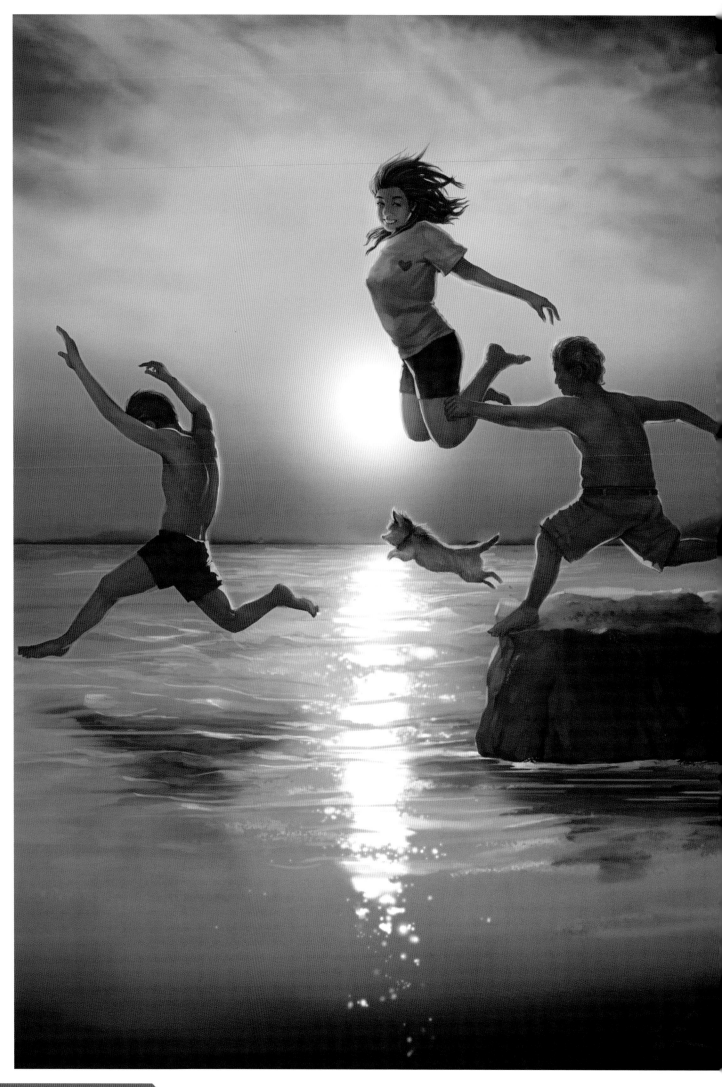

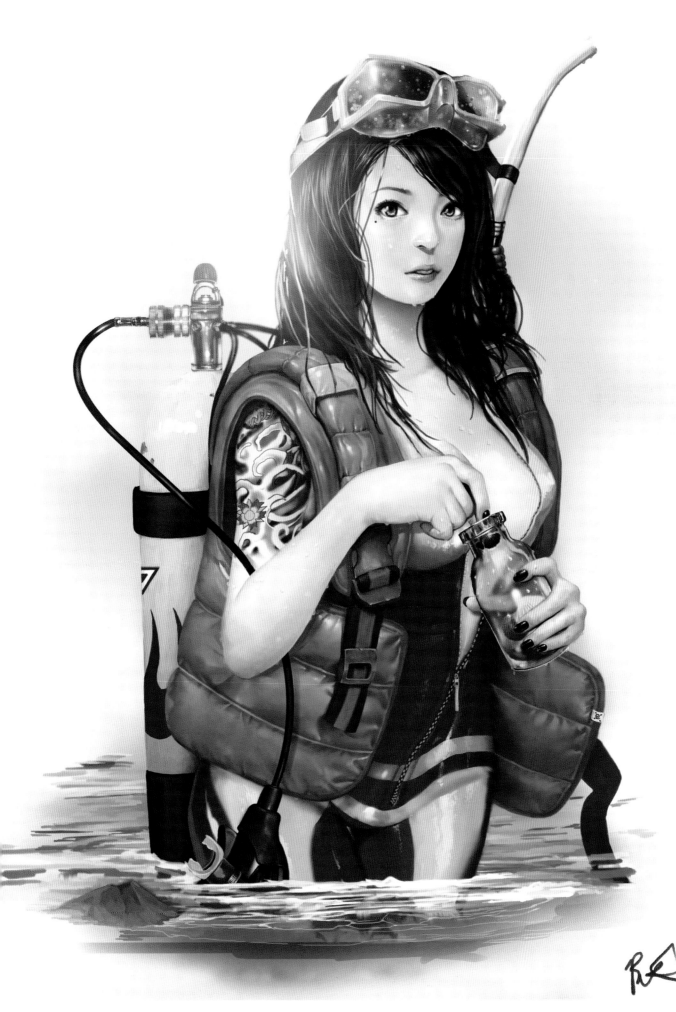

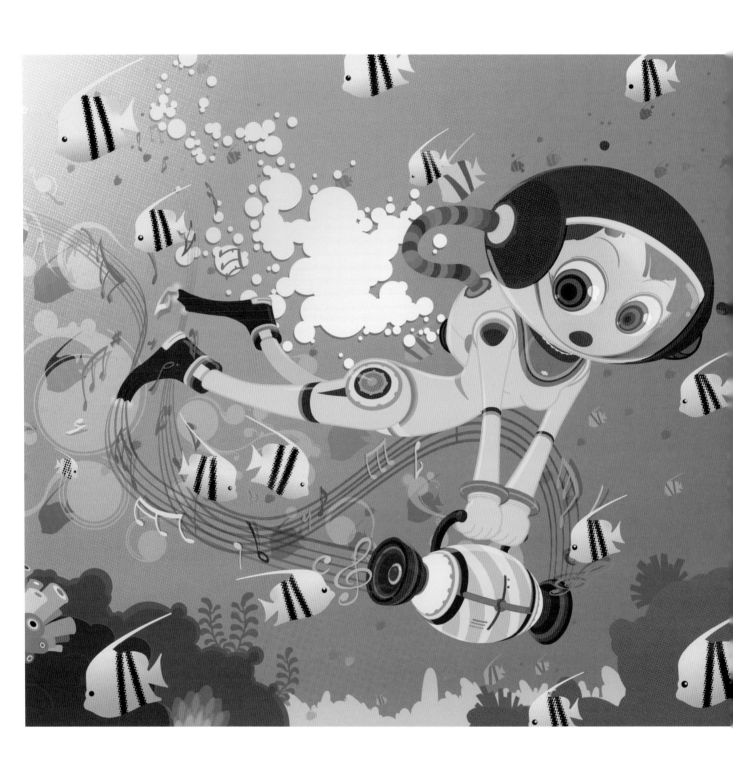

LAST SUMMER

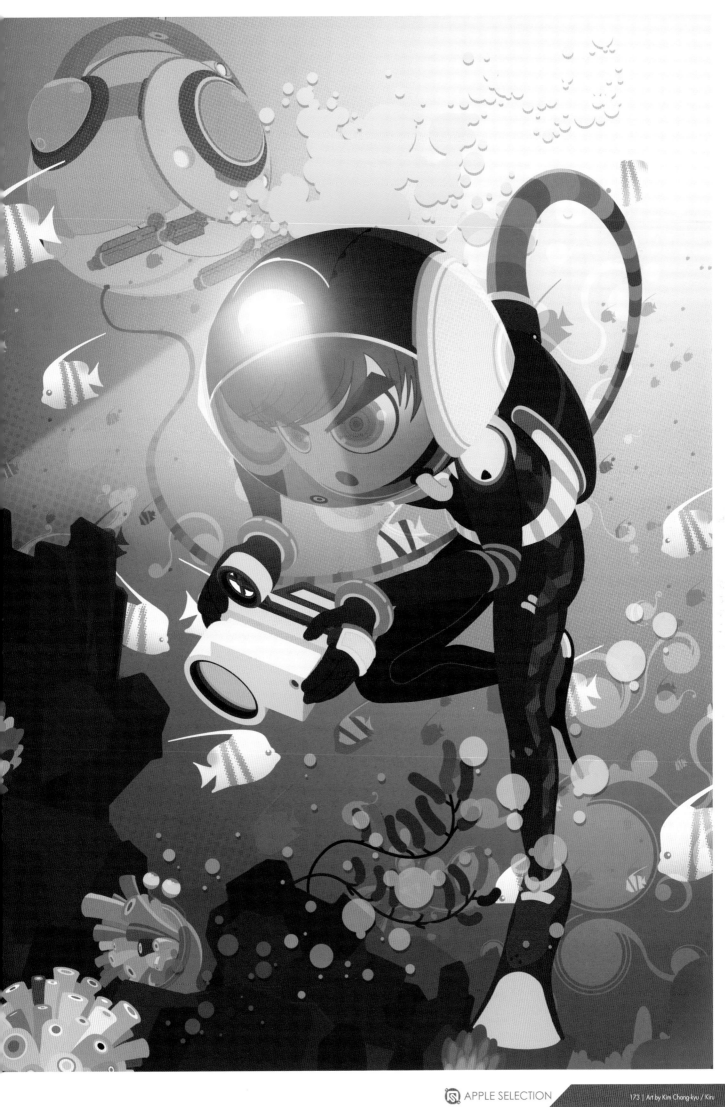

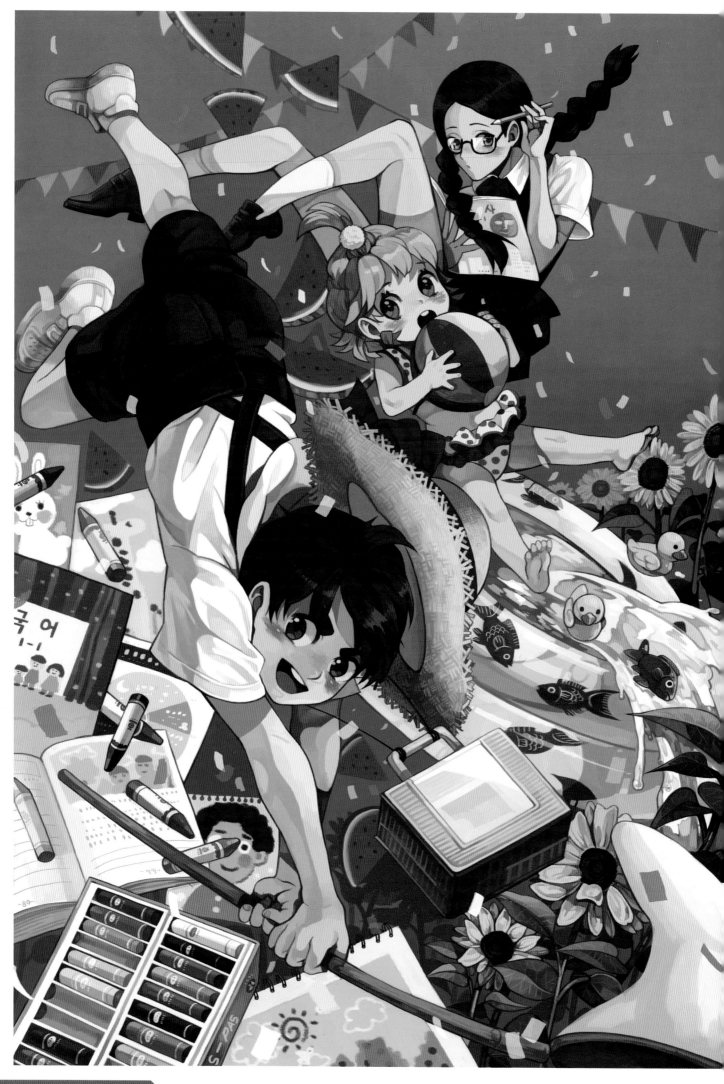

LAST SUMMER

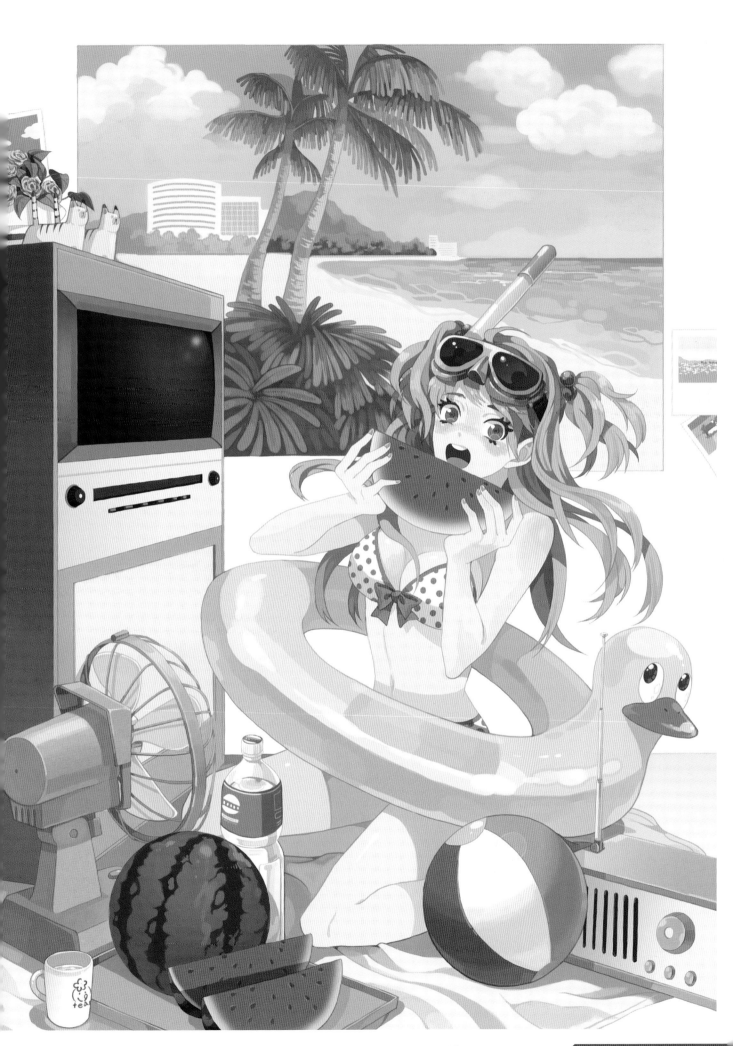

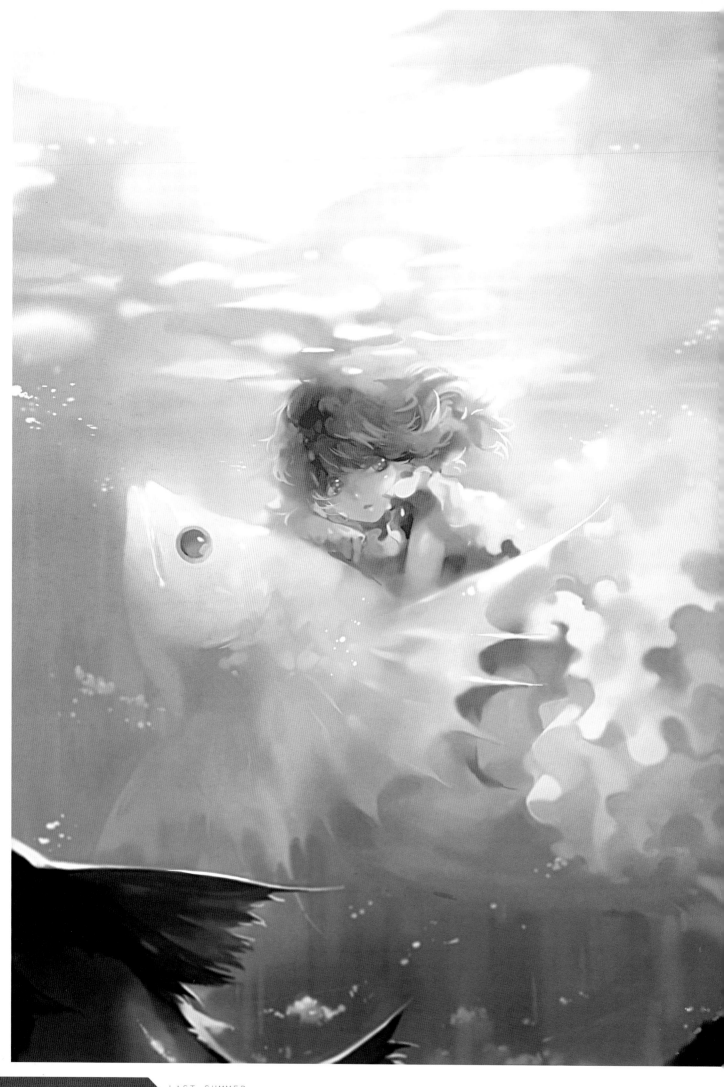

LAST SUMMER

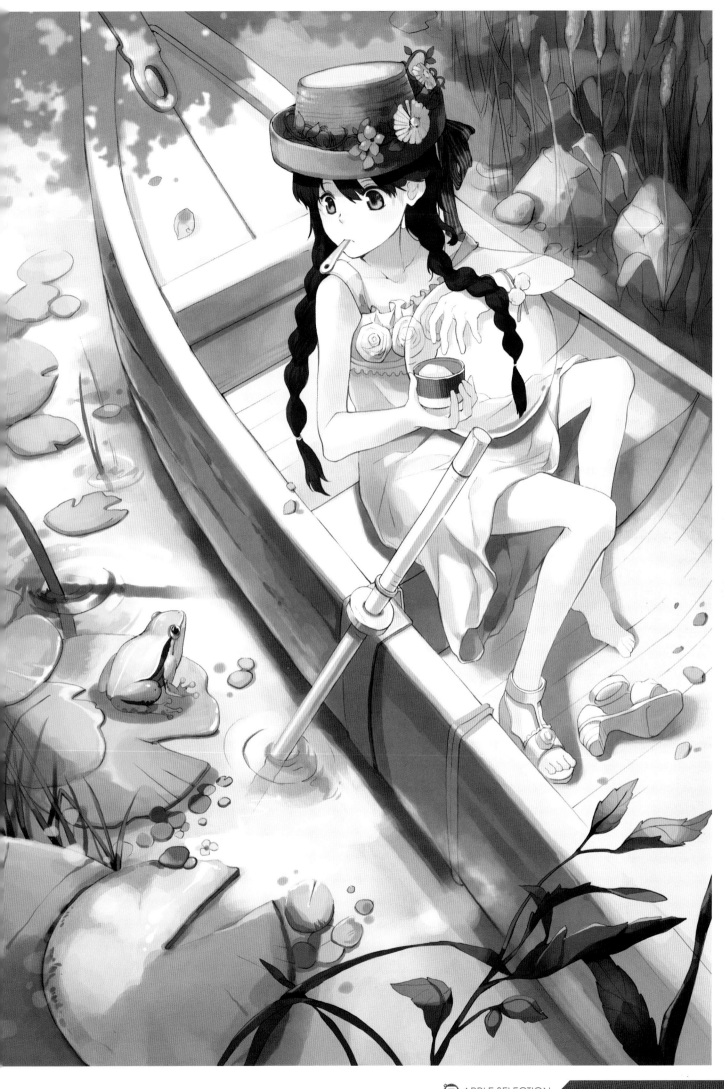

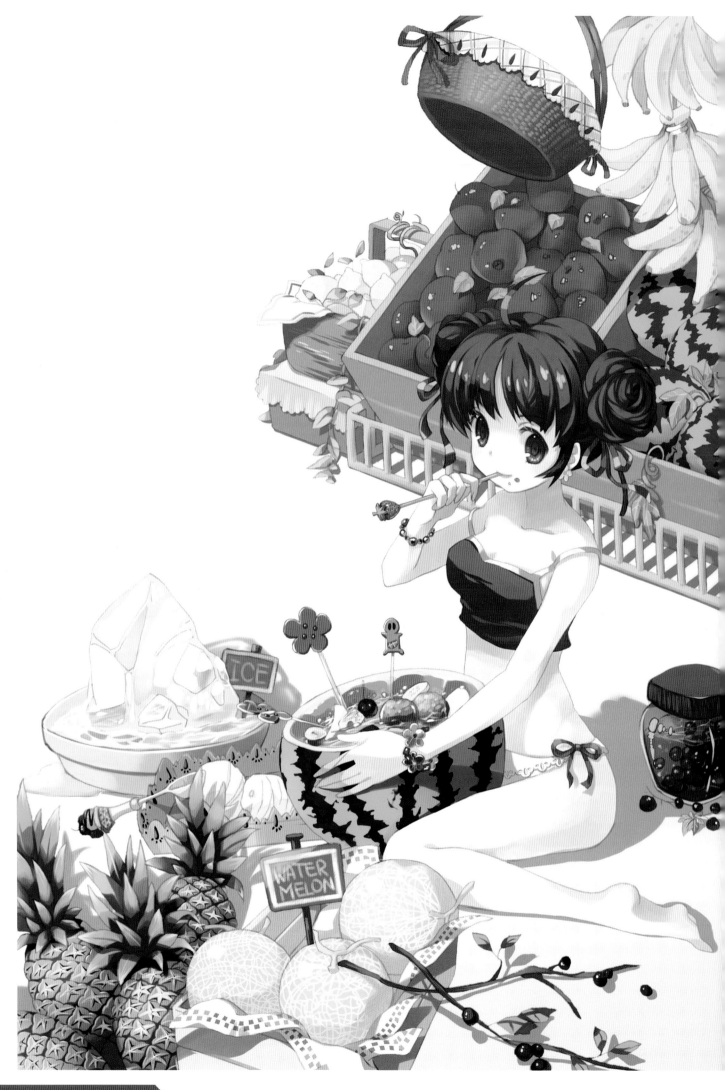

LAST SUMMER

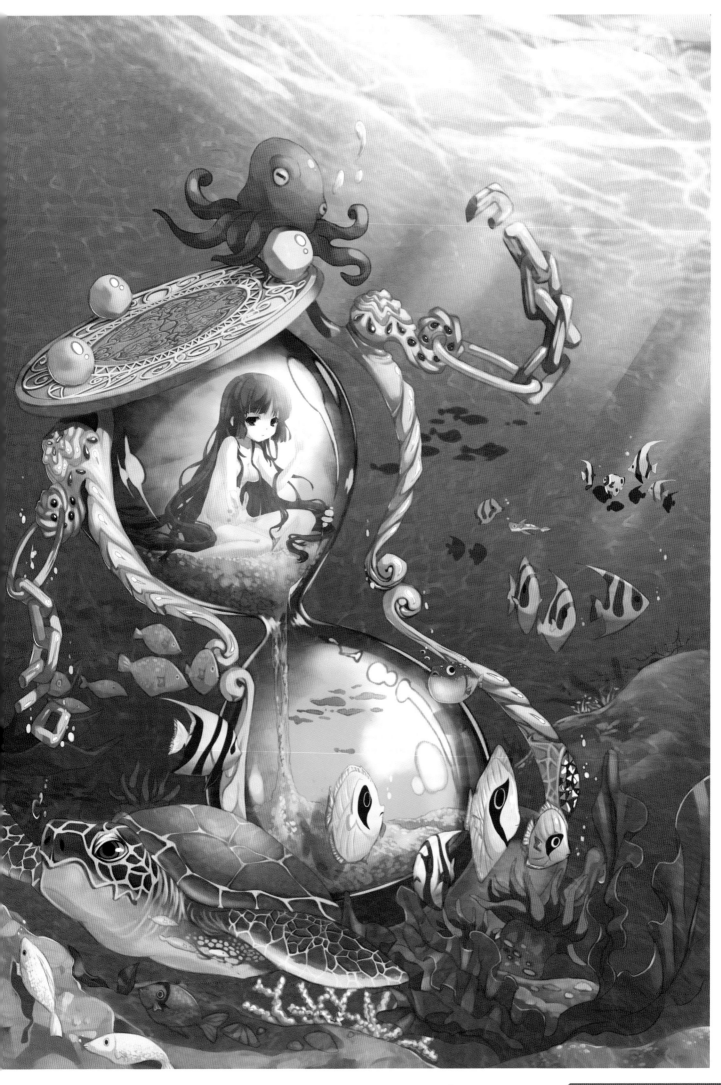

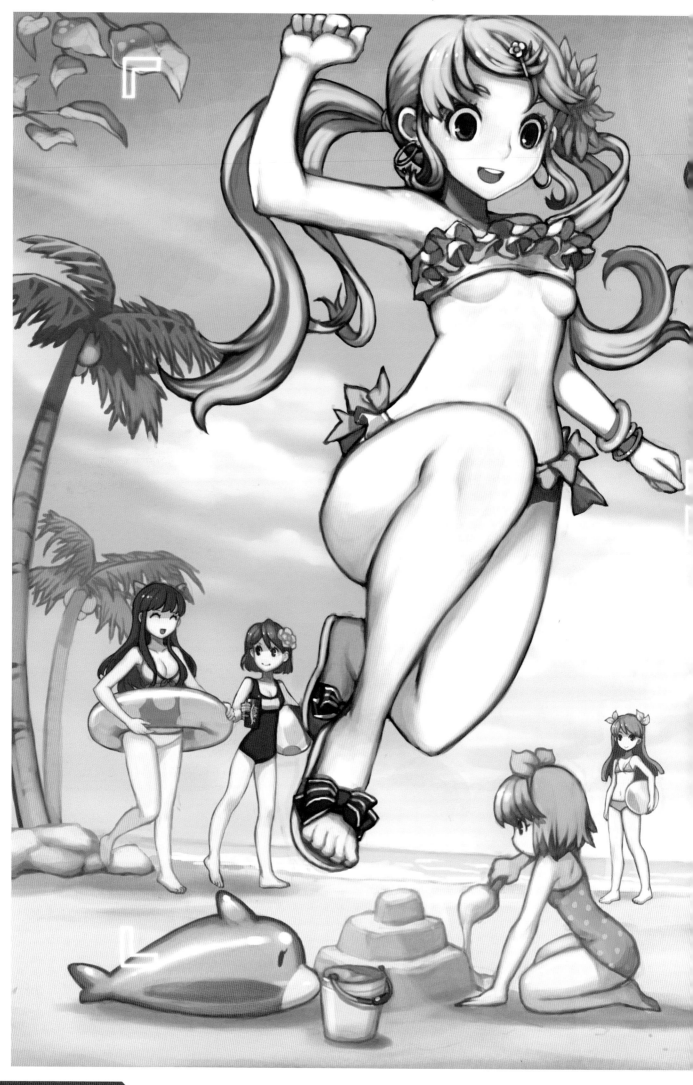

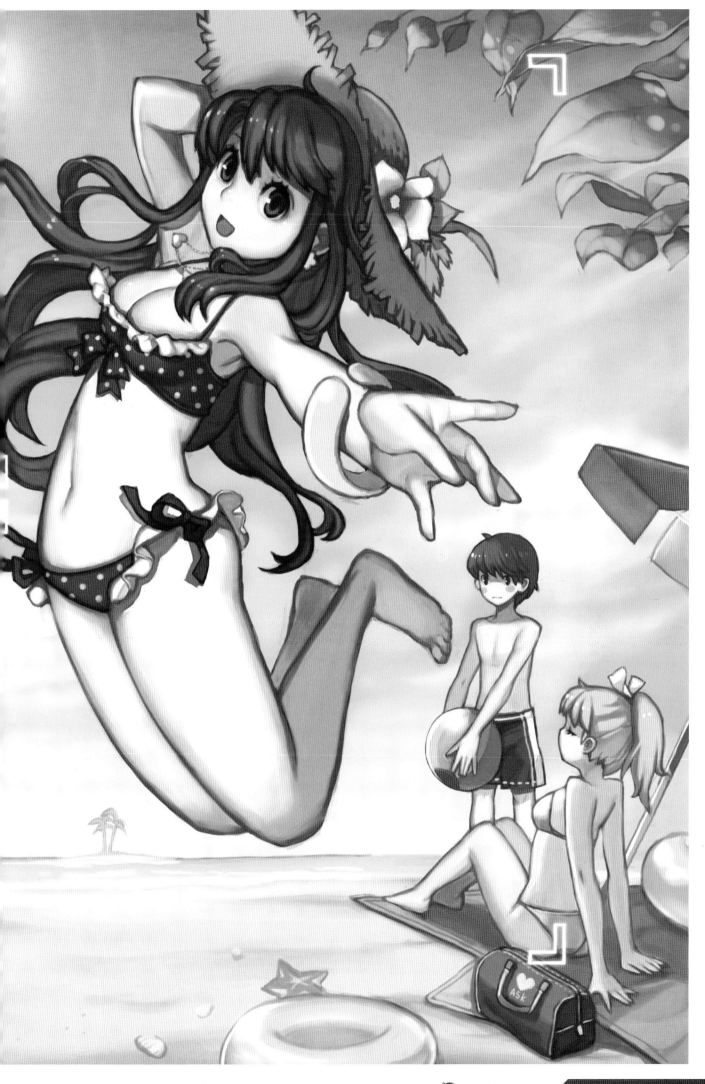

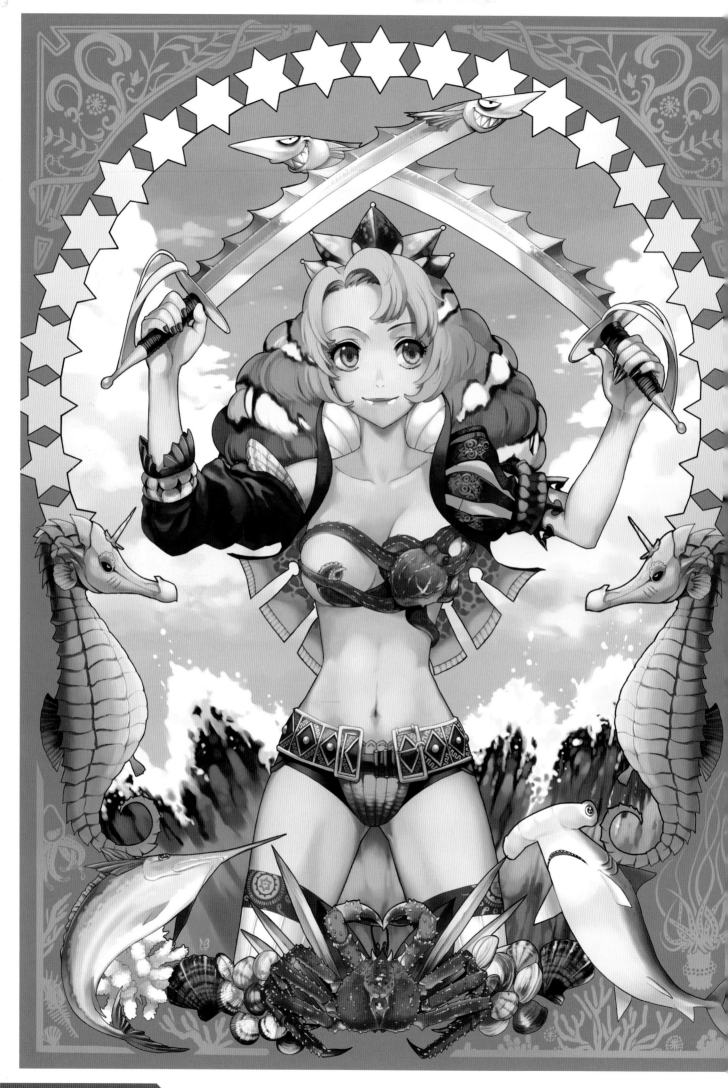

LAST SUMMER

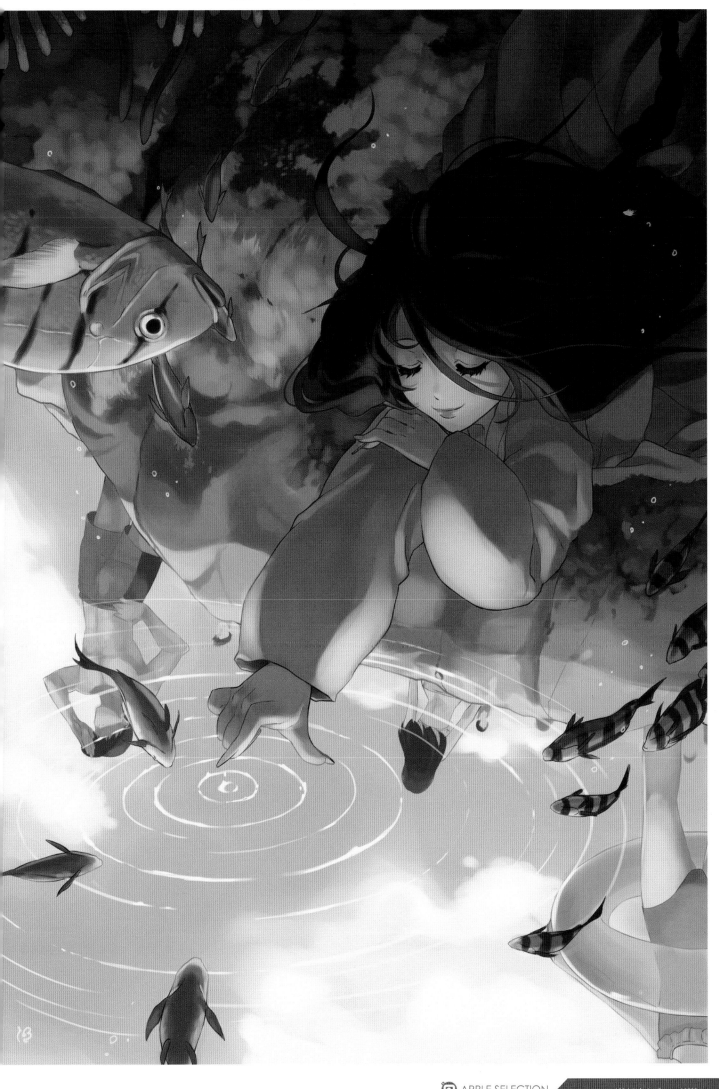

KOREAN EDITION CREDITS

PUBLISHER: Eddie Yu
MEDIA DIRECTOR: Hyun Kook Kim
EDITOR IN CHIEF: Seoung Hwan Lee
EXCLUSIVE DESIGNER: Sun Min Hwang
ART PRINTING DIRECTOR: Yuwha
EDITOR: Hye Young Shim, Mi Hee Yoo

ENGLISH EDITION CREDITS

ENGLISH TRANSLATION Yewon Kim
LAYOUT/DESIGN ADAPTATION Matt Moylan

UDON STAFF
CHIEF OF OPERATIONS Erik Ko
MANAGING EDITOR Matt Moylan
PROJECT MANAGER Jim Zubkavich
DIRECTOR OF MARKETING Christopher Butcher
MARKETING MANAGER Stacy King
ASSOCIATE EDITOR Ash Paulsen
JAPANESE LIAISON Steven Cummings
EDITOR, JAPANESE PUBLICATIONS M. Kirie Hayashi

© Seoul Visual Works

Originally published in Korea by Seoul Visual Works. APPLE SELECTION Concept Art, all associated characters, and their distinctive likenesses are copyright Seoul Visual Works. All rights reserved.

English edition published by UDON Entertainment Corp.
118 Tower Hill Road, C1, PO Box 20008, Richmond Hill, Ontario, L4K 0K0, Canada

Any similarities to persons living or dead is purely coincidental. No part of this publication may be reproduced, stored in retrieval systems, or transmitted in any form or by any means (electronic, mechanical photocopying, recording, or otherwise) without the prior written permission of the publisher.

www.UDONentertainment.com

Printed by Suncolor Printing Co. Ltd.
E-mail: suncolor@netvigator.com

First Printing: May 2012
ISBN-13: 978-1-926778-36-5
ISBN-10 : 1-926778-36-7

Printed in Hong Kong